The Education of a Comics Artist:

Visual Narrative in Cartoons, Graphic Novels, and Beyond

edited by Michael Dooley and Steven Heller

ALLWORTH PRESS
NEW YORK

School of
VISUAL ARTS

08 07 06 05 04 5 4 3 2 1

Published by Allworth Press
An imprint of Allworth Communications, Inc.
10 East 23rd Street, New York, NY 10010

Cover and interior design by James Victore
Page composition/typography by SR Desktop Services, Ridge, NY

Library of Congress Cataloging-in-Publication Data
 The education of a comics artist: visual narrative in cartoons, graphic novels, and beyond / edited by Michael Dooley and Steven Heller.
 p. cm.
 Includes index.
 ISBN 1-58115-408-9 (pbk.)
 1. Caricatures and cartoons—United States—History—20th century. 2. Cartooning—Study and teaching.
3. Cartooning—Vocational guidance. I. Dooley, Michael (Michael Patrick), 1948– II. Heller, Steven.

 NC1320.E29 2005
 741.5'071—dc22
 2005005865

Printed in Canada

Contents

Magazine Cartoons

Editorial Cartoons

Political Comics

Comic Strips

Kids' and Teens' Comics

Action/Adventure Comics

Alternative Comics

Graphic Novels

Miscellany

Comics in Art and Illustration

Dedications

To brother Kevin Dooley, fellow dark and
stormy knight, for treasured comics
memories shared.
—MD

To Jules Feiffer and Art Spiegelman, for their
incalculable contributions to comics.
—SH

Acknowledgments

This book could not be possible if not for Tad Crawford at Allworth Press. Thanks also to the great support team at Allworth: Nicole Potter, editor; Monica Lugo and Jessica Rozler, editorial assistants; and Gebrina Roberts, Cynthia Rivelli, Birte Pampel, Michael Madole, and Bob Porter.

Our deep gratitude goes to those writers and interviewees who so generously contributed ideas and content to this endeavor. And special thanks goes to Lalo Alcaraz, Gary Baseman, Ivan Brunetti, Leslie Cabarga, John Carlin, Jay Chapman, Seymour Chwast, Robert Grossman, Denis Kitcher, Victor Moscoso, Dan Nadel, Eric Reynolds, Patrick Rosenkranz, Marc Rosenthal, J.J. Sedelmaier, Fred Seibert, J. David Spurlock, Kim Thompson, Tom Tomorrow, Micah Wright.

Thanks, as always, to James Victore for his cover and interior design.

And finally, in addition to our official dedication, this book is also dedicated to the cartoonists and comics artists who have taught, mentored, and inspired the unstoppable future generations. We extend a special debt of gratitude to Will Eisner, a giant of comics art and art education, who passed away during the completion of this book.—MD & SH

Introduction

The Most Popular Course in Art School

Steven Heller

When I attended art school in the sixties, comics classes were for misfits. Although Roy Lichtenstein's monumental Pop Art comics panels were exhibited in museums throughout the world, everyday comics were low on the cultural food chain. Other arts courses had infinitely more cachet. The prestigious fine-art department was a haven for young Pollocks and Warhols, the graphic design department was ascending to respectable new heights, the illustration department was coming off a decade when illustrators dominated magazines and advertisements, and the photography department was emerging as a wellspring for both art and commerce. Comics classes, despite a few great teachers (including *Mad* founder Harvey Kurtzman), were considered unsophisticated because most of us post-adolescent students fixated on inventing déclassé superheroes with dubious world-altering über-powers. Nonetheless, comics classes offered something more valuable than any of the other programs.

First, comics classes were less pretentious than the so-called higher, and often humorless, art courses. Second, comics encouraged storytelling through words and pictures. In those days, painting was mostly abstract, design was cold Swiss, illustration was faux-surreal, and photography was about capturing a single moment. Comics, however, demanded an intricate weaving of tales into concise multi-perspective narratives. And there was something more: the underground "comix" had just started tackling taboo subjects such as sex, drugs, and anti-authoritarianism in breach of the puritanical Comics Code Authority, the self-censoring industry standard that curtailed anything remotely fostering sex, drugs, and anti-authoritarianism. So this was the dawn (and for some, the Second Coming) of comics as a wildly experimental, at times bawdy, and always confrontational phenomenon that surprisingly evolved into a major movement.

While our parents who footed the school bills believed comics were something we would grow out of—like sucking our thumbs, growing long hair, or fornicating in public parks—we knew that comics provided untold free expression. Most of us were committed for the long haul. Okay, the underground comics, even with their "adults only" warning labels, were admittedly rooted in an insatiable compulsion to sow wild oats by shocking conservative society; nonetheless, undergrounds offered critiques of social hypocrisies that ultimately altered some contemporary mores. They were also hilariously, raucously, and sinfully ribald. (When was the last time we really laughed at, or were erotically excited by, *Archie* and the rest of that insipid, post-Code comics pap?) At that time, simply attacking convention was as life sustaining as oxygen—and underground comix were fresh air. They still are.

Over three decades since these comix first published in underground newspapers and comic books, many of the underground-breakers—including R. Crumb, Art Spiegelman, and Bill Griffith—have become accepted as mainstream artists, entertainers, and even pundits. Crumb is the subject of a major documentary and various books of criticism, Spiegelman (page 110) is a Pulitzer Prize winner and was contributor to *The New Yorker*, Griffith (page 43) has produced a long-running syndicated comic strip, *Zippy*, for over twenty years, and all have collectively published several popular monographs. Although in Europe comics have long been celebrated for their integral cultural role, in the United States, the phenomenon is only now reaching explosive proportions. Cross-cultural consumption has, nonetheless, surprised even the visionaries.

Historically speaking, ever since Superman premiered in the late thirties, super-heroes have been the bedrock of comics lit, and the idols of teenage boys. However,

as comics impresario Chip Kidd explains (page 104), today comic books and strips of all kinds have become "a springboard to movies both high and low budget, alike." Like novels and non-fiction books before them, comics are currently the inspiration for live-action television series and films, not to mention a slew of animated shorts and features, as well documentaries. In a comic twist, comics have also directly influenced critically acclaimed novels by Michael Chabon (*Kavalier and Clay*) and Jay Cantor (*Krazy Kat, Great Neck*). And in a turn on the old novel/film adaptation formula, writer Paul Auster encouraged a version of his novel *City of Glass* to be transformed into a graphic novel (could the next step be an animated feature?). The increase in mainstream and independent publishers of graphic novels has given further impetus to an expanding and profitable field. Largely owing to Spiegelman's autobiographical *Maus*, spawning a genre of emotionally intense non-fiction comics, and Spiegelman and Françoise Mouly's late eighties and early nineties *Raw* magazine, inspiring psychologically complex narratives, comics is now Mecca for a range of artists interested in alternative approaches to journalism, memoir, and literature, as well as theater, film, and even opera. Thanks also to inroads made by Jim Steranko (page 67), Bill Sienkiewicz (page 79), and Dave McKean (page 83), among others, the superhero genre is more intellectually and aesthetically esteemed than ever before. Such is the superiority of the field that while misfits are still drawn to art-school comics classes, they are no longer perceived as pitiful outcasts. To be a comics artist or cartoonist, as *Simpsons'* creator Matt Groening would doubtless attest, is to be afforded cultural hero status above and beyond that of mortal men. And he is not alone in the new cultural pantheon for which the annual Comicon in San Diego serves as a huge and continually expanding anteroom.

With the weight of western culture in the balance, a good education is more critical now than ever. So how does one effectively learn to become a comics artist? Is it indeed teachable? Through the mid-twentieth century comics pedagogy was limited to correspondence courses that were advertised in the backs of pulp magazines and comic books; to be educated was as simple as reading a how-to manual and copying the examples. For those who could not afford it, tracing characters from the newspaper funnies was also an acceptable way to learn the comics language. Instinct was as useful as innate talent, and intuition went a long way towards making viable art. While there were rules, they existed to be broken. Promising comics artists filled sketchbooks with inventive drawings that served as ersatz portfolios. And if lucky, the truly gifted among them could find educational opportunities as apprentices to established veterans—as Jules Feiffer did with Will Eisner

(page 221)—and further develop their comics chops in the cartooning bull pens. A few successful comics artists are, in fact, college graduates, yet they probably did not learn nuanced craft in their respective institutions of higher education. For example, after leaving the painting department at Yale in the mid-sixties, Victor Moscoso rejected the Bauhaus-influenced simplicity taught by his famous teacher, Josef Albers, and consequently embraced complexity as the keynote for his psychedelic posters and comics. But the past is past. Today, a solid formal education is essential, and integrated comics programs are necessary to teach both craft and conceptual foundations.

Speaking of foundations, there is not just one; indeed there are as many as there are comics art genres. Although the common root is drawing and writing, there are various ways to conceive and make comics and cartoons and, therefore, use the comics language(s) for illustrative and other pictorially narrative ends. Moreover, artists are rarely locked into a single genre: Seymour Chwast, best known as an editorial illustrator and designer, has produced many comic strips and animations. Tony Auth (page 17), a leading daily editorial cartoonist, has applied his fluid style to children's books. Mark Alan Stamaty (page 39), creator of weekly comic strips on political and social issues, has also authored children's and adults' illustrated books. Barron Storey (page 73), a legend in the comic strip world, teaches the art of representational illustration. Micah Wright, creator and writer of mainstream comic books, also produces biting polemical, partisan propaganda posters using the wonders of Photoshop. Incidentally, many contemporary graphic designers and art directors find in Chris Ware's (page 106) precisionist graphics and lettering a perfect new style for posters, book jackets, and CD covers. Cross-pollination is endemic to comic art, and education is the best way to plant the seeds.

Teaching comics is, in large part, about planting seeds of knowledge and experience. So the purpose of *The Education of a Comics Artist* is to preview current educational possibilities while surveying the broad field of comics art and how it can be applied to art in general—a heavy load. This volume is not meant to make the reader into a keen practitioner but rather to introduce the likely neophyte (and some veterans too) to a large range of possibilities. The essays and interviews herein are intended as inspirational overviews and insightful behind-the-scenes accounts. Reading from the beginning or dipping in at any juncture is possible, for everything in this book will illuminate what is decidedly a complex yet accessible discipline. There are common themes—personal expression being the most recurring—but each essay and interview further uniquely addresses the significance of comics art in social and cultural terms.

This book is aimed at those—young and old—who believe comics is a calling (in fact, comics has religious overtones for some devout practitioners), but it is also geared for illustrators, painters, designers, filmmakers, and even writers who might embrace and apply the inherent characteristics of comic artistry in their own distinct art forms. Just as important, this book makes it clear that not every piece of comics art is a multi-paneled, sequential narrative. Comic art as practiced today dates back to the eighteenth century when Thomas Rowlandson (1756–1827) and James Gillray (1756–1815), among other graphic commentators in England and France, produced single satiric images (often with captions or speech balloons) that laid waste to the fools and foolhardy of their day. The single-image "cartoon" (as it was dubbed in 1831 by *Punch*) was the state of the art that prefigured the gag cartoon so smartly practiced over a hundred years later in *The New Yorker* (page 2) and continues to this day. Ignoring the multi-image cave paintings at Lascaux, the modern sequential visual narrative, credited to Rodolphe Töpffer (1799–1846), developed in the early nineteenth century. So this book attempts to place comics art in perspective of the past, present, and future, and examine it, through the voices of many leading exemplars, as a holistic endeavor that involves many formats and numerous visual and verbal arts.

Yet despite the cultural weight placed on comic art today, the editors here contend that it is still an endeavor for alien beings—or misfits if you will—because only those who truly think outside the panel can transform such a now mainstream method of mass communication into a truly exceptional art. For all the analysis, introspection, and investigation this book provides, the most superlative comics art is drawn from deep dark recesses, pushed to the surface by desires to express compelling ideas through words and images that would otherwise be suppressed if the form did not exist. This is, perhaps, why comics art is—at least in the minds of the contributors here—the most popular course in art school today, and probably tomorrow.

Foreword

What's So Funny about Comics (and Understanding)?
Michael Dooley

"We're looking for people who like to draw," read the old ad for a correspondence art school. You'd sketch a deer or a pirate, submit it, and after a period of "training" you were supposedly ready to earn a living as a cartoonist.

Okay, you're savvy enough to know that responding to a matchbook solicitation isn't the way to blaze a trail to a hot job these days. Still, you're seriously considering a comics career. Your options may be daunting.

Steve Heller and I originally envisioned this book as a portable Comics Art Education conference, one designed to let you investigate a spectrum of approaches to understanding the art, craft, and business of comics and cartooning in their various forms. No stuffy academic seminar laden with theory and lit-crit, we organized our "conference between two covers" into a series of panel discussions by some of the most outstanding and knowledgeable practitioners, teachers, and thinkers, each with their own point of view.

Let's begin with cartooning. "Cartoon," with its lingering taint of "Draw Winky," is often used derogatively but it actually has an honorable, and even sacred, etymology that dates back to the Renaissance. At that time, cartoons were full-sized preparatory paper studies used as outline guides for oil paintings, frescoed ceilings, stained glass, and tapestries.

We can hardly think of the contemporary, sophisticated magazine cartoon without conjuring images of *New Yorker* artists, whether Peter Arno, Saul Steinberg, or Roz Chast. So to open our first panel we have esteemed *New Yorker* cartoon editor Bob Mankoff with a lighthearted behind-the-scenes peek at the serious methodology behind making readers laugh with—rather than at—his publication. R.C. Harvey then provides a chronology, from Prohibition to the present, of how the people he likes to call "cartooners" go about soliciting for sales. Next, Paul Krassner recounts cartoon highlights from his courageous, groundbreaking magazine of free-thought criticism and satire, *The Realist*. If the Harvey Kurtzman of *Frontline Combat*, *Mad*, *Help!*, and *Humbug* is the father of underground comix, then Krassner is certainly its midwife, as *The Realist* served as inspiration and breeding ground for many of the movement's most subversive participants.

Speaking of subversion, our Editorial panel starts with a couple of opinionated Pulitzer-winning cartoonists: Ben Sargent, who sketches the noble legacy and powerful potential of the craft, and Tony Auth, who recounts his on-the-job experiences. Auth also notes that newspapers have downsized the ranks of his profession to under one hundred artists. The fact that over three dozen of them reacted to 9/11 with a weeping Statue of Liberty seems further evidence that our daily illustrated elephant and donkey show needs to choose between full reinvention or extinction. Steven Brodner, whose grotesque portraits of his subjects have been described as Howard Zinn peyote visions, adds his downbeat view of the current state of caricature.

Our adjacent Political panel strikes a more positive note for those of you seeking to skewer the powers that be, graphically speaking; it covers the type of critical graphic commentary usually seen in alt-weeklies and crusading comics. Scholar and *Radical America Komiks* publisher Paul Buhle tracks a high-spirited lineage from a fifteenth-century European garden of delights to today's Lower East Side tenements. Peter Kuper picks up the journey from there with a frontline report of the genesis and evolution of his comic, *WW3 Illustrated*, over the past quarter-century. Following up is newcomer David Rees, whose acerbic anti-administration clip art comics demonstrate the potential for undiluted, self-syndicated content via the Internet.

Shifting slightly over to the social arena, we can eavesdrop on two pairs of veteran newspaper cartoonists who converse in our Strips panel. Of the weekly variety, Stan Mack reveals the MO behind his documentary-style *Real Life Funnies*, progenitor to the comics-format reportorial strips currently running in *The New Yorker*, among other publications, and Mark Alan Stamaty ruminates over his own methodologies and motivations. Speaking for the dailies, Bill Griffith and Nicole Hollander let us in on the creation, care, and feeding of their cartoon characters. With over three decades of syndication each, Zippy and Sylvia continue to distinguish themselves amid pages lousy with characters that barely have any dimension beyond "adorable."

Next up: comic books. Comics for youngsters currently extend from Disney quackery, post-Barks and Gottfredson, to the hipper, Matt Groening–spawned Bongo Comics line, to Art Spiegelman and Françoise Mouly's "Little Lit" hardcover series, to numerous forms of manga (see page 144). At our Kids' and Teens' panel, the focus is on appreciation: design historian Teal Triggs resurrects Bill Woggon to give due credit to *Katy Keene*'s influence, not only on comics

art but other creative disciplines; Jessica Abel tells us how a certain redheaded Riverdale High student altered her life as both creator and teacher; and children's book author Barbara McClintock recalls how *Top Cat*—both the Arnold Stang-voiced Hanna-Barbera TV cartoon and the Gold Key comic—was a formative influence.

Opening the Action/Adventure panel, author Arlen Schumer flies through the past half-century of distinguished superhero artists and trains his x-ray eyes on three significant trends and developments. Then Jim Steranko chats about his secret identities as Mister Miracle and The Escapist, among other topics. Schumer sees Steranko as a Silver Age artist ahead of his time, citing in a recent correspondence the landmark 1970 story "At the Stroke of Midnight," which "pushed his designed drawing into a high-contrast, high-definition black-and-white chiaroscuro that would skip the seventies and not show up in others' styles until the following decade," where it would be adapted by artistic sensibilities as dissimilar as Jaime Hernandez and Frank Miller.

This panel continues with a roundtable of creators Schumer tags as Multimedia Artists, beginning with instructor/guru Barron Storey, whose brooding, oblique stories are published by Vanguard. He's succeeded by three of his followers, in spirit if not in fact: Bill Sienkiewicz, Dave McKean, and David Mack. Each has dabbled in superheroes, although their skills are most fully realized in less restricted, often self-created, venues outside the genre. Such adult-oriented material—popularized by DC's Vertigo in its prime with titles such as the *Sandman* series and currently advanced by artists such as Ashley Wood and Ben Templesmith under the IDW Comics imprint—helps fill the chasm between traditional mainstream and alternative.

Alternative—a.k.a. independent—comics are considered to date from 1982 when Fantagraphics launched *Love & Rockets*, Jaime, Gilbert, and Mario Hernandez's humanistic, barrio-perspective tales. This category ranges from crudely drawn, solipsistic autobio to superbly rendered, insightful, and nuanced poetics. It covers a multitude of transgressions against conventionality, even as some practitioners—see Charles Burns and Kaz in *Nickelodeon* magazine—achieve more widespread acceptance. And it continues to flourish and diversify, thanks to Fantagraphics, Drawn and Quarterly, and other courageous publishers.

Our first Alternative panelist is Monte Beauchamp, editor of *Blab!* magazine, which is a tribute to high production values as well as offbeat visual narratives. Next up are four artists, each with their own style and philosophy. Gary Panter, a transitional figure between "undergrounders" and "alternativistas" who's also helped shape

over-ground visual culture—one need look no further than the zigzag hairdos on the Simpsons kids—hints that the wellspring of his creativity may be partially divined within his heated early upbringing. Then David Sandlin marvels at Marvel's Jack "The King" Kirby, his boyhood idol, while metaphysical humorist Peter Blegvad includes Marcel "The Champ" Duchamp among his muses. And "Bravo!" for Blegvad: a master mentor to fine artists for over a century, Duchamp actually began his career as a magazine cartoonist. His mustachioed Mona Lisa, "L.H.O.O.Q," and upturned urinal, titled "Fountain" and containing a sly nod to *Mutt and Jeff*, are both, in their own way, bawdy, captioned "funnies," yet he is woefully underutilized as a font of inspiration for comics artists. Concluding is Mark Newgarden, gag deconstructionist extraordinaire with a nose for humor, who alternately makes light of, and sheds light on, his chosen profession.

Now we come to the graphic novel. Where "comic book" (not necessarily comic and more pamphlet than book) is often used as a derisive diminutive, "graphic novel" (a pretentious but lucrative marketing moniker) has come to provide counterbalance. As Eric Reynolds observes elsewhere (page 174), the term's grasp far exceeds its reach: it encompasses biography, journalism, and history, as well as repackaged, sometimes serialized, sagas. It was coined at least as early as the 1960s and a decade later it began to be applied to specific works such as Steranko's 1976 *Red Tide* (a.k.a. *Chandler*), a hard-boiled detective thriller told with storyboard-style captioned illustrations, and Will Eisner's 1978 collection of tenement short stories, *A Contract with God*. From Hell artist Eddie Campbell recently declared in a ten-point "manifesto" that, rather than serving as a descriptive phrase, it should signify a general movement—which has become the prevailing consensus anyway.

Leading our Graphic Novel panel with his personal perspective is editor of Random House's Pantheon imprint, Chip Kidd. Kidd is followed by a quartet of Pantheon-published graphic novelists: Chris Ware, whose *Acme Novelty Datebook* is an exemplary compendium for those who appreciate the value of doodles and diaries; Art Spiegelman, whose *Breakdowns* collection is practically a primer in formalist comics analysis; Marjane Satrapi, whose popular two-volume *Persepolis* provided evidence that *Maus'* success wasn't just a one-time fluke for comics memoirs; and Kim Deitch, whose stroll down *The Boulevard of Broken Dreams* led him back to the birth of the comics industry. Next, Rick Geary lets us in on his process for visualizing not only novels and other works of literature but also true murder tales. Then, Ho Che Anderson, *King's* "God," considers the ups and downs of the omnipotence biz.

If you'd like even more subsets to draw from, over in our Miscellany panel teacher Leonard Rifas grades the benefits and drawbacks of comics as an educational tool, journalist Tom Spurgeon covers mini-comics, test labs for new talents, *Ganzfeld* editor Dan Nadel explores the accomplishments of Fort Thunder, the avant-garde art comics collective, and writers Bart Beaty and Bill Randall expand our horizons with perspectives on, respectively, European comics and manga. There are numerous other categories worthy of attention; the rapidly evolving Internet environment, for instance, brings a world of visions, literally, to the comics form, from the sublime, three-panel, low-tech, free-verse fumetti of *A Softer World* by writer Joey Comeau and photographer Emily Horne (*www.asofterworld.com*)—who collaborate across opposite Canadian coasts—to the bizarrely ridiculous interactive animations of Dutch artist Han Hoogerbrugge (*www.hoogerbrugge.com*).

At least as far back as cartoonist-turned-animator Winsor McCay, comics creators have explored and enriched a wide variety of related disciplines, including concept art and storyboards for films and, more recently, design for motion graphics. Several of our assembled comics panelists also work on children's books. And our Border Crossings panel investigates a couple of other options for the ambitious comics artist: commercial illustration and fine art. Many illustrators derive their pictorial syntaxes from iconic comics imagery: Leslie Cabarga, Lou Brooks, Mick Brownfield, and this conference's Arlen Schumer (page 69) and Craig Yoe (page 177), just to cite a few. Here we present Elwood Smith, premier practitioner of the knockabout cartoon style, who credits his accomplished career to a lifelong infatuation with the medium. We also have Robert Williams, a high-profile lowbrow painter of adolescent fever dreams with patrons such as actor Nicolas Cage—who, not so incidentally, chose his last name in tribute to Marvel's *Luke Cage, Hero for Hire*. Williams gives us the lowdown on his *Juxtapoz* magazine, which features the likes of Gary Baseman, Mitch O'Connell, brothers Rob and Christian Clayton, our conference's own David Sandlin (page 95), and Gary Panter (page 93), and a growing number of others who work both sides of the narrative art/art gallery divide.

At this juncture you might want to drop into our gallery exhibit, which features comics commentary from Nicholas Blechman, David Heatley, Dan James, and Rick Meyerowitz, especially created for your educational edification.

The conference resumes in the Business panel as ace reporter Heidi MacDonald shows how comics "cons" can help turn fans into "pros" while *Comic Art* magazine publisher Todd Hignite and *Comics Journal* publicity person Eric Reynolds grapple with ways in which the medium can develop more muscle in today's marketplace.

In the Creative panel we discover that the answer to, "Where do you get your ideas?" isn't, as writer Harlan Ellison would claim, a post office box in Schenectady. In truth, it's located at the crossroads of Observation, Imagination, Research, and Reflection. And ideally within the comics medium, it's found in a well-balanced synergy of art and literature. Emphasizing the "images" side of the equation are designer Craig Yoe, who raps rhapsodic as he romps through graveyards, the better to climb aboard the shoulder bones of bygone masters, and writer Colin Berry, who studies potential prophecies written on urban walls and posits that a graffiti and comics reunion may be only a movement away. Bridging the visual/verbal divide is acclaimed editor and writer Dennis O'Neil, with some straight talk for anyone who might decide to collaborate on comics as a writer. Offering further perspectives on the "texts" side are: political cartoonist Tim Kreider, who believes a well-chosen word can be worth more than a thousand stunning but vacuous pictures; comics commentator Robert Fiore, who suggests how far comic books and newspaper cartoons can, and should, go with their content; cartoon animator Ward Sutton, who stresses the significance of character development; and historian Trina Robbins, who examines romantic relationships among comics teens, superheroes, and antiheroes.

Our Teaching panel starts off with Scott McCloud, interviewed by graphic designer and writer Gunnar Swanson. An open-minded theorist more interested in dialogue than didacticism, McCloud ventures into "potentially toxic" territory to identify four modes of thinking about comics. Then we move on to the institutions of higher learning themselves: Joe Kubert walks us through his eponymous trade school, which has been following a formula for producing industry-ready grads for over a quarter-century; historian Roger Sabin traces the divergent career paths of three products of the London art and design university where he lectures; and, in an interview with illustrator and educator Joel Priddy, Will Eisner reflects on what he's come to value about comics and teaching over a career that has included mentoring *Spirit* assistants Lou Fine, Jack Cole, and Jules Feiffer in the early 1940s.

Our conference draws to a close with a Lesson Plan panel featuring three artist/instructors: Ted Stearn on the importance of formal training, James Sturm on narrative structure, and Matt Madden on experimentation. And, since every worthwhile study should include a recommended reading list, comics critic Rich Kreiner wraps up with a survey of classic and current literature on comics.

There you have it: a sampler of presentations that we hope you'll find informative and inspiring. Feel free to browse. And don't forget to ask questions.

Section I:
The Comics Field

Magazine Cartoons

Cartoons at *The New Yorker*

Bob Mankoff

Hi, I'm Bob Mankoff, the cartoon editor of *The New Yorker* magazine. I'm also a cartoonist for the magazine and the president of The Cartoon Bank, a company that licenses *New Yorker* cartoons. People often ask me if there's a conflict of interest given that I'm in a position (or positions) to buy and sell my own cartoons. This question is not worthy of me, and to put this issue to rest I've appointed a blue ribbon committee . . . which, incidentally, I'm heading. If all goes well, I should be cleared of all charges, so I'll just proceed with this essay unless instructed otherwise by an officer of the court.

Part of my job is selecting each issue's cartoons. As cartoon editor I get to see about one thousand cartoons a week. Of that number I select about sixty to show to the editor of the magazine, David Remnick. Together we winnow this number down to between fifteen and twenty cartoons for selection in the magazine. These cartoons then go to the *New Yorker* library, where they're compared to the over 68,000 cartoons that we've published since 1925, just to make sure we don't repeat ourselves. Then they go to the fact-checking department to make sure there is no logical inconsistency that would vitiate the cartoon (the concept of the "vitiated" cartoon is unique to *The New Yorker*). Then, if all goes well, the cartoonist redraws the original submission (it's technically called the "rough") and resubmits it in final form (this is technically called the "finish"). I hope I'm not getting too technical for you here.

Of course, this process is in some sense nuts—fact-checking cartoons?—but this obsessive attention is what makes our cartoons not just the work of individual artists but also a *New Yorker* cartoon. It's a special category, the "*New Yorker* cartoon," a unique brand, impossible to confuse with anything else. This is why most magazine cartoonists want to be published in *The New Yorker*, and it's also why celebrities such as Norman Mailer, Johnny Carson, Charles Grodin, and David Mamet have submitted cartoons to the magazine. All, I might add, were rejected.

Have I scared you away yet? If so, that's too bad, because you're going to miss out on the secret formula for becoming a *New Yorker* cartoonist. I can't be too

explicit—it's a secret, of course—but I can outline a few rules. Follow them closely and satisfaction is, if not guaranteed, at least a statistical possibility.

Rule 1: Get an education but not too good an education. You should learn just enough about the world to make fun of it, but not too much more. Real knowledge will only depress you.

Rule 2: Don't just submit one cartoon to the magazine. You may think it's a great cartoon idea, but to me it'll look like the only idea you ever had. Instead, submit ten ideas. Why ten? Because nine out of ten times, things just don't work out.

Rule 3: Learn the difference between bad-bad drawing and good-bad drawing. When a person who can't draw doesn't like to draw, the result is usually awkward and charmless. On the other hand, a love for drawing, even in the absence of drafting skill, can produce a kind of miracle: if you have enthusiasm for communicating graphically, you may end up with truly inspired work (think Thurber).

Rule 4: Learn the difference between bad-good drawing and good-good drawing. Bad-good drawing is overly detailed and fussy. It smothers an idea with misguided notions of realism or accuracy. Good-good drawing gives the impression of accuracy while distorting reality for heightened comic effects. It's simple, really: one isn't funny and the other is.

Rule 5: It's not the ink, it's the think. In other words no matter how good a drawing is, it's not a cartoon unless the drawing is in the service of an idea. I once drew a guy just sitting in a chair. After staring at the drawing for an hour I realized that all I had to do was turn the drawing on its side and title it "Budget Recliner." *Voilà!* I had a cartoon.

Will scrupulously following these five rules get your cartoons published in *The New Yorker*? Don't make me laugh! Actually, that should be Rule 6. It just might work.

Wednesday "Look Day" and the Freelance Magazine Cartooner

R.C. Harvey

The last of New York's Wednesday watering holes for magazine cartoonists closed recently, making official by reason of its finality the end of the profession's fabled "look day." The place was called Costello's for a long time. "The cartoonists who were mostly writers came here—Walt Kelly and James Thurber," Milton Caniff told me years ago when taking me on a tour of cartoonist landmarks in the city. The Costello's we were lunching in was the second of the name. Thurber had scrawled pictures of his haphazard men and women and dogs on the walls of the first Costello's, and when it moved, they cut his drawings out of the wall in plaster chunks, framed them, and hung the pictures in the new place on East Forty-fourth Street. Then they whitewashed the east wall in the dining room and asked a new generation of cartoonists to decorate it with their signatures and drawings of their characters. Some years ago, the place acquired a new owner and a new name, Turtle Bay Café, but still boasted about the wall of cartoons. In the winter of 2004 it lost its lease, and the rumor was that the new owners would gut the building, thus eradicating the last vestige of Costello's and the cartooner trade. Fortunately for posterity, the rumor was subsequently disproved: the wall will endure because the new owners see it as the place's chief attraction. But it is, indeed, the last vestige of a once vibrant freelance magazine cartooning enterprise in New York City: the wall remains, but "look day" is gone forever, and without it, the wall is a mystery. Why is it there? And what does it mean?

The Pen and Pencil, a former speakeasy slightly below street level on Forty-fifth Street near Third Avenue, had been the more popular of the cartoonists' Wednesday destinations. John Bruno had started the bistro during Prohibition, and when adult beverages became legal again in 1933, he applied for a restaurant license. For the application form, he needed a name for the place. He asked his patrons for advice. Most of them were newspapermen and cartoonists. Cartoonist Gil Fox told me that he suggested the name Pen and Pencil because that described the tools of the trade of those who frequented Bruno's. But the Pen and Pencil preceded Costello's into oblivion several years ago.

Wednesday was dubbed "look day" because cartoon editors looked at cartoon submissions that day—in person. Back in the thirties, forties, and fifties when the city was the locus of the nation's largest concentration of magazine offices, that was

the day cartoon editors permitted itinerant cartoonists in the vicinity to enter these sanctum sanctorum to show their wares, face to face.

Henry Boltinoff, whose signature appeared everywhere—magazines, comic books, newspaper panels—for half a century, started peddling cartoons to magazines in 1937 after the newspaper he was drawing for folded. Out of work, he turned to two high school classmates, George Wolfe and Ben Roth, both cartoonists, who were sharing a studio. They advised him to start doing cartoons for magazines.

"They said, 'Do a batch of roughs, about ten to fifteen a week,'" Boltinoff told me. "'We'll meet you on Wednesday and take you around.' In those days, you could make a living doing magazine cartooning. You could spend the whole day Wednesday, going from one magazine to another. There were that many magazines. The *Saturday Evening Post* was published out of Philadelphia, but the cartoon editor came in every Tuesday night to see the cartoonists on Wednesday morning."

Starting at the highest paying magazines and working down the pay scales, cartoonists went from office to office, sitting in waiting rooms, waiting; then showing their wares to stone-faced cartoon editors. Most cartoonists submitted roughs on "look day." If an editor liked one or more, he'd ask for a finished drawing. Or he might "hold" a rough until the next week. When the cartoonist returned the next Wednesday, the editor either returned the rough (rejected) or asked for finished artwork.

Every Wednesday the magazine cartoonists took a midday breather and a beaker or two over lunch at the Pen and Pencil. Despite their being competitors—each one visiting and trying to sell cartoons at the same magazines—they didn't feel cutthroat about it, Boltinoff said. In fact, one time when he had to be out of town on a Wednesday, he gave his batch to his friend George Wolfe, who took them around. He'd show his batch first, then Boltinoff's.

The fellowship of the lunches was stimulated by shop talk and networking about potential markets, not by high-octane beverages. "The lunches weren't very wet," John Gallagher told me; after all, the cartoonists still had half-a-day's business to do.

"Look day" expired before either the Pen and Pencil or Costello's/Turtle Bay. It was a long and lingering death that set in with the demise in the sixties of the *Saturday Evening Post* (temporarily) and *Collier's* and *Look*. When these giant periodicals of yesteryear expired, the great "general interest" market for cartoons wizened considerably. In its place sprang up scores of "special interest" magazines, a development that complicated the life of a freelance cartoonist by making it increas-

ingly impractical. Magazine cartooning has always been a highly speculative enterprise: a cartoonist produces a quantity of cartoons, hoping to make a living by selling a small percentage of his output. In the days of the great general-interest magazines, the same cartoon could be offered at several places, and the chances of it selling were consequently enhanced. But the new environment effectively reduced the possibilities for sales: a cartoon aimed at making wind surfers laugh in the wind surfing magazine would not likely be purchased by a magazine about radio-controlled model airplanes.

The market today is further complicated because there are drastically fewer magazines that buy cartoons: art directors have taken over, and their aesthetic sensibilities are doubtless offended by the way cartoons would break up a typeset page, the solid typography of text being a stalwart neutral gray element in the layout design.

Despite all these disadvantages, scores of cartoonists still produce dozens of single panel cartoons every week. But they sell by mail, not in person. Even in those golden days of yore, most magazine cartoonists lived somewhere other than New York and mailed their submissions, willy-nilly, without regard to the day of the week. They still do that today, those who remain. And the pay is still fairly miserable: the best magazines pay in the hundreds, but there are only a few of those, and the rest pay $5–25. Most of the mail-in 'tooners hold day jobs to make a living; few are full-time gag cartoonists. But Art Bouthillier, working out of a tiny cabin on Whidbey Island overlooking Puget Sound, cartoons full-time. It requires dedicated concentration, inflexible determination, and the sort of unflagging optimism that can tolerate more rejection slips than payment checks.

"But you don't get into cartooning for the money," Bouthillier told me, "you get into it because you love it." And there are advantages to the freelance life: freedom. "I don't have a nine-to-five job," he said. "I don't have to be anywhere. And I can do this from anywhere: I can live wherever I want to."

Being your own boss in today's market, however, requires a slave-driving attitude. Bouthillier devotes four days a week to generating ideas. He resolutely clears his mind of all other considerations on those four days and focuses, by turns, on the varied readerships of the magazines he sells to. Diversity is the key to magazine cartooning success these days: the cartoonist must be able to appeal to a variety of markets: family situations, pets, children, parenting, adult sex, sports and hobbies of all kinds, and so on. Bouthillier has a weekly quota of thirty to forty cartoons,

which he sends out in about four relatively small batches. It's a salesman's strategy: He believes editors are intimidated by large batches and are more inclined to open thin envelopes than thick ones to which they must devote more perusal time. He makes a final, inked drawing of every cartoon but sends out photocopies. As the cartoons get dog-eared, he makes fresh copies from the originals.

Freelancing to magazines also requires precise record keeping: the cartoonist must know which cartoons have been sent to which magazines, which cartoons are being held for consideration, and which ones he hasn't been paid for yet. Bouthillier spends Friday, his fifth working day, on paperwork and processing. He opens the returned envelopes (which he sent out with the batches, self-addressed and stamped for return), records sales, packages the remaining cartoons to be sent out again to new destinations, and notes those destinations and the date sent. He stamps every cartoon on the back with his name and return address and a distinctive five-digit tracking number. He prefers the clasp-type envelopes because licking envelope flaps slows him down, and speed is important when processing dozens of batches.

The business of gag cartooning has changed as the market has, but the art of the single-panel cartoon remains the same. At its best, the gag cartoon is an exquisite blend of word and picture in which, ideally, neither makes sense without the other. The most evident element, the picture, becomes a puzzle, and the caption underneath, the solution. We laugh in delight both at the incongruity of the cartoon, the elements of which are now made congruent, and at the abruptness of the revelation. It is also a laugh of pleasure at experiencing the epiphany of cognition or recognition, at having the trick pulled on us. The single panel cartoon is the haiku of cartooning, its balance of visual and verbal elements essential to its function.

In Praise of Offensive Cartoons
Paul Krassner

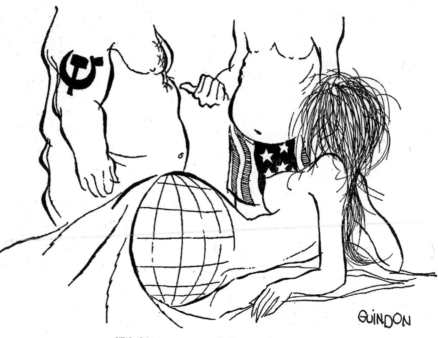

"It's his turn now and then me again . . ."

© *Richard Guindon*

In the late 1950s, I read an article in *Esquire* by Malcolm Muggeridge, former editor of *Punch*, the British humor magazine. "The area of life in which ridicule is permissible is steadily shrinking," he wrote, "and a dangerous tendency is becoming manifest to take ourselves with undue seriousness. The enemy of humor is fear and this, alas, is an age of fear. As I see it, the only pleasure of living is that every joke should be made, every thought expressed, every line of investigation, irrespective of its direction, pursued to the uttermost limit that human ingenuity, courage and understanding can take it. . . . By its nature, humor is anarchistic, and it may well be

8

that those who seek to suppress or limit laughter are more dangerous than all the subversive conspiracies which the FBI ever has or ever will uncover. Laughter, in fact, is the most effective of all subversive conspiracies, and it operates on *our* side."

The article was called "America Needs a *Punch*," and I took the implications of that title as my personal marching orders. After I launched *The Realist* in 1958, it developed a reputation as a haven for material that could be published nowhere else. Our first cartoon, unsolicited, by Drury Marsh, was a reaction to the National Association of Broadcasters amending its TV code to ban the use of actors in "white-coat commercials." The revised ruling read: "Dramatized advertising involving statements or purported statements by physicians, dentists, or nurses must be presented by accredited members of such professions." The cartoon showed a man dressed like a doctor doing a cigarette commercial, then changing to his civilian clothes in a dressing room, going back to his office and getting dressed like a doctor again, and finally telling a patient, "You're going to have to give up smoking."

Another unsolicited cartoon arrived from syndicated editorial cartoonist Frank Interlandi. It showed a man walking along, spotting a poster of a mushroom cloud with the question, "If a BOMB Falls, What Would You Do?" He continues walking—thinking, thinking—and finally says out loud to himself, "I'd *shit!*" Interlandi told me that he simply could not conceive of a more appropriate reaction, and had refused to compromise.

When the Cuban missile crisis occurred, Richard Guindon created his most popular cartoon for *The Realist*, which I put on the cover. It depicted a reclining nude woman, leaning on her elbow with her back to us—her buttocks a globe with latitudinal and longitudinal lines—as she faced a couple of faceless men, both naked except that one was wearing boxer shorts with stars and stripes while the other had a hammer and sickle tattooed on his chubby arm. The Kennedy-like American was gesturing toward the Khrushchev-like Russian and speaking to the Earth-woman: "It's his turn and then me again." That cartoon captured a feeling of powerlessness that permeated the country. Two Broadway stars—Orson Bean in *Subways Are for Sleeping* and Anthony Newley in *Stop the World, I Want to Get Off*—had it framed on their dressing-room walls, even while several bookstores and newsstands were displaying that issue face down.

When abortion was illegal, I published a cartoon by Mort Gerberg, depicting a Mother Goose character—the old lady who lived in a shoe and had so many children she didn't know what to do—speaking on the phone: "Dr. Burnhill? . . . uh . . . you don't know me, but . . . uh . . . I've been told that you could . . . uh . . . perform

a certain operation . . ." It turned out there was an actual Dr. Burnhill who called me in distress after patients started bringing that issue of *The Realist* to his office. Every succeeding cartoon by Gerberg had a character named Burnhill, except for his double-page spreads, "The Poverty Pavilion," "The Junkie Battalion," and "The Fag Battalion."

New Yorker regulars sent me their cartoons that were rejected for controversial subject matter, poor taste, and taboo violation. Ed Koren had a centaur on an unemployment line, being asked by the clerk, "Are you sure you looked for work this week?" Another Koren centaur at a cocktail party was saying to a woman, "I find it very difficult to be an intellectual in the United States." Ed Fisher depicted a Native American ceremony with a few hippies sitting cross-legged among a large group of Indians, with the chief saying to an associate, "Yes, ever since drug-trances were ruled a legitimate practice of our religion, they've been drifting in . . ." Fisher was so prolific that "Ed Fisher's Page" became a regular feature.

Another *New Yorker* cartoonist who preferred to omit a byline presented a TV talk-show guest saying, "Frankly I didn't give a *damn* about it!" Then we see a family at home watching him say, "Frankly I didn't give a *bleep* about it!" Thought balloons show the mother thinking, "Fuck?"; the father thinking, "Piss?"; the grandmother thinking, "Shit?"; and the little kid thinking "Crap?" That cartoon graced many kitchen refrigerators and office bulletin boards, especially at TV channels.

And Lee Lorenz sent a cartoon—bypassing *The New Yorker* because he *knew* it would be rejected—where, in the corridor of an office building, a man with an attaché case is about to enter the office of the Anti-Defamation League, while directly across from him a man with a briefcase is opening the door to the office of the Italian Anti-Defamation League. The caption: "Wop!" "Kike!"

William M. Gaines was the head of Entertaining Comics, which published a line of crime and horror comic books, plus *Mad*. Here was a comic book that poked creative fun at society in general and comic books in particular. What a kick it was to see "Clark Bent" undressing in a phone booth to change into his "Superduperman" outfit, only to find that a woman already occupied the booth. *Mad's* gang of artists and writers were slicing through American piety with irreverence and imagination.

When *Mad* became a magazine, I started writing freelance articles for them. My first article was based on the premise, "What if comic strip characters answered those little ads in the back of magazines?" I wrote the script and Wally Wood did the artwork. Orphan Annie sent for Maybelline for her hollow eyes. Dick Tracy

sought a nose job. Alley Oop got rid of his superfluous hair, only to reveal that he had no ears. But Popeye's flat-chested girlfriend, Olive Oyl, wasn't permitted to send away for falsies.

Gaines explained, "My mother would object to that."

"Yeah," I complained, "but she's not a typical subscriber."

"No," he replied, "but she's a typical mother."

Other ideas of mine were rejected because the subject matter was considered "too adult." Since *Mad*'s circulation had already gone over the million mark, Gaines intended to keep aiming it at teenagers.

"I guess you don't want to change horses in midstream," I said.

"Not when the horse has a rocket up its ass," Gaines responded.

John Francis Putnam, *Mad*'s art director, whose column in *The Realist* was titled "Modest Proposals," wrote one about the apocryphal publication of a collection, *Tillie and Mac: Those Little Comic Books that Men Like*, resulting in an obscenity charge. Accompanying this was *Mad*'s Sergio Aragones' hysterical full-page parody of the genre, labeled as "Exhibit A," with "excerpts" ranging from Blondie in bed with her husband's boss—"Now Dagwood, stop complaining! You're disturbing Mister Dithers!"—to Orphan Annie copulating with Sandy, her hollow-eyed canine. "Gee," Annie says, "A girl's best friend *is* a dog!" And Sandy, wagging his tail, barks back, "Arf! Arf! (Pant, pant) *Aaaarrrf!*"

Recently, Simon & Schuster published an *actual* anthology, *Tijuana Bibles: Art and Wit in America's Forbidden Funnies, 1930s–1950s*. It was a case of satirical prophecy. The introduction is by Art Spiegelman, whose cartoon showing two soldiers smooching on a bench in front of a sign, "Make Love, Not War!", appeared in *The Realist*. As the Vietnam War escalated, and monks began immolating themselves as the ultimate form of protest, Don Addis depicted a gas station attendant asking a Buddhist holding a gas can, "Regular?" During the burgeoning days of underground comics, I published Disney adversary Dan O'Neill, S. Clay Wilson, Skip Williamson, and Jay Lynch, who contributed a psychedelicized logo.

The Realist was the first to publish Sam Gross, a mild-mannered accountant who visited my office with his samples one day and eventually replaced Charles Addams as the king of macabre cartoonists. Take, for example, his drawing of a man with a hammer nailing a sandwich-board, reading "Christ Died for Our Sins," onto the back of a religious zealot. Or his Cyclops-inspired gynecologist with one large eye centered on his forehead. Or a Gross full-page spread, "Humor of the Handicapped," offensive to many, though lauded by disabled readers.

Ed Sorel's first published illustration, "A War for Civilization"—with a parade led by Cardinal Spellman, followed by a biker gang and other assorted stalwarts— appeared on a *Realist* cover, bleeding through the back cover. Robert Grossman contributed a series of movie posters, starting with the musical, "Ethel and Bob Kennedy in *I Got Rhythm*, produced by Eighteenth Century Fox." Charles Rodrigues did a sardonic full-page spread, "Up with Violence," and B. Kliban gave me a cartoon with a door marked "Sperm Bank," with a nearby slot for "Night Deposits."

During a period of severe anti-Communist hysteria throughout the nation, John Francis Putnam and I responded by designing a patriotic poster that proudly proclaimed, "FUCK COMMUNISM!"— with FUCK in red-white-and-blue lettering emblazoned with stars and stripes, and COMMUNISM in red lettering with hammers and sickles—suitable for framing. It included the helpful line, "Additional information available from the Mothers of the American Revolution." At the time Robert Scheer had been researching a booklet, *How the United States Got Involved in Vietnam*, to be published by the Fund for the Republic. He was frustrated because he wanted to witness firsthand what was happening in Southeast Asia, but they wouldn't send him. Since *The Realist* had already sold a couple of thousand FUCK COMMUNISM! posters at a dollar each, I was able to give him a check for $1,900, the price of a round-trip airline ticket. He traveled to Vietnam and Cambodia, then wrote his seminal report.

Proceeds from another poster—a cartoon first published in *The Realist*, depicting an anthropomorphic deity sodomizing Uncle Sam, with the legend, "One Nation Under God"—were used to bail the artist Frank Cieciorka out of jail after he was arrested for voter registration work in Mississippi.

When Walt Disney died, I somehow expected Mickey Mouse and Donald Duck and all the rest of the gang to attend the funeral, with Goofy delivering the eulogy and the Seven Dwarfs serving as pallbearers. Disney's death occurred a few years after *Time* magazine's famous "God Is Dead" cover, and it occurred to me that Disney had indeed acted as God to that whole stable of imaginary characters who were now mourning in a state of suspended animation. Disney had been *their* Creator and he had repressed all their baser instincts, but now that he had departed, they could finally shed their cumulative inhibitions and participate together in an unspeakable Roman binge to signify the crumbling of an empire. I contacted *Mad's* Wally Wood and, without mentioning any specific details, I told him my general notion of a memorial orgy at Disneyland. He accepted the assignment and presented

me with a magnificently degenerate montage: Pluto is pissing on a portrait of Mickey Mouse, while the real, bedraggled Mickey is shooting up heroin. His nephews are jerking off as they watch Goofy fucking Minnie on a combination bed and cash register. The beams shining out from the Magic Castle are actually dollar signs. Dumbo is simultaneously flying and shitting on an infuriated Donald Duck. Huey, Dewey, and Louie are peeking at Daisy Duck's asshole as she watches the Seven Dwarfs groping Snow White. The prince is snatching a peek of Cinderella's snatch while trying a glass slipper on her foot. The Three Little Pigs are humping each other in a daisy chain. Jiminy Cricket leers as Tinker Bell does a striptease and Pinocchio's nose gets longer.

This center spread became so popular that I decided to publish it as a poster. The Disney Corporation considered a lawsuit but realized that *The Realist* was published on a proverbial shoestring and besides, why bother causing further public embarrassment? In Baltimore, a news agency distributed that issue with the Memorial Orgy removed; I was able to secure the missing pages and offered them free to any reader who had bought a partial magazine. In Oakland, an anonymous group published a flyer reprinting a few sections of the center spread, and distributed it in churches and around town. The police would have moved in for an arrest had it not been for my west coast distributor, Lou Swift, who asked them not to act until they got a *complete* issue. In Chicago, however, a judge found the whole issue to be obscene—for the cover story was my own infamous "Parts Left Out of the Kennedy Book"—but the ACLU sought a federal injunction restraining authorities from interfering in any way with local distribution. I tried to imagine a prosecutor telling a jury how they might get horny because look what Goofy and Minnie Mouse are doing, but even if the memorial orgy *did* arouse prurient interest, the rest of *The Realist* was not *utterly* without redeeming social value.

In 1971, Stewart Brand invited Ken Kesey and me to edit *The Last Supplement to the Whole Earth Catalog*, which would also serve as an issue of *The Realist*. Kesey had been reading a book of African Koruba stories. The moral of one parable was, "He who shits in the road will meet flies on his return." With that as a theme, we assigned R. Crumb to draw his version of the Last Supper. He came through with a cover so delightfully irreverent that it could zap Mel Gibson with severe apoplexy. In response to Mr. Natural reciting the moral of that parable, Jesus says, "Tsk! Please, I'm eating!"

Several years later, when Woody Allen was accused of sexually molesting Mia Farrow's child, I wrote a full-page comic strip, "Honey, I Fucked the Kids," illustrated

by Kalynn Campbell. Brand wanted to reprint it in *The Whole Earth Review* but their printer refused, so they blacked out that entire page and found a new printer for the next issue.

In 2001, I was awaiting inspiration for a cover of the last *Realist*. Norman Rockwell's paintings on the covers of the *Saturday Evening Post* had always been synonymous with saccharine wholesomeness, but now on C-Span I saw his son, Peter, speaking at the National Press Club, and he mentioned that his father's long-standing ambition was to visit an opium den. Ultimately, he was dissuaded from taking that trip by advertisers in the magazine, but I immediately assigned Campbell to capture the venerated artist's secret vision in Rockwell's familiar style. And, indeed, this under-the-surface image of American culture served as an appropriate metaphor for the final issue of *The Realist*.

Editorial Cartoons

Stop Them Damned Pictures

Ben Sargent

One of the historical anecdotes most treasured by the editorial cartooning profession is a quote attributed to New York political boss William Marcy Tweed when he and his corrupt regime were being tormented by the relentless attacks of cartoonist Thomas Nast in the 1870s.

"I don't care what the papers write about me," Tweed is supposed to have groused. "My constituents can't read. But they sure can see pictures. Stop them damned pictures."

"Them damned pictures," worn ever since as a badge of honor by editorial cartoonists, speaks not only to the power of cartoons but to their strong appeal to readers, who are likely to read, digest, and react to cartoons whether or not they stop to read the written opinions in the neighboring columns.

Presumably, in contrast to Tweed's characterization of his nineteenth-century constituents, newspaper consumers of our own age can all read. But the appeal of the picture is still so strong that editorial cartoons are one of the most widely read forms of opinion journalism, both in print and online.

Some of the appeal, of course, is due to the easy visual accessibility of a picture. But some must be due to the visceral punch a cartoon can give to an opinion, affording the reader a thrill of outrage or affirmation he'd never get from written paragraphs.

That's how an editorial cartoon works, and what sets it apart from written opinion. Text speaks to the rational, conscious mind, trying to mark a path of persuasion through a field of complexity, ambiguity, and nuance. The editorial cartoon, on the other hand, rides straight to the reader's subconscious, with one stroke affirming or challenging his inner convictions, prejudices and beliefs.

The cartoon's tools in this are symbolism—the language of the subconscious—and the simplifying (often, admittedly, over-simplifying) of events into their most easily understood elements. As illustrator James Montgomery Flagg summed up the point nearly ninety years ago, "The cartoonist makes people see things."

Editorial cartoons, if they're living up to their potential, can be a powerful force on an opinion page, and yet for all their unruly vigor, they are crafted in a very

complex environment, bounded by expectations and requirements from many differ-
ent—and often competing—sources.

The first of these arises from the reality that editorial cartoons are journalism,
and as such are necessarily bound by the ethical expectations of the profession. They
must be accurate, fair, and complete: accurate in grounding their opinions in solid
information, fair in making an honest point and avoiding the cheap shot, and com-
plete in not reaching a conclusion by ignoring inconvenient truths.

The only journalistic virtue missing here is objectivity—the standard from
which opinion journalism is exempt, leaving it the freedom to advocate earnestly
and vigorously only one side of a question.

Also shaping the editorial cartoon are the requirements of management. These
may vary wildly according to management's attitude toward the cartoons themselves
(ranging from appreciation of them as a vital and appealing element of the paper to
fear and loathing of them as a strange force that produces heartburn from readers
and advertisers), and to management's conception of how much control-from-above
is necessary in the daily production of the cartoons.

Lastly, there are the requirements imposed by the cartoonist on himself. If he is
conscientious in his craft, he wants on a regular basis to express strong, cogent, rele-
vant, and consistent opinions. He wants to express them with an idea that's easily
comprehensible and serves by its own workings to nail home the point. And he
wants to convey this idea with a drawing that's well organized, skillfully executed,
and visually striking.

So a good editorial cartoon emerges from this thicket of requirements and
restraints, trying to look as though it had simply burst from the newspaper page
with no effort at all.

The complex workings of this seemingly simple device—the editorial car-
toon—require that a cartoonist come to the job not only with a certain set of job
skills but a certain combination of mental quirks. The craft is ideal for a person who
brings together a love of people, politics, and human society with a tendency toward
passionate convictions, a naturally satiric take on life, an analytical turn of mind,
and a creative imagination.

And, oh, yeah . . . it helps if you can draw.

Interview
The Obligation to Be Honest
Tony Auth

What made you want to become an editorial cartoonist?

From a very early age I wanted to find a way to turn my love of drawing into a livelihood. I majored in art and biology in college, and had become a medical illustrator at a large teaching hospital when the war in Vietnam was expanded by Lyndon Johnson and became the dominant issue in American politics. A few friends, whom I had worked with at the UCLA *Daily Bruin*, where I did decidedly non-political drawings, approached me and said that they were starting a weekly anti-war newspaper, and asked me to be their political cartoonist. I gave it a try and, within a year, realized that I loved it and wanted to do it professionally.

Daily cartooning is a grueling job; how do you discipline yourself to be on top of the news with poignant and acerbic observations?

Trying to stay informed is a full-time job. I begin the day by scanning *The Philadelphia Inquirer*, *The New York Times*, and *The Washington Post*, and reading articles, editorials, and columns of interest, taking notes, and writing down any thoughts that might lead to cartoon ideas. I listen to NPR on the way into the office and three times a week attend editorial board meetings where we discuss various issues and what the *Inquirer* editorial page should say about them. Those arguments are often passionate and profitable. Should I side with the minority, there is no expectation that my drawings reflect the position of the paper's editorials. Once I decide what my cartoon for the next day's paper will be, I often listen to NPR while I am drawing, and usually have a muted CNN on. I'll put the sound on when I notice breaking news of importance. I also find *The New Yorker*, *The New York Review of Books*, and the *Atlantic Monthly* invaluable, and I read as many books as I can. I spend much more time reading than drawing. Paul Conrad, the great editorial cartoonist and a mentor, once told me that the secret of political cartooning was "read, read, read and draw, draw, draw." Unless you enjoy the search for ideas as much as the execution of the drawings, this line of work is not for you.

What is the most challenging aspect of your job?

The most challenging aspect of this work for me is achieving the right tone in my response to an issue or event. Not everything calls for laughter or sarcasm.

Sometimes sadness, whimsy, or detached bemusement seems more appropriate. Having decided on the idea and tone, I try to marry the idea with the style of the drawing.

Are there dictates that constrain you in any way?
I feel an obligation to be honest. That means not overlooking inconvenient facts that contradict preconceived notions or beliefs. To me this is the difference between being an independent commentator and a propagandist. Judging by e-mails from readers, there are many people who expect editorial cartoonists to pick a side and then become partisan advocates. Sometimes I've been accused of being a "traitor," as if one drawing indicated a complete rejection of previously held beliefs. This medium is generally an excellent one for making one point at a time. What I try to do is to make that point as forcefully as I can. I'm told that the editors of *The New York Times* say they won't hire a political cartoonist because a cartoonist can't say "on the other hand." They're wrong. The way you say "on the other hand" is to come back to the same subject a day or two later.

As far as "balance" is concerned, there is no need for me to offset myself. Other cartoonists and columnists we publish do that. When readers demand that I be more "balanced" I ask them who their favorite columnist is. If they answer William Safire, I ask whether they expect him to do a liberal column for every conservative one he does, for the sake of "balance." They are rightly appalled at the thought. If you see a contradiction here, between the demands that cartoonists be more balanced on the one hand, and the equally vociferous demand that they be less so on the other, you are correct. This is just one more example of why it's impossible to please everyone, and why it would be foolish to try.

There are no constraints placed on me by my editors. That is not the case at all newspapers. I don't know how common this is, but it used to be that some papers defined the job of the editorial cartoonist as illustrating the lead editorial. Some cartoonists have told me that they are not allowed to comment on important national or international issues. Those issues are left to the syndicated cartoonists to whom those papers subscribe. Such job descriptions make a mockery of the role of the editorial cartoonist as serious journalist. One of the reasons I work at the office, and not at home, is so I can show my roughs to people who have an ability to respond in ways that are helpful. If I have unwittingly constructed a barrier to communication, I can fix it only if I realize there's a problem. These people may, or may not, be editors.

What makes an effective political cartoon?
I think the most effective political cartoons are those that make a case for a point of view, instead of merely celebrating it. These are the drawings that elicit responses from readers along the lines of "you made me see that in a new light," probably the highest praise we can get.

What are some of the taboos that even you won't address?
I don't believe there are any taboos that can't be addressed with editorial cartoons. In fact, one of the main purposes of editorial cartooning, and a source of much mischievous delight, is to do exactly that. However, there is the question of appropriateness. I remember doing three drawings on the controversy surrounding Karen Ann Quinlen, a New Jersey teenager who had been in a car accident and was being kept alive artificially. There was a legal battle between her parents, who wanted her taken off life support, and the state of New Jersey, which did not. Those drawings were not jokes about a teenager in a coma. Appropriateness is subjective, of course, and here is another case where it is very valuable to have colleagues whose intelligence and judgment I respect to tell me what they get out of my rough sketch. At the end of the day, though, the responsibility for deciding what to publish should be the cartoonist's. It is, after all, a signed piece of work.

How would you define your style?
Line is by far the strongest weapon in my arsenal. I vary the speed and energy of my line depending on the mood and content of what I'm drawing. Likewise, whether or not to use crosshatching, wash, tones, or solid blacks in addition to line depends on the emotional response I'm trying to elicit from my readers. In art school, I remember seeing a series of, I believe, ten drawings of a bull by Picasso, which varied by degree from highly complex to extremely economical. I vowed then to be against style in the sense of "this is how I draw the world," and I approach each drawing with the question "how does the world look from the point of view of this cartoon?"

For students who believe they have something to say about the political scene, is editorial cartooning the best outlet?
Editorial cartoonists possess a relatively rare combination of talents and interests. The number working for daily newspapers has always been low and is shrinking. When I began my career at *The Inquirer* thirty-three years ago, there were about

two hundred full-time editorial cartoonists in the United States. There are now about eighty-five of us. Retiring cartoonists are not being replaced and positions vacated by cartoonists moving to other papers are not being filled. There is also a distressing tendency on the part of a significant number of editors to see political cartoons as a sort of light filler to offset the ponderous and serious prose on their pages. We have a long and glorious history of biting political art and cartoons in this country, and there will always be those with the urge to create more. I don't know if newspapers will continue to be the home for such acerbic observations, but nothing could be more American than the irreverent, iconoclastic, raucous, and impolite drawings that epitomize the best editorial cartoons.

Caricature: Biting the Face that Feeds You

Steve Brodner

In the 1970s, when I first started looking for work as a freelance caricaturist, one art director told me, "We don't use caricature much anymore. We overdid it during Watergate with Levine, Sorel, and those guys. Now we're using photographs." In

other words, the dearth of jobs for folks like me had less to do with how good we were than with changing fashions in graphic design. Around this time I had an exchange on a Society of Illustrators jury with a designer of a national weekly, who, looking at a slide, said grumpily, "Whatever happened to that strong political caricature? You just don't see it anymore." I replied to him, "Well, if you don't use it, you won't see it." It was really a chicken-and-egg situation, I felt. Without editors and art directors valuing this work, it starts to vanish from the scene. Conversely, I felt, if they would build it, the artists will come.

Looking back, I can say that I was lucky in having a kind of faith that this pendulum could also swing back. This "vision" I had was due largely to the fact that I had no other choice. I was a caricaturist; this was all I could do! Luckily for me the scene did change. It took some years but, deep in Ronald Reagan's second term, the exploding Iran-Contra scandal blew magazines wide open for satiric art in the United States. Suddenly it was open season on the Reagan image. This happened in conjunction with the emergence of new designers in important places: Stephen Doyle at *Spy*, Michael Grossman at *The National Lampoon* and, later, *Entertainment Weekly*, Michael Walsh at *The Washington Post Magazine*, Rip Georges at *Esquire*, and Fred Woodward at *Rolling Stone*. In addition to the more familiar caricature artists we now saw the spontaneous generation of Blitt, Cowles, Burke, Risko, Payne, Kunz, and yours truly. When Tina Brown took the helm at *The New Yorker*, greatly appreciating caricature there, she brought younger and older voices together in a way that sent strong tremors through the world of magazines.

By the late 1990s (as celebrity-culture hurt photography) caricature became, once again, an important weapon in the arsenal of design. As a result, the annual illustration shows—The Society of Illustrators, American Illustration, Communication Arts, etc.— were dominated by this work. Artists who had specialized in other kinds of illustration now felt forced to try their hand at caricature! Today I would say that we are in a kind of golden age. The Vietnam Era artists are still with us and are still great. We of the Iran-Contra Revival are still plugging away. Newer and very exciting artists of many techniques and sensibilities are coming along all the time.

Paradoxically, as things have gotten better for the humorous portrait, the strong commentary that that grumpy art director was talking about has gone missing in action. The places that would run art with strong content have not only dwindled, they've all but disappeared. The *New York Times* Op-Ed page is more a lost cause than ever. *The Village Voice* recoils from hard-hitting article illustration. The firing of

Patrick Flynn at the *Progressive* was like the Dodgers leaving Brooklyn. So now we see social and political graphic commentary, *at a time when it is historically most needed*, becoming, in the popular press, a moribund form.

And where are the artists? We're all working hard at magazines, doing assignments that, luckily, pay the bills. But we do not make art that participates in and helps clarify and frame the great national debate. The powerful work goes elsewhere: to personal art, gallery painting, Web art, zines, and theatrical presentations. I am currently making independent films that involve drawings that deal with issues I'm concerned about.

When I saw Michael Moore's *Fahrenheit 9/11*, the most important piece of political art of our time, I couldn't help thinking, "This is wonderful. It used to be our job."

Political Comics

Learning from the Political Cartoon

Paul Buhle

One could easily trace the lineage of the political cartoon back to the staggering breakthroughs of Hieronymus Bosch (1453–1516), offering caricatures and savage satire in place of Christian iconography and otherworldly narrative. The very posture of the artist, ironic commentator on the sad consequences of human nature, can be found in the best cartoon work across the ages since, and likewise the absence of cynicism and/or loyal service to existing elites. The real political cartoonist, a rebel unwilling to become merely didactic, remains in his or her own terms critic and outcast from follies of the age.

The rise of nineteenth-century illustrated humor magazines like *Puck* and *Simplissimus* alongside newspaper art offered a small army of aspiring cartoonists outlets, paychecks, and a sense of self-definition. Dialogue balloons had existed for more than a hundred years before *The Katzenjammer Kids* used sequential narrative panels as a regular feature in 1897. Ostensibly nonpolitical, the emerging "funny pages" of the daily press usually, but by no means always, offered conservative values in gender, race, less so class or ethnicity, thanks to the nature of their popular readership.

Suppression was the exception rather than the rule for cartoonists, but hardly unknown. In 1898, Kaiser Wilhelm II was enraged at a cartoon appearing in *Simplissimus*, the issue in question was confiscated, and a government lawsuit was launched against publisher, writer, and cartoonist. The artist fled Germany, while the publisher and writer (the famed avant-garde dramatist, Fred Wedekind) served months in prison.

Political cartoons in the frame of comic strips were also taking another controversial tack, their possibilities best illustrated in the United States by Ernest Riebe's *Mr. Block* (reprinted in 1913 as perhaps the first American "comic book") in the *Industrial Worker*, organ of the Industrial Workers of the World. Enraged at the effects of industrial capitalism and agribusiness upon the health and morals of the unskilled worker, *Mr. Block* was actually aimed at the blockhead of the title, the hopelessly conservative proletarian certain that the system or a kindly boss would take good care of him. *Mr. Block* (likewise a lesser socialist variant, *Henry Dubb* by

Ryan Walker) was the avowedly political counterpart to Rube Goldberg's work in the commercial dailies, veering from one-panel *Foolish Questions* and weekly pseudo-inventions to *Boob McNutt, Bobo Baxter*, and others, always pressing the sub-political moral of human foolishness (in later decades, the threat of fascism, and then of nuclear war).

One might suggest that the political cartoonists outgrowing the most primitive styles needed to learn more from the street, and from other artists of the big city street bent on creating a new art. The Ashcan School grew out of the illustrated papers' new style, the *flaneur* with pen or brush in hand who for political reasons looked with great care as well as sympathy toward the inhabitants of the slums. *The Masses* (1911–1917) magazine was not strong on the comic strip but with its successor *The Liberator* (1918–1925) and the Left-leaning Yiddish weekly *Groysser Kundes* (1907–1927) it offered young artists unforgettable mixtures of styles and attention to current events. *The Masses*, most influential—it arguably invented the cartoon style later made canonical in *The New Yorker*—of the three, was suppressed in 1917 after a series of antiwar cartoons appeared. The most brilliantly political of the *Masses* cartoonists, Art Young, actually published his own satirical magazine, *Good Morning*, in the early 1920s, but political support lagged and the experiment died.

By this time, conservative political drift and equally conservative stylistic impulses in the American dailies, valorizing realism or pseudo-realism at the expense of what could be called popular-expressionist styles, may be said to have pushed the artistic innovator-critic toward lithography rather than cartoon work. Linocuts, also influenced by Kathe Kollwitz and Jose Guadalupe Posada, and woodcut series (most notably the gnomic radical engraver, Lynd Ward, after the styles of Franz Masereel) created a different kind of cartoon in printmaking, halfway between popular and high art. The better works of the Works Progress Administration (WPA) murals followed this trend, sometimes utilizing the logic of the political cartoon within a Diego Rivera–like landscape, sometimes on the poster or printed page with an elevated artistic intent.

The next major breakthrough followed the logic of the comic book and turned that logic inside out. *Mad* (1952–1955)—the fruit of a genius-ridden collaboration between researcher-editor-writer Harvey Kurtzman and his artists—has rightly been described by the rebellious artists of the next generation, like R. Crumb and Art Spiegelman, as their training school and the unattainable ideal. Every *Mad* story might accurately be described as political, in the sense of deconstructing the

public face of commercialism, comic books themselves, film, magazine advertising, and the drama of the Army-McCarthy hearings. The repeated assault upon *Dragnet* (the most conservative television show of the era), *Terry and the Pirates* among other military dramas, *Archie* comics (agents of the repressive Comics Code), as much as of Senator Joseph McCarthy, offered slashing stylistic gestures as a vital element of the lampoon, a condensed expression that can be compared to Bosch, or perhaps Daumier.

We jump to the later 1960s to find the next steps, remembering Jules Feiffer and Walt Kelly as lone warriors of the interim. Robert Crumb has become fond of saying that he had to take LSD to become completely "cartoony," that is, to recuperate from childhood memory the styles not only of cartoons but urban commercial signage and street "look" he had unconsciously assimilated. As the proclaimed king of the underground genre, Crumb took the lead in breaking all existing taboos on expressions of sex, violence, and socially critical matters, from the actions of the presidency to personal bathroom habits. Around Crumb, and sometimes against Crumb (that is, the feminist artists like Trina Robbins, founder of a women's liberation comix line), ranged the first generation of political-minded artists who could, for a time, sustain themselves outside the commercial mainstream and who chose the cartoon rather than the easel or the print.

Underground comix had actually been born in the underground press, and the technological breakthrough of low prices for short runs of locally produced tabloids made possible the most dramatic opening for journalism since the penny press of the 1830s. Anything was possible and everything related to a counter-culture deeply embedded with antiwar politics and images taken out of popular life but also reworked dada-style. Here, the emerging political comic found its ethnic group, so to speak, and the varied work of Gilbert Shelton, Spain Rodriguez, Howard Cruse, Jay Kinney and Paul Mavrides (co-editors of *Anarchy Comics*), and Harvey Pekar (a scripter whose *American Splendor* became a much-awarded 2003 film), among others, added new dimensions to the political comic.

The momentum could not be maintained, for both commercial reasons (like the forced closing of "head shops" where these comix were sold) and political ones (the well-known intervention of COINTELPRO in the collapse of the most volatile underground press sector during the early 1970s). But the imprint remained upon the possibilities of the political cartoon. *Doonesbury*, the brainchild of Garry Trudeau, most definitely drew upon the daring of the undergrounds but also upon the left-of-center politics resilient among a popular readership when conservatism

had taken the center stage. Bill Griffith (of *Zippy the Pinhead*), himself one of the central figures in underground comix of the 1970s, made over the daily and Sunday strip into a running commentary about the sub-politics of commercial cultural trends. Griffith's *Arcade* magazine (1975–1977) had been the last effort to hold the underground artists together, before he turned to a daily strip.

Griffith's partner in *Arcade* was none other than Art Spiegelman, one of the heaviest influences in the art and the dignity of political cartooning. From the experimental journal *Raw* (1980–1990), the first (and, thus far, last) truly global comics anthology published in the United States, Spiegelman consolidated his Holocaust narrative in *Maus*, one of the most influential graphic novels ever published. In a controversial drawing about police recklessness for *The New Yorker*, he aroused the ire of political conservatives as no artist had done for generations.

The political cartoon was never in danger of outright disappearance, but the sharp decline of the daily press raised a question mark over the cartoonist just as the spread of the Web and various forms of commercial animation (above all *The Simpsons*) suggested where the young cartoonist might go for purposes of art and survival. Ben Katchor, "discovered" in *Raw*, and flourishing in the alternative press, marked one way forward with weekly cartoon commentaries on an imagined, heavily Jewish (actually Yiddish) universe rendered into curious multi-media theater pieces, once again about the nature of urban life, this time in almost archeological memory of lived experience in the metropolis.

Meanwhile, the political cartoon in its own format made a curious comeback. *World War 3 Illustrated*, an approximate annual launched quietly in 1979 in defense of the city neighborhood (portentously, New York's Lower East Side) against destruction-through-gentrification, evolved over decades into the showpiece of the young and radical, the experimental and cutting-edge work that recalled *Mr. Block* and even Hieronymus Bosch. Founders Seth Tobocman and Peter Kuper, and contributors including Joe Sacco and Tom Tomorrow, put the political comic firmly into a post-modernism that was also post-9/11 without losing a bit of its punch. From the looks of things, satire on the printed page is destined to be both famous and politically dangerous for another century.

Launching *World War 3*

Peter Kuper

For decades I've been anxious to find ways to address my political and social concerns through art, and particularly comics. With nuclear weapons poised to launch, global warming and, ah, I'll spare you the laundry list of issues . . . suffice to say we stand at the precipice and I don't want to be just scribbling while Rome burns. Through years of examination and trial and error, I have concluded the best way to get people's attention on life and death issues is to use humor. Sex also works.

What first brought me to this conclusion was *Mad* magazine. The satires of those brilliant sages—"the usual gang of idiots"—demonstrated that a well placed joke, combined with an image, could have the ability to explode hypocrisy and pull back the curtain on the lies of advertisers and presidents (often interchangeable). *Mad* also had a way of getting you laughing and then socking your brain with something much heavier—a rope-a-dope comic strip wallop. Comics are a perfect medium to address portentous subjects; the title "comics" already suggests something funny, light, kid-friendly, so the reader doesn't see the POW! coming.

Irony goes hand in hand with humor and serves as an ideal weapon, given how *unironic* most of my targets are. Using a cartoon to show Tarzan unable to swing through the trees because the "healthy forest initiative" (a logger-friendly presidential policy) has chopped them all down would be one example of this applied science.

With an interaction between picture and text, comics can display the difference between what we are told in words and the reality that is before our eyes. Applying comics in this way opens the possibility that a reader will contemplate a contradiction and may even fleetingly reconsider their stand on a subject. Or failing that, at least laugh.

Mission accomplished!

I don't want to just preach to the converted (I could never pass myself off as a preacher) which brings me back to *Mad*, where I first learned these lessons and now regularly contribute. My hope is that somewhere out there there's a battalion of youngsters who will read comics like mine, get a good chuckle, then have a light bulb appear over their head that reminds them to question authority and be inspired to start their own comic revolution.

Creating social commentary is one thing, getting it to an audience is a whole other story.

Through my rabid interest in all things related to comics I stumbled into the world of fanzines—these are handmade magazines produced on a printing press or photocopied, then exchanged with, or sold to, other rabid fans. My childhood friend Seth Tobocman and I published our first zine, with the inspired title *Phanzine*, at the age of eleven. It included our first feeble attempts at cartooning and interviews with various cartoon-world professionals (including *Mad*'s publisher William Gaines, R. Crumb, Jack Kirby, and Vaughn Bode). It was these early experiences that led us to publish *World War 3 Illustrated* in 1979 while in college. At that time there were few outlets for non-superhero comics and, with Ronald Reagan heading towards the Oval Office, we were anxious to apply our art as a form of rebellion. It was very empowering to produce a magazine, and the form proved to be effective enough that we are still producing *WW3* to this day.

We didn't start *WW3* with a manifesto, we just wanted to create an outlet for our political comix and have the opportunity as editors to publish work by other artists who also were not being seen much beyond local lampposts. If we had written a manifesto, it might have said something about creating an historical document that let someone from the future know that guys like Reagan didn't fool all of us. It also may have said if you are going to make declarations about changing the world, a magazine is a decent place to start. In many ways *WW3* represents a microcosm of the kind of society we'd like to see, a place where people of various backgrounds, genders, and abilities can pull together to the benefit of all.

It also makes great bathroom reading.

One of the biggest hurdles between creating work and reaching an audience is distribution. We began by selling the magazine outside the school cafeteria as well as local bookstores and comic shops that took it on consignment. Eventually we expanded when a record distributor, a fan of *WW3*, took us on and hooked us up with Diamond, the country's biggest comics distributor.

Another reality you encounter in self-publishing is, the bigger it grows the more of a businessperson you are forced to become. Add to that dealing with printers and promotion and it can become overwhelming. Still, these are the same skills one needs even when someone else is your publisher. Thanks to what I've learned through self-publishing I've found myself much better equipped to move through the labyrinth of mainstream book trade.

Self-publishing remains a fine way to produce uncensored work. And you join a long line of artists who successfully reached a worldwide audience through this approach—see *The Masses*, *Zap*, *Raw*—Art Young, R. Crumb, Art Spiegelman and Françoise Mouly—among many others. I suspect that I will still be at it as the oceans rise and my hairline recedes.

Interview
My New Distribution Technique is Unstoppable
David Rees

How did you come to create *Get Your War On*?

I read a report by Oxfam International that described the humanitarian situation in Afghanistan on the eve of the American bombing campaign. The report said there was a risk of massive starvation because the United States was demanding the blockage of relief routes and winter was approaching. Jay Leno and David Letterman couldn't seem to make jokes about that particular element of the War on Terrorism. So I decided to make some comics about how horrifying a bombing campaign is and how weird an open-ended War on Terrorism is.

Finding a venue to publish anti-establishment satire is not easy these days, especially after 9/11; how did you manage?

The Internet took care of everything. After I made the first page of *Get Your War On* comics I forwarded the link to a handful of my friends (friends who I thought would be sympathetic to the comic's sensibility and wouldn't take offense at the language). Those friends forwarded the link to their friends, posted the link on their Web logs, etc. Within two weeks hundreds of thousands of people had seen the comic and alternative weeklies were asking if they could publish it. I think the alt weeklies were excited because GYWO was one of the first satirical responses to the War on Terrorism. It wasn't necessarily insightful or original, but it expressed what lots of people were thinking privately.

GYWO's initial success was a perfect example of the Internet's utility as a distribution network. I'm sure if I had made the comic and submitted it to a newspaper editor on October 9, 2001, I would have been told that it was "too soon" to make those jokes or whatever. But the Internet allowed the comic to find its own audience without having to go through the extra step of being approved by an editor.

As to GYWO becoming a book, I had a hard time finding a publisher who would do it the way I wanted until I was referred to Soft Skull Press. They understood the sensibility of the comic and it was a good fit with their catalog, which focuses on the intersection of politics and pop culture.

There are plenty of Web sites that race across cyberspace for a few weeks, known to millions of people, but it's hard for many of those sites to find a home on paper, as a book. So I feel pretty lucky that Soft Skull decided to publish the GYWO book!

Nicholas Blechman defined your work this way: "He managed to express something that a lot of us felt during the aftermath of the terrorist attacks but couldn't find elsewhere. He tapped into a certain disaffected powerlessness and anger, and he did it with unapologetic nastiness and humor." Many artists got soft after 9/11, saying how difficult it was to draw given the circumstances; how did you manage to keep your wits about you?

I made GYWO because of my post-9/11 feelings. It's not like I already had a goofy comic strip running in all the papers, and then I had to figure out how to do justice to the horror of 9/11 within that comic. I wouldn't have done that anyway, because I always make a new project to express different feelings.

For instance, pretend there is a massive nuclear strike in the United States next year. I'm sure I'll tear my hair out trying to figure out how to incorporate that horror into GYWO. Someone else, however, will just create a new form out of their experience of that horror, which will be more effective because it won't be constrained by formal rules and norms that existed prior to the nuclear attack.

As to the nastiness, that was really intuitive. I wanted to cut through all the national self-denial about what was going to happen in Afghanistan. I also wanted to cut against the sense of aggrieved exceptionalism in the United States that was making it hard to have an honest conversation about our War on Terrorism, and some of the horrors that would deliberately and accidentally spin out of it. So I wanted the strips to be very dark and cutting. I wanted them to be the exact opposite of misty-eyed.

How do you keep the strip flowing in such a way that keeps old readers with you and new ones coming on board?

I've never thought about the strip in this way . . . satisfying old readers while gaining new readers. I assume the only people who continue to check for GYWO updates on my Web site are already fans, so I don't have to work too hard to satisfy them beyond satisfying myself. The challenge is to keep myself interested in the project, and to figure out how to continue to grow within this very limited framework.

As for new readers, I think being in *Rolling Stone* exposes me to a new audience. I try to make these strips a little different from the strips on the Web. Whereas on the Web site I usually post a series of seven to eight strips that riff on the same theme, in *Rolling Stone* I only get one single strip, so I try to make it pretty

"robust." I've also noticed that the *Rolling Stone* strips contain a little more reportage . . . maybe because I want these readers to know that I'm not sticking my thumb in the eye of the Administration just for the hell of it. I want to surround my criticisms with facts so people don't think I'm just being an asshole.

Your comics are entirely made from common generic clip art; can you draw well?
I used to draw comics by hand, which is a very time-consuming process. I am a decent drawer, but it's hard for me to draw the same thing/person twice, which is necessary in sequential art. I'm better at drawing things once. I'm also really bad at drawing people. I guess I could draw cute "cartoon character" people, but that's not really my style. So comics are not the best vehicle for my drawing skills; doodling is. Especially since my comics don't hinge on characters' facial expressions, so there wouldn't be an advantage to me drawing my own characters.

What is your target demographic?
I'd say it's a white, college-educated thirty-something from middle-class background who likes expensive cheese and feels guilty about it.

What is it about words like "fuck" and "shit" that is so funny?
I think they're funny because the dialog is about such strange things: imaginary karate fighters who become real; a karate fighter who is literally just a circulatory system; etc. The fact that these characters discuss these phenomena using the same language the guys on my block use to discuss what a pain in the ass it is to hang sheetrock makes the world of the comic a little more believable, in a way.

I also realized, after the fact, that the profanity is good at conveying a mood of anxiety and confusion. This idea of people using profanity because they're simply not able to express themselves otherwise works well in both the *My New Fighting Technique Is Unstoppable* series (because they're dealing with such bizarre goings-on) and the GYWO series (because *we're* dealing with such bizarre goings-on).

You work with a repertory of characters in *MNFTIU*, yet find various ways of riffing on them; how do you know when the gag is used up?
I think there are a few stages you move through. The first stage brings pleasure with the surprise of a new gag—a guy standing around like an idiot with his foot in the

air. The image itself is funny enough that you might as well use it again with a different punchline. Now the pleasure is compounded—recognizing the first visual gag and seeing it used to tell a different story. There's the visual joke, the new context it's being used in, which is itself a separate joke, and then a joke in the fact that reusing the image gives the lie to the illusion of some cohesion/narrative. It's the joke of how stupid jokes are, in and of themselves. They're just gimmicks. Then you move to the third stage, which is using the image over and over again, relentlessly, until people are right on the edge of getting sick of it. I hope you stop before they get sick of it. Or maybe you push so hard that they break through the wall of being sick of it and find it massively funny again.

Comic Strips

Comics Vérité

Stan Mack

© Stan Mack

For many years I wrote and drew a weekly comic strip called *Stan Mack's Real Life Funnies: guarantee, all dialogue is reported verbatim.* It was a documentary-style look at New York City life that took up almost a half-page in the New York City weekly, the *Village Voice.* I acted like a reporter, wandering the city looking for stories I could tell in my strip. I planted myself at cocktail parties, on movie lines, at demonstrations—anywhere New Yorkers congregated. I wrote down what people said and drew what they looked like.

Since it was a freewheeling era in New York and at the *Voice*, nothing was off-limits. Well, almost nothing. When I did an explicit strip from the set of a porno movie, there was immediate editorial enthusiasm. When I did a behind-the-scenes story on the training of Christmas elves at Macy's Department Store, Macy's complained and the *Voice* ad department reprimanded me.

In the following paragraphs, I will describe the quirky way I worked. The student of the comic strip form can decide if there are lessons to be learned.

Anything that titillated, shocked, or amused me was my raw material. I butted in where I didn't belong and tried to dope out what was happening. I'd loiter, go undercover, engage people, soak up the scene. I overheard conversations at singles' bars; hung out with anarchists in Tompkins Square Park; interviewed pigeon breeders at their convention. I spent time with a guy who rolled himself in a rug on the sidewalks of the Village, waiting for people to unwittingly step on him.

I followed my instincts, unobtrusively filling my pad with what people were saying. This was the mining stage; I didn't worry about what was gold and what wasn't. I also surreptitiously made sketches of people. I made a point of matching the words of a speaker with how he or she looked. I also took photos of places and things that were hard to sketch quickly, like street corners and fire engines.

Back home, I copied my notes into word balloon lengths, deciphering my phonetic shorthand, speaking the words aloud, getting a feel for the language. Because spoken language is often too long for word balloons, I learned to cut away the fat without changing the essential message. Out with those adverbs and adjectives!

Then I taped all the word balloons on the wall and began to move them around, adding sketches, searching for the tightest story line. It was exciting watching the sometimes unexpected story gradually emerge. I continued switching and discarding words (oh, why did I write so much), sharpening the plot line and the emotions. I cut lines I loved because they didn't move the story forward, and I discovered that a wonderful quote could carry the whole strip on its shoulders.

Finally I transferred my words and sketches to paper, designing panels, still cutting, of course. Penciling in the visual details of the strip felt like making a movie. I already had the script, cast, costumes, and locations. It was time to start shooting. I choreographed the actors, dialogue balloons, and props, zooming in, pulling back, going for the best angles.

I assumed my readers were new to whatever world I was reporting on. In the first panel, it was my job to introduce them to, for example, people who believed they'd been abducted by extraterrestrials. I would take the readers by the hand and

lead them through the strip, trying not to lose them along the way. My aim was to deposit them safely on the other side, having left them surprised, entertained, and knowing more than when they started.

The actual drawing of the strip took place on deadline morning. I had until eight that night to deliver to the *Voice*. I laid out my ink, pen, water, and opaque white. I taped my sketches and photos around my drawing paper, which held the sketch of the strip. My old dictionary sat nearby. I worked standing up, with Bob Dylan or Willie Nelson playing in the background. I threw myself into the drawing, part method actor, part action painter, part pizza pie maker.

As the day wore on, my smudges, mistakes and white-outs increased (being left-handed didn't help). The pressure of time and the spontaneity of my approach echoed the loud, fast-paced life of the city itself. By evening, the strip looked like I'd done it on a bus or subway, which was appropriate for a documentary-style comic strip of life in New York City.

Interview
Gut Feelings and Waves of Intuition
Mark Alan Stamaty

**You started by writing and illustrating children's books.
When did you start creating political cartoons?**
Some political references showed up in my work in the late seventies in my strips
MacDoodle St. and *Carrrttoooonnn* in the *Village Voice*, but I had NO INTEREST in
being a political cartoonist until I got a call from Meg Greenfield, editorial page
editor of *The Washington Post*, in January 1981. Meg said she was a big fan of my
work and wanted me to do a *MacDoodle St.*–type of comic strip for her Op-Ed
page. What intrigued me most was the opportunity to learn about a whole new
subject—politics up close—and to appear in an intriguing new venue, which Meg
referred to as "some of the best real estate in the country." What I was *not* enthusi-
astic about in the beginning was having to get into the middle of political argu-
ments in a public way. My experience as part of the "Vietnam Generation" was
that most political people I'd known on whichever side of an issue tended to be
narrow-minded, agenda-driven, quick-to-label, and basically intolerant of any
questioning of their particular beliefs. I dreaded voicing my point of view in the
midst of such people.

But I got over that eventually and learned to rather enjoy spewing my own vit-
riol when I felt so moved. But also, a lot of what I did as a political cartoonist was
to raise questions about the logic of the debate, etc. Anyhow, I created a comic strip
called *Washingtoon* and it turned out to be a good experience that taught me a lot.

**Your cartooning at times has a primitive feel, obsessively
detailed at times, but always controlled. How did you arrive at
your style?**
My style evolved over time. I have a lot of influences and a rather deep desire to be
original. My parents met in art school in Cincinnati. They both worked as freelance
gag cartoonists for magazines when I was growing up. I can see influence in my
work from each of them. Also, I grew up reading collections of gag cartoons. I can
still probably reel off a list of names of gag cartoonists from the forties, fifties, and
sixties that most people never heard of. But revelation came to me in the works
of four master cartoonists: Jules Feiffer, Ronald Searle, Saul Steinberg, and
George Grosz.

When I was fourteen, I discovered Feiffer's book *Sick, Sick, Sick* and it was one of the greatest things I'd ever seen. For me, it was all about how *a cartoonist could be a writer*. He kind of broke the fourth wall at times and had the character talk straight to the reader. Characters had real conversations with each other. And the drawing was amazing and so alive. It could embody atmosphere, mood, nuance, and sound effects in a way I had never seen before. And it wasn't all about gags and punch lines. It gave value to the whole content.

George Grosz in *Ecce Homo* has a visceral quality to his line that moved me a great deal and that I sought to absorb. In art school, I had an appreciation for a certain degree of "grotesqueness" in pen and ink in particular. And I do have some appreciation for the expressiveness of "naïve art" in various forms. In art school, the thing I liked best was making etchings. And very recently I've started doing that again and loving it with a passion.

What about the lower arts, like *Mad* magazine?
The detail of the art in *Mad* inspired me, as had some old gag cartoons of Robert Day of years back in *The New Yorker* where he sometimes did large scenes with lots of different things going on. I loved to look at all the details. The comic strip *Smokey Stover* was also a favorite of mine, the way Bill Holman would stick in "FOO" and "Notary Sojac" and various other nutty little details and asides. I just really dug stuff like that. So, that is some of how my style evolved.

How do you straddle the divide between reality and fantasy?
I like to find realities that give me a certain somewhat mysterious *gut feeling*. And from there I hope to discover. The joy of the work is the immersion, whenever and wherever I can find it. And hoping it will take me somewhere. I grew up on the Jersey shore. As kids we used to ride waves. In my work, I search for waves to ride. Waves of intuition. And I hope to surprise myself as well as my reader. The work needs enough "reality" to give enough structure to the fantasy so I don't just end up with mush. Though, for my own pleasure (aside from external demands), I can find a good deal of joy in the mush, and tend to believe it can lead to new structures.

I also tend to believe that the bridge between reality and fantasy, to some extent, is the resonance of an idea or intuition beyond its creator. I used to love Jean Shepherd on the radio, the way he made such an entertaining legend out of his childhood that others could share. I hoped to do the same sort of thing. Some people's

inner worlds succeed in reaching the outer world in greater degrees than others. But our inner worlds are very real to each of us, even though a lot of it is fantasy and unreal to everyone else. But once upon a time, Bugs Bunny was just somebody's fantasy. Now Bugs Bunny is as real to us as . . . Mickey Mouse. Or Elvis.

Do you use your cartoons to preach to your audience? What kind of response are you looking for?

I don't think I'm all that interested in preaching. Except that sometimes I guess I do really hope an anti-Bush cartoon (for example) will change the world. I probably am more interested in preaching than I used to be. On the other hand, my essential dream has tended to be to make something great, magical, beloved, and enduring. Something brilliant and classic that comes from some true, deep place in me and stirs a powerful joy and enrichment in my readers. Maybe that sounds like a bunch of flighty adjectives possibly launched by a grasping ego. I mean for it to be about intuition. I do believe we carry a magic and a miracle inside of us and that great artists tap into it and bring it forth in ways that give their audience a powerful experience of the magic and miracle within themselves. And that is what I always hope to do. And that is really *not* at all about ego, when someone really succeeds in getting to that place within and bringing forth something that truly contains and truly connects.

How would you rate yourself as a draftsman? And is being one more important than being a writer?

I don't know how to rate myself as a draftsman. Or maybe I do know, but am unwilling to face the ugly truth. *But,* on the other hand, given enough time, I think I can draw pretty damn well. But I'm not as fast and facile as some people and there are techniques I haven't mastered that I probably could master. But I believe I can draw plenty well enough to get my points across. In cartooning though, as far as I'm concerned, the big issue is *the writing.* That is the hard part. That is the part that makes me bleed. The writing, the rewriting, the re-re-rewriting. The pacing. The rhythm. The structure. Once the writing is done, the drawing part for me is just a matter of time. Drawing is much easier than writing, except that drawing does take time. But sometimes with the drawing I'm a little bit like Alfred Hitchcock was with the actual filming process of his movies: impatient. Because once Hitchcock finished the storyboards on paper, he felt like the filming process was rather anti-climactic. I love to draw, but sometimes deadlines, etc., take some of the joy out of

the process. And I'll tend to feel like once the writing of a thing is done, I almost want to farm out the drawing. But that also has a lot to do with how economics distorts art. Or too often threatens to.

Why do you insert yourself autobiographically into your work?
I like self-expression. Tom Wolfe might disagree, but I think "mining" one's own life for one's work is OK. It's what I know and it is the puzzle presented to me by "the universe" or "God" or the void or call-it-what-you-will. To a certain extent, I view my work as a means of probing the mystery of being. We get thrust into this world with no explanation and we find ourselves having all sorts of deep emotions and launched into reveries over memories of sandboxes and kids we knew when we were six. And that stuff has a power for me that I feel moved to investigate in my work. In terms of merely inserting some image of myself somewhere simply for the sake of it, I guess it's part signature and possibly less of interest to me now than maybe it once was.

Your dad was a cartoonist; what did you learn from him that has affected your work?
Complicated question. I got a pretty stark view of the dark side of this profession. When I was a kid, my parents were friends with Hank and Alice Ketcham and I played with Dennis (the Menace) a couple of times when we all got together. Hank had been a gag cartoonist along with my dad. Then Hank got that multimillion-dollar idea and got launched. My father never got one of those big ideas, try though he did and love it though he did. And it broke my heart to see where he ended up. With no security, no savings, out-of-fashion, unable to make a living, with a serious heart condition, and in danger of losing his house. But he was sitting in the back-yard resting and drawing in his sketchpad up to the last minutes of his life.

My father took a financial gamble to live according to his soul. Hank Ketcham took the same gamble. Hank won. My father lost. Or at least that's how I've tended to score it. But did he have a choice? Was he right or "wrong"? He followed his soul. In theory, that is what I believe in doing. Well, these are the sorts of things I wrestle with, why it seems to work out so much better for some people than others in this world. And whether or not it ultimately matters. Which is where the questions begin to get much bigger than what you're asking me.

Interview
Zippy, My Alter Ego
Bill Griffith

How did the Zippy character come about?

Shortly after I arrived in San Francisco, in the fall of 1970, an underground car-
toonist friend, Roger Brand, asked if I'd do a story for his *Real Pulp Comics*. My
Romance Comics parody comic, *Young Lust*, had just come out and was selling
briskly, so Roger asked me to do a "love story, but with really weird people." At the
same time, another undergrounder, Jim Osborne . . . Jeez, I just realized both of
these guys are dead . . . showed me his collection of sideshow freak photos, includ-
ing ones of "Schlitzie," one of the pinheads featured in Tod Browning's classic 1932
film, *Freaks*. I came up with a three-way love triangle tale called, "I Fell for a
Pinhead, but He Made a Fool Out of Me." The name "Zippy" came from the
Barnum sideshow star, "Zip the What-Is-It," so named by Charles Dickens on a
visit to Barnum's "Museum of Human Oddities" in New York. I thought Zippy
would be a one-shot character but clearly, it turned out otherwise.

Could you predict then that he would be such a long-running character?

Not a clue. A year or so after the *Real Pulp* story, I decided my mainstay character,
Mr. The Toad, needed a "sidekick," someone his diametric opposite, perhaps to
modulate some of his anger and meanness. So I brought back Zippy and played
him off Toad. It felt right; it gave my stuff more range right away. Of course, I had
no idea Zippy would become my comics "voice"—along with Griffy—for the next
thirty-four years.

How do you perpetuate this personality? What must Zippy be to stay human?

Zippy was at first more of an addle-brained character, meandering and child-like,
spouting non-sequiturs at a machine-gun pace. I remember thinking that creating
dialogue for Zippy was kind of like writing Beatnik poetry. I just opened the tap
and let it flow. But after a few years, even I felt a little like someone trapped in an
elevator with a crazy person. Zippy needed a new "sidekick" . . . Toad had begun to
scare me a little. Around 1975, I came up with my alter ego character, Griffy: neu-
rotic, self-righteous, and opinionated, someone with whom Zippy would certainly

contrast. I brought the two characters together around 1979, perhaps symbolically bringing the two halves of my own personality together as well. It worked. Their relationship seemed to make Zippy's random nuttiness more directed and Griffy's cranky critical persona had his foil, someone to bounce happily off of his constant analysis of everything and everyone around him.

Once a character is concretized, it's difficult to take him out of character; what would you say are the most radical changes introduced to Zippy's persona?

Over the years, Zippy became more of a vehicle for satire than he used to be. He's not as out of control or as random, though many of my current daily newspaper readers would disagree. Some of his "loose cannon" qualities are less in evidence. Another change came in 1998, when I moved from San Francisco to Connecticut. I started tuning in to my environment after almost thirty years of living in one place. No longer living in a big city, I began to notice all the quirky roadside artifacts and diners spotted all over the Northeast. In San Francisco, the only outdoor sculpture Zippy ever carried on a conversation with was the huge "Doggie" head, a baleful, cartoony dachshund rotating on a pole outside a San Francisco hot dog joint called the "Doggie Diner." But after my move back East, Zippy started talking to "Muffler Men," Giant Ducks, 25-foot ice cream cones, and a multitude of other roadside icons. I took photos of dozens of these things on road trips and readers sent me hundreds more, as they still do. One fan described Zippy's new direction by observing that he had "escaped into the real world." That sounds just right. I found a way to look at that part of America that most fascinates me, "Brand X" America, the America that still survives amid all the corporate sameness. It was a little like Zippy had a new "mission," a new reason to wander the pop landscape.

What can't you do with Zippy by virtue of who he has become?

I don't feel constrained by who Zippy is. I feel as if he's still a work in progress. And whatever Zippy can't do, Griffy or the other members of the strip's "cast of characters" usually can. Once in a while, the strip takes a turn into different territory, as when I did a long series on my trip to Cuba a few years back, or the long series I did on my father and growing up in Levittown, Long Island. I'm percolating another continuity series now, about my mother and father's relationship, tentatively titled *Barbara and Jim.* Leaving the regular characters aside once in a while is always an option, and my readers seem to go along for the ride when I do.

After so long, how do you personally relate to Zippy?
Zippy is probably my happier, "at peace" self, rolling with the punches and taking things one at a time. In that sense, when I'm writing his balloons or drawing him in various poses and expressions, he's me at my most open and accepting. Of course, Griffy has to make an appearance at "zen" moments like this and interject a healthy dose of skepticism and doubt; otherwise it wouldn't be honest.

With so much invested in him, can you ever see forsaking Zippy for another character?
I've created a sturdy little repertory company around Zippy—Claude Funston, Zerbina, Shelf-Life, Mr. The Toad, The Toadettes, etc.—who give me plenty of opportunities to deal with subjects and story lines that wouldn't work for Zippy alone. Once in a while, new characters pop up; a few years ago, I introduced two permanently-attached-to-their-stools diner patrons named Bert and Bob, who give me a chance to recycle all the real conversation that I overhear in real diners all over New England. So, no, I think that as long as I call upon these other players to say or do things un-Zippy-like, I'm satisfied. With any luck, I hope Zippy's flexibility keeps me inspired to keep cranking out my three or four little panels a day until they pull me away from the drawing table and plop me in the Cartoonist's Retirement Village somewhere on the Jersey shore, maybe between the Lollipop Motel and the giant inflatable Elvis next to the peeling Bob's Big Boy.

Interview
Sylvia, My Role Model
Nicole Hollander

Beyond her cats and her droll remarks, who is the real Sylvia? And how did she take shape on the page?

I created Sylvia to be a role model for me. I wanted a tough, smart, politically aware, self-confident woman to point the way to growing older ungracefully. Her remarks are usually in response to a political or cultural situation that calls out . . . *screams* out for irony.

The strip is also based on the exchange of ideas between friends, Sylvia and Harry, Sylvia and Rita, and Sylvia and everyone she tries to involve in her self-help seminars. Are they real or not? How does she make a living? Even the cats are occasionally political—but mainly they stand for all that is selfish and self-absorbed in all of us. They are *me! me! me!* writ large.

Your strip's frequent appearance on refrigerators is a testimony to your sharp, incisive use of words; how did you acquire your writing skills?

I started out as a graphic designer and the combining of words and images has always interested me. I read a lot, not particularly good books, but a lot of them. I learned to read early because my parents wanted me to be able to read the Sunday funnies and leave them in peace.

Writing a cartoon forces you to choose your words carefully, to edit without losing meaning. My strip is wordy, but the copy starts out much longer and more convoluted. I like to cut. I feel like a plastic surgeon. Sometimes the results are more frightening than elegant, and I have the help of a wonderful editor, who has worked with me for years.

Many ideas come to me from the detective novel and the film noir. *The Lonely Detective* is modeled on Raymond Chandler characters; my detective is always trying to help the little guy, always getting beaten up, and always falling for the wrong dame. *Alien Lovers* and the *Adventures of Lor* come out an early love of science fiction. Now I like the novels of William Gibson, more future fiction than science fiction. I owe the timing in the strip to my early exposure to the comedy of Jack Benny on radio. Now Jon Stewart of *The Daily Show* is my idol. As to strips: *Doonesbury*, *The Boondocks*, *Get Fuzzy*, and *Dilbert* are favorites.

How helpful were your MFA studies at Boston University in developing your drawing's distinct quality?
German Expressionism and Medieval art were my favorite periods in art. The passion in what were very static, stylized images attracted me. I did a lot of etching and woodcuts at the University and I think those techniques are reflected in *Sylvia*.

How does your creative process operate when you're low on ideas— and faced with a deadline?
I've learned to handle the terror of "no ideas." I ride it out. I read, goof off, see a movie, look in my refrigerator, take a bath. And then sometimes I am rewarded with an immense flow of ideas. Sometimes it seems like chiseling rock—I might start with two characters looking at each other and then their speech comes. I hear things in the supermarket, on the train. I'm the person listening to your intimate conversation in a restaurant. Here's my advice regarding restaurants: "Don't ask a woman to marry you on Valentine's Day unless you already know the answer."

What change have you observed in the comic strip market over the years?
It's more difficult to break in, of course. Many newspapers have dropped out of sight or have condensed their pages to make room for more ads, and alternative papers are also dropping like flies.

Opportunities for women cartoonists have not opened up. Just count the number of women in the comic pages. Count the number of women who are characters in strips. Even the *animals* are guys.

When I first started I thought there would be many strips like *Doonesbury*, but the politics of the papers seem to have become strikingly narrow, scared, and right wing. To me, humor is about ideas and words; cartoons that are made up of "Nya, Nya, Nyas", rather than ideas, seem too prevalent. Rush Limbaugh has hit the comic pages, and no one ever called him a great wit.

How would you advise students who want to break into your field?
I would suggest that students start with their school newspaper and then do cartoons for every association publication that they feel an affinity to. Some cartoonists start on the Internet; that's a fresh new possibility. Start a comic zine, print and distribute your work and the work of others. Collaboration may be the way to go.

I suggest that they follow their passion and not think about what might get them published. I think if you really want to be a cartoonist, really have something that you must get across, you keep pushing, looking for a place that wants your work, your vision. And then arrange to get paid for it.

Kids' and Teens' Comics

Katy Keene: Forgotten Comic Icon

Teal Triggs

"Katy and the gang inspired all my ideas concentrated between the covers of a 10¢ book."—John Lucas, 1981

Some comic characters are so inspiring that writers and artists want to work on them. But who has heard of Katy Keene? This Archie Comics character had her heyday between 1945 and 1961 and had at least as loyal a following. What was different about *Katy* was that young readers sent in their stories and designs, which were then redone by professionals. This made for a unique and charming comic book that deserves study, not least because some of those juvenile contributors would later become major figures in the worlds of fashion and design. Some, too, would become comics artists in their own right.

During the period when the comic book industry was seeking to publish "good" material for a growing female readership, Katy Keene made her fashion supermodel debut in *Wilbur Comics* (No. 5) the summer of 1945, created by illustrator Bill Woggon (1911–2003). Woggon's inspiration for Katy was drawn from a number of then-contemporary popular culture sources. *Katy Keene Magazine* fanzine editor Craig Leavitt makes a link between the early drawings done by Woggon's brother, cartoonist Elmer, for the *Big Chief Wahoo* character, Minnie Ha-Cha, and the way in which Woggon drew Katy. Leavitt comments, "One is taken with the Katy look-alike character Minnie Ha-Cha, who loved hats, fashions, and a muscle man." [1]

Equally, Woggon was inspired by the early *Esquire* pin-up "Petty Girl" and also credits Russ Westover's strip *Tillie the Toiler* (1921–1959), whose female protagonist "toiled" for a fashionable women's wear company. After appearing in over sixty issues of *Wilbur*, Katy was given her own title in 1949 where until 1961 she was the main character for stories centered around the burgeoning, New York post-war fashion industry and later, the Hollywood film industry (Katy relocated in 1949).

KATY

KEENE

by
BILL
WOGGON

by
BARBARA RAUSCH,
1878 CATALPA
BERKLEY, MICH.

In this story we star another very faithful fan, and up and coming artist, Barbara Rausch, who has designed all the fashions, Pinups, etc. in this story

Barbara likes the idea of Debby moving next door to Katy and also thinks the news of Tammy and Danny's engagement is simply super!

So, dear fans, in this story ... well, let's have Katy tell you

OH, HELLO, FANS! I WAS JUST GETTING DRESSED TO GO AND INVITE ALL MY GIRL FRIENDS TO A KITCHEN SHOWER FOR TAMMY.

© Teal Triggs

Katy Keene emerged out of a stylistic tradition previously held by newspaper comics portrayed by strips such as *Winnie Winkle* (1920–1996), *Brenda Starr* (1940–), and *Miss Fury* (1941–1951). While the story lines featured the antics of young career women, they were also significant as contemporary fashion plates. [2] Katy Keene was no exception, and as if to emphasize this, the comic book contained paper doll cutouts with wardrobes to match. Katy was featured wearing glamorous, sophisticated evening gowns and chic suits suitable for a career woman as well as appropriate sportswear for play. Comics artist and fan Barbara A. Rausch writes: "Katy herself, as Woggon has said, began as his ideal girl. In the early strip we see her as a charming, spunky, breezy, and rather coltish co-ed type of pinup girl, but she swiftly matures beyond this flat Suzie-ish image into an archetypal ideal woman; glamorous indeed, but also self-directed, creative, energetic, generous, with a warmth that reaches right off the page to the reader." [3]

It was also the illustrators who assisted Woggon in the production of *Katy Keene* who were able to provide a sense of realism to the garment designs and the glamour to Katy herself. Cassie Bill, for example, had been a sketch artist for movie costume designer Irene at Bullocks Wilshire and at MGM, creating sketches of gowns for, amongst others, Jean Harlow, Ginger Rogers, Marlene Dietrich, Carole Lombard, Lucille Ball, and Judy Garland. She worked for Woggon for five years and, according to artist John Lucas, was responsible for moving "Katy from the fifties Jane Russell–looking Katy (as done by Hazel Marten Steffen) to the late-fifties Audrey Hepburn–looking Katy." [4]

Although Katy held a unique position as a comic book "pin-up girl," she is not considered to be part of "good girl art"—that is, women illustrated as sexual objects with exaggerated silhouettes. [5] Woggon, who was a religious man, upheld his belief in family values and drew Katy as a sophisticated, fashionable, 1950s female career woman. Rausch, herself an early contributor to *Katy Keene*, has observed, "Katy Keene was actually ahead of her time as a female role model, consistently portrayed as fully human; struggling career person; single 'parent' to her younger sister; sportswoman (rider, swimmer, golfer, tennis player, skier, skater); relating effectively to other women (except the impossible Gloria) and relating successfully to men but not dependent on them financially or emotionally." [6]

Woggon wasn't the first to use readers' drawings for the basis of its pages. Other strips included *Boots and Her Buddies* (1924–1960) and Dale Messick's *Brenda Starr*, with other fan designs appearing in *Suzie, Betty and Veronica Stories*, and in some cases within the pages of *Millie the Model* (1945–1975) and

Patsy Walker (1944–1967). But what was also unique about *Katy Keene* was the way in which Woggon actively sought to use drawings and stories sent in by fans internationally through calls for submissions like, "Hey kids, send your designs to Katy." Such was the popularity of this process that Woggon would also receive "every Wednesday fifteen to twenty bags of mail that needed to be opened with requests for paper dolls in return for sending their twenty-five cents." For those designs that were selected, he would personally write back to each fan and let them know when their designs would appear in the comic book. **7**

Fans would send in their ideas for the supermodel, her sister "Sis," her two steady boyfriends, boxing champion K.O. Kelly and aristocrat Rand van Ronson, her rivals Gloria Grandbilt and Lucky Red Lorelei, her best friend Bertha Bumples, and "would-be suitor" Chubby Chuckles. Designs ranged from stories and drawings for garments and accessories, interiors, futuristic auto designs, and character's poses to typographic lettering styles. They would often trace figures from advertisements found in magazines of the time, Sears, Roebuck's catalogs or Simplicity pattern books. **8** Craig Leavitt comments that his "drawings adopted the poses found in a contemporary issue of *Bride's Magazine*." He would then add to the tracings his own ideas for garments. **9** Although Woggon redrew the submissions normally twice the size of the finished published size, he was careful to give fans full credit lines next to their chosen designs in the comic book. For example, in a 1959 issue for a feature titled "Winter Wonderland," Woggon credited Katy's pose, costume and lettering to fan "Liia Pukk, 301 Plymouth N.E., Grand Rapids, Michigan." *Katy Keene* collector R.K. Storch comments, "No other comic had the level of interaction between artist and reader." **10**

It was such interaction, in part, that ultimately inspired many *Katy* fans to become comics artists. E. Norman Bridwell, for example, served in a number of capacities at DC Comics, including as an associate editor and feature writer for the superhero Captain Marvel. As an early fan he had submitted numerous drawings to *Katy Keene* in the fifties, many of which were published. Former Eclipse Comics publisher cat yronwode remembers one "spectacular" Bridwell dress in particular— a Katy Keene sausage dress with little dachshunds running after it. **11** Another young fan, Barbara A. Rausch (1941–2001), whose fashion drawings were published in *Katy Keene* when she was sixteen, would later join Woggon as his protégé, drawing *Katy* as well as other successful comic book characters such as *Vicki Valentine* (Renegade Comics, 1985). Rausch, who won Woggon's "Designer of the Year Award" (1959) for her design of a wedding dress, trained as a painter and art educa-

tor **12** and worked as an art teacher for seventeen years before taking up drawing for *Katy Keene Magazine* and, in the 1980s, working as a Barbie paper doll illustrator.

Another contributor to the fanzine and *Katy Keene* paper dolls was John Lucas, who also holds a lifelong interest in *Katy Keene* comics. At age seven, he saw his first *Katy Keene*—the *Katy Keene Spectacular* (1956)—and "immediately fell in love." Lucas reflects, "The stories were incidental, but the artwork was what I fell in love with—the hairstyles, the fashions, the cars and boats and everything all credited to all of those young people." As a young boy, Lucas took private art lessons and continued to produce comic art for his "own and his friends' amusement," and has since been involved in fields from set and costume design to fashion illustration, commercial art, and art direction. **13** His first contact with Woggon was as a child sending in work for *Katy Keene* but it wasn't until 1973 that he phoned Woggon in Santa Barbara, California. From then on Woggon continued to encourage Lucas, who shared with him the artwork he was doing at the time. As a contributor to *Katy Keene Magazine* Lucas attended the first Katy Kon Convention (1983), held in Santa Barbara, where he finally met Woggon face-to-face. Lucas has written, "The foundation he laid for me as an artist has been so important in all the later ideas and work I've done." **14** Lucas' involvement in drawing the Katy character for the fanzine prompted fans to send letters into Archie Comics requesting that Lucas take over the artwork for the revival of *Katy Keene* (1983). He did so, along with calendars and other promotional items, until its cancellation in 1990. **15**

One person who was especially influenced by *Katy Keene* was Trina Robbins. Robbins has become the foremost historian of female artists and characters in comics and was a pioneering cartoonist in the days of the underground (1960s–1970s). In her work for more mainstream publishing in the 1980s she made deliberate reference to Woggon's style and the *Katy Keene* comic book format. This included not just drawing characters in a "glamorous" way but also soliciting ideas for garment designs and paper dolls from young readers. In *California Girls* (1987, eight issues), for example, fans designed swimsuits for "Tropical Fashions" where high school girls "Max and Mo demonstrate half a dozen clever ways to wear a scarf and a swimsuit." **16** Trina Robbins' feminist position, however, has not negated the "glamorous" way in which her female comic book characters are drawn nor the stories in which they are involved. Her protagonists continue to be clothed in classy resort wear, retro-chic gowns from the 1960s, and sexy swimsuits. She sees no contradiction in this, observing, "Young women are into 'we can be powerful *and* cute.'" She recalls only one journalist's criticism of *California Girls* who suggested "she didn't

understand why the girls all had to have different outfits all the time, and why my stories were so lightweight instead of being inspiring and uplifting and supplying role models for girls." In response, Robbins argued, "Why can't a girls' comic just be a fun read, like boys' comics are; why does it have to always be so damn *good* for you!?" [17]

Robbins also reinstated the section "Designer of the Month" in which young creators are recognized for their fashion design contribution. "We're showing you a picture of Tracie with one of her beautiful cats and a page of her lovely designs, and we can't decide which is prettier—the designs or the cat!" In another issue, "Designer of the Month" is presented to a sixteen-year-old male from Oak Park, Illinois: "Brendan is a fanzine artist and editor, and would like to break into the comic book field." Or, he writes, "I may go into advertising design or fashion design because I like to design clothes for females with flair." [18] In a similar way as *Katy Keene, California Girls* has inspired young girls and boys alike.

Not surprisingly, *Katy Keene* also influenced fans who have moved into professional careers as fashion designers, architects, interior designers, illustrators, and graphic designers. Amongst these are fashion designers Anna Sui, Betsey Johnson, Thierry Mugler, and the late Willie Smith (1948–1987) who, as an eleven-year-old, won a *Katy Keene* butterfly contest. Smith, when interviewed in 1978, remarked, "For me it was definitely Katy. She was my *Vogue*, total fantasy. She was a white Diana Ross." [19] As a professional fashion designer, Smith paid tribute to *Katy Keene* in the catwalk finale of his 1978 Spring collection. Craig Leavitt, who is now a successful California interior designer, remembers that *Katy Keene* was important in his education about design: "I wanted to understand how clothes looked, how to make someone look good. It wasn't necessarily the construction of the garments, but the shape and detail that was appealing." For Leavitt, this was important in the formation of an individual design aesthetic. [20] Other professionals, including fashion illustrators Antonio Lopez and Mel Odem, Hanna-Barbera animator Floyd Norman (worked briefly for Woggon in 1957), and graphic designer Jack Evans (*Katy Keene* "Designer of the Year," 1958), equally acknowledge Woggon's influence. Lloyd Sensat, now a retired architectural preservationist and educator, perhaps sums it up best when he writes, "I must credit my incentive and drive to become an artist for *Katy Keene* to Bill Woggon. He was my first master teacher who shaped my life and that of so many other professionals in the arts." [21]

Notes

1 Craig Leavitt (1984), "Katy Keene: The Overstreet Connection" in *The Overstreet Price Guide* (Cleveland: Overstreet Guide), A-70.

2 For a detailed discussion of women in comics see Trina Robbins (2001), *The Great Women Cartoonists* (New York City: Watson-Guptill).

3 Barbara A. Rausch (1981), "Katy Keene: Not Just another Pretty Face." *Katy Keene Magazine* Jun/July/August, n.p.

4 John Lucas, (September 30, 2003), e-mail to author.

5 Marilise Flusser writes that, "Lonely servicemen fantasized about Katy." *Soho Weekly News* December 7, 1978, 51.

6 Barbara A. Rausch (1982), "Katy Keene: Not Just One of the 'Girls,'" *Golden Age of Comics*, Summer, 49–50. *Katy Keene* enjoyed a short revival in 1983, prompted by fans of the comic book and *Katy Keene Magazine*.

7 Interview with Craig Leavitt, December 2003, San Francisco.

8 Interview with Craig Yoe, December 2003, Peaksville, New York.

9 Interview with Leavitt, December 2003, San Francisco. *Katy Keene Magazine* ran for eighteen issues. Leavitt began by printing twenty-five copies, with an eventual print run of up to three hundred, financed by himself and through subscriptions.

10 Leavitt (1981), "Katy Keene: Myth or Monument?" *Katy Keene Magazine*, No. 5, n.p. Another fan feature of the comic book was "Katy's Pin-up Board," located in the back pages, which provided photographs of fans whose designs had been selected for that issue and included their full names and addresses. Interestingly, through this practice a demographic may be built of *Keene's* fan base. For example, in Issue No. 45, 1959, out of thirty readers pictured, seven are young boys and three of the girls have Hispanic surnames. Barbara A. Rausch observes, "Due to *Katy Keene's* use of reader submissions, its audience included a high proportion of artistic and creative youth and young adults of both sexes (though females predominated), from both urban and rural communities in every part of the United States, and even from foreign countries."

11 Interview with cat yronwode, December 2003, San Francisco.

12 Barbara A. Rausch (1969), "Painting, Drawing." Extracts from a letter accompanying MFA Thesis, Department of Art, Michigan State University.

13 John Lucas (March 14, 2004), e-mail to author.

14 Lucas (1981), letter reprinted in *Katy Keene Magazine*, No. 3, n.p.

15 Lucas (March 14, 2004), e-mail to author.

16 *California Girls*, January 1988, n.p.

17 Trina Robbins, May 9, 2004, e-mail to author. The link between *Katy Keene* and Robbins is further extended in Rausch's appearance as a guest penciler for *California Girls*, November 1987, n.p.

18 *California Girls*, November 1987, n.p.

19 Marilise Flusser, December 7, 1978, *Soho Weekly News*, 54. Amongst other visual comparisons, Flusser highlights the relationship between fan's drawings and professional fashion designers as exemplified by Mary Ellen Esler (age sixteen), 1957, and Yves Saint Laurent "Rose bias gown" (1978), a sci-fi–inspired gown designed by Thierry Mugler (1978) from his "Up in the Clouds" collection, and a fan's drawing of Katy as "Miss Sputnik" (1959).

20 Interview with Craig Leavitt, December 2003, San Francisco.

21 Lloyd Sensat, January 4, 2004, e-mail to author.

Acknowledgments
Research for this essay is supported by a generous grant from the Arts and Humanities Research Board, United Kingdom. Special thanks also goes to Trina Robbins, John Lucas, Craig Yoe, cat yronwode, Craig Leavitt, and Lloyd Sensat.
Image on page 50 kindly provided by the Comic Art Collection, Special Collections, Michigan State University Libraries, East Lansing, Michigan.

How I Learned to Stop Worrying and Love Archie Andrews

Jessica Abel

The first comic I ever drew, in 1988, was drawn on small sheets of office paper, using a tiny, .01 mm technical pen (I had been told that one needed to use a "good" pen). Practically devoid of backgrounds other than the occasional column, it told a trippy version of the play *Medea* that flashed back and forth between ancient Greece and the twenty-fourth century (or thereabouts). In the end, Medea throws her kids out the airlock. In short, I had a lot to learn. One thing that first attempt did have, though, was a story—but that's just because I ripped it off from Euripides.

In the ensuing seven years I drew a lot more comics, and I learned about Bristol board, perspective, steel nib pens, figure drawing, India ink, writing dialogue, sable brushes, capturing emotion on a character's face, beveled rulers, and even the Ames lettering guide. But I did not learn a single thing about how to give structure to a story. I even took a class in screenwriting, and another in fiction writing. I majored in English, I read a million novels, but no one had ever helped me to understand what makes Jane Austen, for just a single well-loved example, tick.

By 1995, I had written a lot of flabby mood pieces, and even, unfortunately, published some of them. I had occasionally stumbled upon a more compelling structure, but even that was accidental, and I had no idea what it was that made one story better than any other. I was feverishly casting about, trying to figure out how to make my stories pop. After all, I had the interesting characters, their fraught relationships, their individual voices, the unusual settings. But the key to it all was missing. I felt like there was some big *secret* out there that no one was telling me, something that would make everything click into place.

And, as it turned out, I was right. In 1995, I won the Xeric grant. The pressure very much on, I had begun working on an ambitious project: my first twenty-four-page comic book, which would be titled *The Four Seasons* and would have a short story inspired by each of the seasons. I was in the middle of my first story, which was summer. Called "The Heart of a Turtle," it concerned a young man remembering a time a few years past when he'd been in southern Louisiana and had seen something strange, which had made him feel a sense of longing and despair. That's it. And it really wasn't happening for me.

Then, the fateful day. The new issue of *Blab!* came out, and there was a book release party for it at a local Chicago bookstore. Terry LaBan was there by the keg

and I fell into conversation with him. As it happened, he had recently become obsessed with *Archie* comics. He extolled the virtues of the stories, and in particular, their perfect, Cordon Bleu reduction of traditional story structure. The next morning, after I got to work, I ran right out and bought an *Archie Laugh Digest* and spent all morning literally charting the characters and their run-ins with one another. I still didn't have the idea down in words but I finally understood: the conflict must spring from the nature of the character, and the story revolves around the change that happens (or doesn't) as a result of that conflict.

Having already drawn four pages or so of my six-page summer story, I changed the ending so that the main character, while recalling the incident to his friend, laughs it off, while he secretly remembers the desperation and sorrow he felt. The contrast between the "now" of the story and "what actually happened" in the past of the story suddenly revealed something very interesting about a character who had previously seemed to be just a chronic moper. It wasn't a big change, but I felt jubilant: I knew I had started to crack the code.

Now, when I teach comics to sophomore cartooning majors at the School of Visual Arts, I save them the trouble. Since 1995, I've worked out a fancy chart that explains my understanding of "three-act structure." It goes something like this: Act one. You have pre-existing conditions: a character, a setting. The character has some characteristics. A new condition comes along in the form of a person or event, and this new condition is calculated (by the author) to interact with the characteristics of the pre-existing conditions to create conflict. The bulk of the story (act two) is developing that conflict and spinning off sub-conflicts. The end of the story (act three) is when the conflict is dealt with; either resolved, or not resolved, but addressed. Once students learn the key they quickly see that the three-act structure governs practically every story they read and love.

But while the chart is useful, the various pointing arrows and lists of exceptions can, for a while, fall in the realm of "too much information." The most important thing I do for them—though they rarely realize it at the time—is to make them read and analyze Archie, Jughead, Betty, and Veronica.

A Passion for *Top Cat*

Barbara McClintock

When I was young, reading was divided into two camps: prescribed reading assigned in school that was supposed to teach basic grammar, sentence structure, and vocabulary, and reading that was fun. The prescribed reading was absolutely dreary torture, the illustrations as constrained and contrived as the text. Those boring *Dick and Jane* readers were left in the bus, overnight outside by the sandbox in the rain, under the car seat. I associate them with the unbearably uncomfortable crinoline dresses worn to school on hot days in stuffy classrooms. The fun reading was absorbing, compelling, and impractical. I spent hours reading books of no apparent merit in my favorite solitary hiding places where my mother wouldn't find me, and my reading material of choice was comics.

I was attracted to the manic action, implausible plots, and impossible situations of comics.

Certain picture books also played an important role in my reading life: Else Minarik and Maurice Sendak's *Little Bear* books, the *Orlando* series by Kathleen Hale, Ludwig Bemelman's *Madeline* books, and a beloved *Aesop for Children* illustrated by Milo Winter that had been my father's as a boy. What these books shared with Donald Duck and Casper the Ghost was a suspension of reality verging on the inane that lacked any self-consciousness, and was presented as truth. The paradox of the reality of these beloved stories and comics and the reality of the world outside my room made them intrinsically funny and charming; I was motivated to read by delight.

My passion for comics was born full-throttle the first time I saw *Top Cat*. Here was a smart-mouthed conniving shyster, an unabashed trickster, living in a trash can and making personal calls (mostly to place bets) on the NYPD's emergency phones; masquerading as a visiting sheik to gain access to a posh hotel room and unlimited room service; working whatever scam he could with the aid of his gang to make a buck. I *loved* him! My parents would have kept a guy like this miles away, but here he was, in my TV room every Saturday, and in the comic book rack of the local candy store where I went after school.

Top Cat flew in the face of the ongoing maturity process implemented by parents, school, and society at large. Cheat a little, lie a little, ignore the law until Officer Dibble shows up—better to seek forgiveness than permission was TC's mantra.

I could safely let *Top Cat* be and do all this for me; he provided a release from the pressures and stress of being the well-behaved little girl I was expected to be, and wanted myself to be, for those precious hours of reading.

The world of Top Cat, presented in television and comic form, was a double treat. TV was intoxicating and easy, but comics allowed me to go at my own pace. I studied how Top Cat was drawn. I could go back to panels in a story that I found compelling and linger over them, and I could read my comic book whenever, and wherever I chose. I could possess a comic book as I couldn't a television set. The strong association of multiple images and words are similar in both mediums; similarities diverge from this point. TV cartoons are married to sound, while comics are a graphic whole, art and words working on the same visual playing field. What made comics so actively compelling for me were the rapid string of images that underlined and moved along the story. Panel size corresponded with the pacing of action and plot, smaller panels with just a figure or two, punctuated by a medium size panel lingering on a plot transition, led to a conclusion (often in the guise of a good gag) in a large, more elaborately illustrated panel. Visual gesture and facial expressions filled in what was hinted at by text. The hours spent reading *Top Cat*, drawing Top Cat, and making my own comics books based on Top Cat gave me the foundation of my approach to balancing the subtle interplay between text and art in my picture books today.

Action/Adventure Comics

Superhero Artists of the Twenty-first Century: Origins

Arlen Schumer

While the superhero genre has been the most dominant, commercially successful genre in comic book art, it is often considered the bane of the medium in the eyes of many purists (as the action film is to cineastes). However, it has also been where many of the advancements in the medium have developed, both in the panel-to-panel, page-turning, storytelling arena and in the graphic delineation of super-people, places, and things. The most popular genre has historically been, ergo, the most available playing field where many of the most talented comics artists and craftsmen have come to play.

Like most of the creative arts of the twentieth century, comic book art flowered in the 1960s (both underground comix and the mainstream, commercial comics of DC and Marvel). The sixties are known in the over-ground as the Silver Age of Comics and it is when superhero comic book art, drawn in a quasi-realistic style, came of age. (This is in contrast to the previous Golden Age, the years covering Superman's birth in 1938 to the end of the forties, when, following the War, most superheroes died out for lack of popularity, only to be revived by DC in 1956, ushering in the Silver Age and, in turn, spawning the birth of competitor Marvel Comics.) Hall of Fame artists like Neal Adams, Murphy Anderson, John Buscema, Gene Colan, Steve Ditko, Carmine Infantino, Gil Kane, Jack Kirby, Joe Kubert, John Romita, and Jim Steranko all developed their mature styles in this era.

But by the end of the Silver Age and the dawn of the seventies, two artists' styles came to dominate the field, representing the opposite ends of the spectrum of figurative/super-heroic comic art: on one end, Kirby's hyper-exaggerated anatomy and stylization, mostly rendered with a bold, inked brush line; on the other, Adams' hyper-realism (often utilizing photo reference), mostly rendered with a cross-hatched pen line.

Kirby and Adams were the primary influences on the next group of mainstream comic book artists who followed them in the 1970s, and who, in turn, influenced the artists who emerged in the eighties, and so on. Here at the dawn of the new century, today's best comic book artists fall, roughly, into three categories, all descendent from a Kirby/Adams axis:

> The New Draftsmen: pen and ink–based, realistic figure artists who often use photo reference in their work
> The New Stylists: pen and ink–based, stylized figure artists
> The Multimedia Artists: artists who combine/alternate between pen and ink, painted artwork, photography, collage, and computer graphics.

(In no way is this breakdown meant to totally comprise the diversity of graphic styles found in all of today's comics; it is simply a road map to understand how some of the most popular comic book art styles have developed.)

First, the New Draftsmen.

Neal Adams' impact on comic book art in the 1970s was so great that, ironically, his realistic style was as much responsible for the bad superhero drawing that followed in his titanic wake as the good; like any enormously successful artistic/cultural style, clones and watered-down versions of the original end up flooding the mainstream.

But it is inarguable that Adams opened the door for a new wave of young comic book artists with wide-ranging styles to come in and define the seventies: Michael Kaluta, Berni Wrightson, Howard Chaykin, Walt Simonson, P. Craig Russell, and others. Adams' drawing style itself was more apparent an influence on artists who emerged in the latter seventies and became stars the decade after: Brian Bolland and Bill Sienkiewicz.

From those artists of the eighties came the seeds that not only birthed the New Draftsmen of today, but the Multimedia Artists as well. Adams, coincidentally, is as much at the root of that movement, too. As if in answer to the dominance that his realistic style imposed, artists broke free first from the shackles of his realistic drawing, and then from the confines of pen and ink itself, and into multimedia.

Brian Bolland became known as the British realistic artist par excellence with his work on the Dirty Harry of the future, *Judge Dredd*. His technique seemed like an unlikely cross between the in-your-face realism of Adams (whom Bolland wrote his art school thesis on) with the more subdued compositions and statuesque posing

of the Superman artist of the Silver Age, Curt Swan. Perhaps because of the Swan influence, Bolland rendered his drawings not with Adams' pen-and-brush approximation of realism, but with more studied, meticulously rendered, engraving-like pen work. Bolland—his solid drawing foundation overlaid with stylized, designed form—opened the gates for an entire generation of New Draftsmen.

Bolland was the vanguard of a British Invasion of artists and writers who were imported into America via DC in the early eighties. The artists included Dave Gibbons, Brendan McCarthy, Glenn Fabry, Steve Dillon, and Philip Bond. Chief among the writers was Alan Moore, who, with Gibbons, created one of the most didactic, densest superhero comics series ever, *Watchmen*. He posited a much more emotionally and sexually realistic take on how superhuman beings might actually interact and affect each other, society, and the world. Unfortunately, the fallout from *Watchmen*'s overwhelming critical and commercial success was that lesser creators downgraded their superheroes into lesser, antiheroic shadows of their former selves, and dragged practically the entire superhero genre down with them.

Soon after, Moore surveyed the carnage his *Watchmen* had wreaked on the genre and decided to right it with his creation of his ABC line. Published under a DC imprint, the titles revived the more nostalgic, Silver Age air of classic, straight-ahead adventure. Appropriately, the back-to-the-basics approach was evident in the styles of his collaborators such as Chris Sprouse (*Tom Strong*), Gene Ha (*Top 10*), and Kevin Nowlan (*Jack B. Quick*)—New Draftsmen all. Of the group, J.H. Williams, with his inking partner Mick Gray, has produced the most sustained, stunning work on the phantasmagorical *Promethea*. Williams' graphic explorations have run the gamut from fully painted work alternating with traditional pen and ink–based work, to Möbius strip–like double page spreads. He utilizes magical symbology that gives these spreads the look of illuminated manuscripts, which support Moore's mythology-based story lines.

Adam Hughes emerged in the nineties as the American Bolland by similarly displaying a masterful command of realistic anatomy—especially female anatomy—which he renders with a graphic ink line more hard-edged than Bolland, choosing a thicker line for outside contours and a thinner line for interiors. Hughes followed in Bolland's footsteps by fleeing the labor-intensive fields of multiple-page storytelling for the rarefied air of covers, most notably *Wonder Woman*, in which he begins with a line-drawn foundation and then colors in fully gradated tones on the computer.

Bryan Hitch throws his brand of Bolland-ism into widescreen, cinematic interior panels that look like frames of the greatest action/adventure film you've never

seen, their foregrounds filled with massive explosions, backgrounds with all the detailed detritus and mechanical rubble that would result. But Hitch is a master anatomist as well, and, like Hughes, carefully renders his shading and black areas into design elements. His *The Authority* (created by British writer Warren Ellis) and *The Ultimates* provide bounteous examples of Hitch's drawing prowess.

Next up, the New Stylists.

Jack Kirby's post–Silver Age influence can mostly be seen in the works of four Marvel artists who became stars by the eighties: John Byrne, George Perez, Walt Simonson, and Frank Miller. Byrne and Perez became fan favorites by synthesizing Kirby's dynamics with a soupçon of Adams' realistic rendering; Simonson eschewed realism, substituting a scratchy ink line and stylized drawing.

Image Comics artists Jim Lee, Todd McFarlane, Erik Larson, and Marc Silvestri are descendants of the Byrne/Perez school of ersatz Kirby, supplemented with Simonson stylization and Japanese manga hyper kineticism run amok. This mishmash of styles proved to be largely destructive in practice, as Image books were reduced to too many full-page pinups of too many big-breasted females and too many small-headed men, all rendered with too many scratchy lines. Unfortunately, the "success" of the Image look has resulted in it being favored by the majority of mainstream superhero comics publishers.

Steve Rude was among the first post-Kirby influences to incorporate more of the essence of Kirby's dynamics into his own more realistic drawing style, claiming a middle ground between Kirby and Adams: realistic drawing as the underpinning to a bold, inked brush line that served to stylize the art and give it a bit of a cartoonish look. Rude demonstrated this dynamic when he began his fifteen-year run in 1982 on the super-antihero *Nexus* (co-created by writer/collaborator Mike Baron).

Frank Miller also rose to fame in the early eighties when he took over the reins of a Marvel B-list hero, *Daredevil*, and catapulted the title and himself to stardom by essentially grafting Adams' Batman onto Daredevil. Miller's Kirby mojo wouldn't really be in evidence until his 1986 Batman graphic novel, *The Dark Knight Returns*, garnered unprecedented outside media coverage for its mature themes and sophisticated graphic approach. It also had a more deleterious effect within the cloistered comic book world, similar to that of Moore's *Watchmen*, rendering every other superhero an angry, angst-ridden *Dark Knight* clone. That, coupled with Image's burgeoning reign of overly rendered hackwork, proved to be a deadly combination throughout the 1990s.

On the positive side, the early nineties saw Mike Mignola emerge from the Marvel superhero trenches and apply Miller influences to his own black and white *Hellboy*. This Dark Horse series seduced readers with stark, still compositions that played large fields of black and white off each other, befitting the demonic subject matter.

Both Miller and Rude influenced Michael Allred, one of the first art stars to surface in the nineties. With his *Madman* character, a hybrid of Frankenstein monster and The Cure's Robert Smith and currently published by Dark Horse, he was immediately hailed as a writer/artist of considerable talent and unique vision. Beneath his designs exists a unique approach to the figure that appears as astute observations of real people, so much so that his figures appear to be taken from photo reference.

In 1992, when the Warner Bros. *Batman* animated series debuted, designer Bruce Timm became an overnight sensation amongst animation and comic book aficionados alike. The look of the show harkened back to the great 1940s Max Fleischer *Superman* cartoons. And with a chin the size of a butcher block and shoulders like twin anvils, Timm's *Batman* had more than a hint of Kirby as well. When he began to draw *Batman* for DC in the years following he proved to be equally adept at the art of comic book storytelling as he was at animation storyboarding.

And now, the Multimedia Artists.

Emerging in the early eighties, drawing a Batman-manqué at Marvel named *Moon Knight*, Bill Sienkiewicz was not so much an Adams disciple as the ultimate Adams clone. Over the years, his drawing became looser, his inking scratchier, his storytelling more abstract, and, with the publications of the graphic novels *Elektra: Assassin* and *Daredevil: Love and War* (both collaborations with writer Frank Miller), he pushed into fully-painted work that was truly multimedia: he ping-ponged between collage, xerography, "bigfoot" cartooning, techniques of magazine illustrators like Bob Peak, Jim Sharpe, Bart Forbes, Marshall Arisman, and Barron Storey, and the remnants of his Adams realism. But Sienkiewicz never shows off; he lets the change in the story itself—be it mood, location, or character—dictate his graphic style.

In England, Sienkiewicz's influence was felt enormously by two very different artists. Simon Bisley wedded his cartoony drawing and freewheeling painting style to the premier fantasy painter Frank Frazetta, resulting in a Frazetta-on-steroids look, displayed most prominently in a series of graphic novels (written by Pat Mills) about Sláine, a kind of Celtic Conan.

Dave McKean's naturalistic drawing, cartooning, and collaging most closely resembled Sienkiewicz's work when his debut was published, the 1987 graphic novelette *Violent Cases* (written by the soon-to-be-giant-in-the-field writer Neil Gaiman), but it was his spectacular covers for the concurrent Gaiman-written DC series *Sandman*, which incorporated drawing, painting, photography, typography, Joseph Cornell–like shadow boxes, and especially a layer of computer graphics, that propelled McKean past Sienkiewicz in the multimedia arena (though it forced the latter to play a bit of catch-up in the nineties and add the computer to his already-formidable art arsenal).

Since the nineties, numerous other comic book artists have employed multimedia to expand the visual vocabulary of their work. Alex Maleev has been quietly refining his signature style for the past few years as artist on Marvel's *Daredevil*, written by one of America's best comics writers, Brian Michael Bendis. Maleev casts his characters with real-life models, photographs them in as close to what the actual situations call for, and then, through a unique combination of xerography and drawing, creates a new synthesis, resulting in a noirish, cinematic graphic storytelling style, its xerographic graininess befitting the gritty city streets of New York's Hell's Kitchen in which *Daredevil*'s adventures take place. Once again, the style serves the milieu.

Finally, perhaps no other artist working in mainstream superhero comics since the dawn of the nineties has had a greater impact than Alex Ross. A blend of Multimedia Artist and New Draftsman, Ross took Adams' pen and ink–based photorealism farther into the realm of verisimilitude, fully painting his prolific body of work, a series of graphic novels for Marvel and DC. Adams once commented that if superheroes were real, they would look the way he had drawn them; now we'd believe they'd look the way Ross has painted them.

Ross not only photographs models, but also has them wear custom-designed costumes of the characters. And unlike his contemporaries—who neglect to cartoon the overlaying drawing and produce stiff figures and even stiffer layouts—he creates photo foundations subsumed by panel layouts and compositions as dynamic as the best of any conventional comic book artist.

Ross is as much of a superhero auteur as he is their greatest delineator. He doesn't so much portray superheroes as pose them in quasi-mythic compositions that both echo the Depression-era, heroic figure work of WPA murals and border uncomfortably close to the fascistic figures of Russian constructivist posters and the Aryan gods and goddesses of Leni Riefenstahl's Nazi propaganda films. And yet,

somewhat paradoxically, his wholesome and grand American settings have made him the Norman Rockwell of comic book art.

With all the graphic diversity, explosiveness, and expressiveness in our midst, one might make the false assumption that comic books are more popular today than ever before. What's bitterly ironic is that while comic books, superheroes, and comic book art itself have never been more influential in American pop culture—witness the boom in Hollywood superhero movies—the readership of the comics themselves has bottomed out to levels that, in a prior era, would have sounded the death knell for countless titles. What happened?

Once the former fan boys of the Silver Age grew up to run the companies (the inmates taking over the asylum, as it were), in their zeal to have comics grow up with them—and there's nothing essentially wrong with the medium appealing to an adult audience—they forgot how to create comics for kids. That, coupled with the ghettoizing of comics books to retail comic book stores instead of the more ubiquitous candy and stationery store outlets of the past and the rise of computer and video games, has derailed an entire generation of kids away from exposure to comic books as their first reading medium.

So while comic books have never been as artistically creative, they also have never been this far on the brink of cultural irrelevance. Nevertheless, they soldier on, continuing to shine brightly with their dazzling drawing, scintillating storytelling, and the greatest of graphic expression.

The First Rule: There Are No Rules
Jim Steranko

Joe Kavalier is largely based on you, but three decades before Michael Chabon's *Kavalier and Clay*, you were the inspiration for DC's *Mister Miracle*. Were you directly involved in the creation of this character?

The genesis of Mister Miracle began in 1970 at a dinner with Jack Kirby in New York. The Kirbys had moved to the West Coast a few years earlier, but when they lived on Long Island, I'd often visit and perform magic for the family—close-up work with cards and coins. But I never mentioned the escape stunts that were another aspect of my theatrical career.

On this night, we were chatting about comics and I mentioned the oddity that almost every Golden Age publisher had a coven of magician heroes—from Ali Kazam to Zatara—but *never* an escape artist. Jack, who'd collaborated on the creation of hundreds of characters, agreed with the observation, but couldn't answer *why*. The subject triggered a wave of recollections regarding my experiences with Houdini-type stunts and Jack became acutely interested, particularly about the dangerous aspects they entailed. Buried alive without the safety of a coffin. Manacled to railroad tracks in the path of an approaching train. Locked in the trunk of a car that was set afire. Tied to a moving Ferris wheel. Nailed into a crate loaded with lead pipes and dropped to the bottom of a riverbed.

Jack recognized the superhero potential in that concept. He said, "Do you have *any idea* what you've been sitting on?" Of course I did, because the subject spun out of my escape-artist-hero question, which was a hint to Jack; I'd finally found a way to repay him for all his kindnesses, not to mention a lifetime of devotion to excellence in comics. "Why don't you *show* me?" I challenged. A few days afterward, I sent him a book that detailed a cross-section of my escape stunts.

About six months later, I was in DC-president Carmine Infantino's office and he reached into his desk drawer and tossed a cover proof at me. "This is *you!*" he said. "*Mister Miracle!*"

As for Joe Kavalier, he and I belong to a very exclusive brotherhood; we're still the only escape artists who became comics' artists. And then there's Chabon; he ended up with a Pulitzer Prize. And I have a stack of comics.

In **The Steranko History of Comics** you cite the "bloody pulps" as progenitors of comics; do you still see remnants of the dime novel spirit in today's comics?

Much *more* than only spirit. Batman is the comics' version of the Shadow and almost identical to the pulps' Black Bat. Superman is part Iron Monro, part Hugo Danner of *Gladiator*, and other direct influences from the pulps, including Doc Savage, who was described in an early ad as a "superman." Tarzan, Zorro, the Avenger, Conan, Phantom Detective, Domino Lady, and John Carter of Mars were all spawned in the pulps and became seminal figures in American pop literature. Spider-Man links to the Spider. Yesterday's comics obviously took their cues from the pulps. Today's comics take their cues from films. But however you correlate it, the source of heroic fiction traces directly to pulp fiction. The beat goes on . . .

Cinema is a strong influence in your development.

I learned to draw from the comics, but all my storytelling techniques and processes are derivative of cinematic aesthetics. When I was five I saw my first movie, the noir film *Mask of Dimitrios*, which had a profound impact on me. As a kid, I was too poor to afford the price of a ticket so I'd often break into theaters, find an obscure seat, and enhance my education. My teachers were Hitchcock, Siodmak, Welles, Capra, Walsh, and Curtiz, who probably had the most influence on me.

Seventy years after Jerry Siegel conceived Superman, what's been the primary loss and gain in the field he founded?

The superhero field and the popularization of the comics' medium? There's the loss of innocence which typified the Golden Age: simplistic morality, stereotypical good and evil, predictable justice and retribution. Certainly, many of today's comics haven't progressed far from that point, but they often attempt to explore gray areas to the point where it's sometimes impossible to differentiate the heroes from the villains . . . somewhat like the eleven o'clock news.

The most significant loss concerns the inability of contemporary writers and artists to tell a story smoothly and dramatically. Adrenalin junkies believe that the more blood and death a comic features, the better it is. From my viewpoint, quality writing, superb art, and well-developed characterizations with ingenious plots are the criteria upon which a book should be judged. Of course, it's much more difficult to generate authentic quality than cliché-ridden quantity.

I'm not recommending a return to Golden Age naïveté, but to a new age of *responsibility* in the arts. All good stories utilize the polarity of conflict. But when evil becomes not only the means, but the end, it may be time to examine motives and policies. At one time, honor and dignity were goals that were worked for, often fought for, and too much of today's media product—particularly comics—attempts to corrupt and destroy those qualities. While that approach may have been tolerable in a more amenable past, contemporary life is too damned dangerous without *everyone* expending a maximum of courtesy, consideration, and respect. Contemporary comics should generate content that defines the triumph of the spirit rather than the degradation of the soul.

What have we gained? Draftsmanship is generally better. Digital production is superior. Printing has improved. What do you want for a 3,000-percent price increase?

In the short span of your *Strange Tales* issues, you radically transformed the art and story line of Nick Fury; describe your on-the-job learning process during that time.

Marvel's 007-wannabe was suffering a slow, painful death from lack of energy, lack of imagination, and lack of interest generated by a succession of artists after Jack Kirby's rough-and-tumble opener in issue 135. So Kirby was called in to punch up the book. He penciled the cover and laid out the twelve-page spy caper in issue 151, which I was to finish and ink. I followed Stan Lee's editorial directive, one given to all Marvel artists: *Do it like Kirby!*

My apprenticeship commenced and I immersed myself in the comic aesthetic, analyzing, learning, practicing, waiting. Kirby was one of my artistic idols and I'd already known him for a few years. But, collaborating with him on my first Marvel assignment was like starting at the top! I remember thinking that I was a pretty hot inker. I had a nice, controlled line and easily handled that aspect of the work. I'd already logged ten years as an advertising illustrator and tore into the pages like a demon, ready to connect with the man I consider an authentic genius. I'd grown up with Kirby characters, studied his art and storytelling techniques so I felt that I could not be better prepared to handle the job. How *wrong* I was!

While I had a great time inking the cover over his pencils, his page layouts were another matter—I simply could not get comfortable with them. I couldn't find the groove I was looking for. The feeling confused me, which I attributed to my inexperience with comic-book production. I thought it would decrease as I completed additional pages. But the more I worked on them, the more oppressive the feeling became.

By the time I was into issue 153, I identified the problem: Kirby's storytelling approach and mine were *in diametric opposition!* I found myself agonizing over his shots. Where Kirby had a medium shot, I would have preferred a close-up. Where he had a low-angle reverse, I felt an over-the-shoulder shot would be more appropriate. When I submitted the story, I told Stan that I *couldn't* work over Jack's layouts again and that I was ready to pencil the strip. In his infinite wisdom, he agreed and I was on my own.

That three-issue stage-wait resulted in a spasm of creative energy. My splash page for issue 154 was wildly over the top with more electronic gingerbread than it took to run the New York subway system, but it was indicative of my enthusiasm. I aborted Marvel's classic page division and panel configuration, replacing them with narrow horizontal and vertical panels that generated visual tension and smaller panels that enhanced my control of temporal pacing.

I was guessing much of the time about those changes, but with educated guesses—often hitting the target, but missing the bull's-eye. I began developing what I call *visual theory*, beginning with an understanding of the size and proportion of the page, the nature and quality of line art, symmetrical versus non-symmetrical layouts, balloon placement, and typographic treatments, on through to psychological coloring. I was creating a narrative arsenal, a kind of cognitive catalog on which to construct my stories.

My draftsmanship was primitive. I wish I could have drawn like Williamson or Buscema, but I was more interested in engaging my readers with ideas. The early stories were raw, but riddled with a kind of energy I didn't perceive in most strips, especially those published by other companies. I soon convinced Stan that the writing and coloring, done by others, were out of sync and he established another precedent by allowing me to be the only Marvel grunt to write, pencil, ink, and color his own work. Along the way, I lettered some of it, too.

What followed was a series of original narrative experiments that ranged from a three-page silent sequence to puzzle and maze pages that readers had to navigate side by side with the hero so they could continue on with the adventure. My approach combined such cinematic techniques as dynamic symmetry, visual metaphors, dialogue matches, symbolic montages, point-of-view angle shots, eye line correlations, visual rhythms, panning and tracking shots, multiple-depth panels, and match-dissolve transitions. I also employed a muscular range of storytelling devices and special effects in ways that had never been explored before in comics history: optical art, photo montages, line resolutions,

strobe effects, and wild concepts such as a nine-month plotline, which climaxed in a panoramic four-page spread that readers had to *buy two issues* to view simultaneously.

You're credited with "psychedelicizing" action hero comics with your *Nick Fury* and *Captain America* work.

I used the term "Zap Art" to describe the style I created for *S.H.I.E.L.D.*, which strip-mined the basics of the Marvel approach—figure distortion, accelerated plot, hyper spectacle, and radical perspective—and fused them with Op and Pop Art, which ironically was influenced by comics. Both, of course, were cultural manifestations of the period.

I only had *one* goal in comics: *to entertain*, the job for which I was hired. To perform that job to the best of my ability, I felt I had to violate or recast comics' prevailing canon. In doing both, I needed to engage other cultural idioms and forms of artistic expression, and freely adapted Surrealism, Expressionism, and Symbolism to the comics medium. My use of external techniques and movements was not a matter of inspiration or defiance of the form's prehistoric code. I did it because I could, because no one else did it, and because it expanded the perimeters of the medium.

Comics are a hot-ticket medium, yet when I entered the field, they were speaking a dead language, still using the visual syntax of 1930s newspaper comics. Editors, publishers, writers, and artists didn't realize their art form was dying from hardening of the arteries and needed a transfusion of fresh blood and new ideas. Most of the artists working during that period were old pros who'd become human photocopy machines, simply repeating the same threadbare clichés, issue after issue. Their narrative processes aped comic strips, which were terminally dated or obsolete. They worked, yes, but they were predictable and worn to molecular thinness!

How could the most liberal and imaginative forum be so rigid and formulized? Why did even those creators with expansive visions accept the shopworn rudiments handed down over the decades without any sign of reform or rebellion? I was baffled! Since I had made no agreement to comply with the Sanctified Laws of Comics, since I wasn't part of the succession of the regimented, since I embraced the work not to conform, but to explore my own vision and, in the process, the comics form internally and externally, I opted to make my own rules, the first of which is *there are no rules.*

How has your comics training aided your subsequent design and film careers?

I tap all my resources constantly to discover what directions are possible in my private and professional lives. Whatever I've learned in any field has an impact on my thought processes, deportment, execution strategies, personal evolution, caprices, dreams, and ultimately, my successes and failures.

Specifically, comics require a very disciplined conviction, but discipline was part of my nature since I was a kid. I had a difficult childhood and had to be resourceful to survive. I wear that ideology like a flak jacket. If you press me on the point, however, I'd have to say my comics training has enhanced my ability to envision graphic solutions with more ease. In other words, whether I'm working on a complex book cover design or storyboarding a scene in a film, my comics experience allows me greater authority and facility in discovering a solution.

What do you see as the future of electronic comics as a creative medium?

There was a time when our only tools were a pencil and a brush. Now, our electronic arsenal can create the fantastic in a fraction of the time, and do it seamlessly. Lines on paper can be interesting, but they can't compete with spoken dialogue, sound effects, music, special F/X, and motion—*fused with the image.* Anything goes and everyone is on a level playing field. You and I and Bill Gates have the same programs, but we don't all have the same imagination and integrity. May the best man win.

Any advice for other artists who aspire to revolutionize the comics industry?

Study my work and improve it. You have nowhere to go but up!

Interview
Illuminating the Darkness
Barron Storey

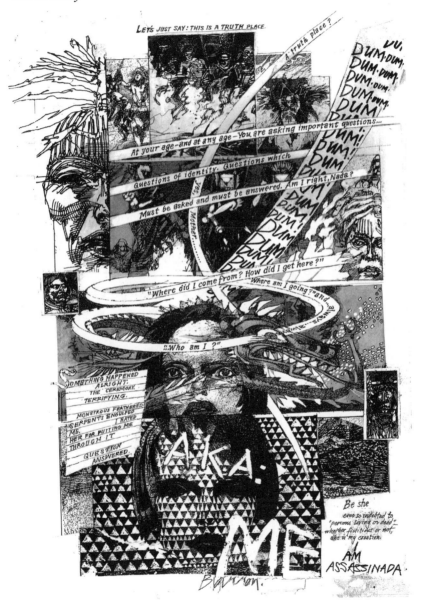

© Barron Storey

What was the most meaningful lesson you've retained from your SVA studies under Robert Weaver?

The primary importance and nature of seeing. What it is and what it is not. (Seeing is not believing.) Belief and its deluding rationalizations are profoundly apparent in today's world. The forces of power hide things from our eyes, do they not? We are blinded, too, by our own priorities—notably, Program Number 1: Survival. Bob wanted us to see. To see clearly, beyond the limitations of our preoccupations and our "programming."

Weaver encouraged what I've come to refer to as "visual dialectics": seeing by thoughtful comparison. Often dividing his pictures into two frames that invited comparison, he looked at singular compositions in the same way: this focal point as it resonates with that focal point. He showed this in photography, often using newspaper photojournalism to make the point.

"Visual Journalism." Weaver was an insightful observer of the society around him. As I watched the 2004 Democratic Convention on television, I was reminded of his coverage of the JFK campaign in 1960 for *Life* magazine. That spread and the one on crime in the same magazine changed *my* life. Weaver was a reporter. Asked by a sports magazine to cover the Green Bay Packers or baseball training camps, Weaver returned from his travels with images that put a larger frame around sport—a societal perspective. A portrait of a city's obsession, the "mean streets" of juvenile urban life, the ambitious agendas of candidates amidst the hurly burly of politics.

Content trumps technique. I came from California with a portfolio full of technical "gimmicks." Mr. Weaver was unimpressed. Through a twist of fate—the suicide of my mother during my time with Weaver—I learned how to depict my chosen theme for that semester, death. My elaborate paintings hadn't captured the subject at all, he told me. When I showed him the drawing I did of my dead mother, he confirmed: "That *is* death." Observe and report directly. Go to the subject and see.

Your comics communicate by implication rather than explanation . . .

"Explanation"? That's believing, which seeing is not. Sharing visual experience, showing evidence, directing attention—offering observations for consideration— that's my lot. A recent story from a famous physicist had Plato telling Socrates that there were no "principles of thinking." Only insight to be shared. I don't believe anyone's "explanations" . . . certainly not my own.

How much visual sophistication, and intellectual participation, do you expect from your readers?

I like Otto Rank's view that the artist is a surrogate "experiencer" of life, redeemed for stepping aside, avoiding society's given roles by reporting to that society, allowing it to see and know itself in the recognition of things that have been too quickly passed over in a busy life. "If your art rings true, they'll be in support of you," I once paraphrased Sue Coe, an artist that I profoundly admire. Sophistication and intellectual capability are often blindness, perhaps. I show my journals to people who do not claim these attributes; they often value seeing them more than self-consciously "smart and savvy" types. It does help to know something and to be ready to think.

Your rendering and placement of text is very unconventional; what factors do you consider when combining word and image?

I try to slow the "quick read." I'm rather bored by the concise and simplified, even the "clear." Life isn't that way. As Larry Rivers said, "Life looks busy to me." Life is a fascinating puzzle. So are some people. So is some art. What makes one stay with a mystery when "explanations" abound? Perhaps I'm just destined to reach out to others who, like me, lack the sophistication, etc., to appreciate the simple, the quick and the . . . *visual sound byte?* I teach that icons, for all their memorability and fast recognition, completely fail to achieve credibility. "You know what it is—*but, you don't care.*" You have to have the iconic power of the focal point—George Washington, why are you standing up in the boat?—but the credibility of the shared visual experience is equally important if you want to create "the suspension of disbelief" . . . emotional identification.

Parting with Scott McCloud's "icons rule" and Weaver's inspired shorthand—"I want it to look like I did it in 5 minutes"—I'm with David Hockney: Why should anyone look at something longer than it took to create it? Giving one's time to a piece sends an endorsement of sorts: this was worth my time . . . perhaps it's worth yours.

How did you go about creating and developing your Assassinada character?

"A.K.A. Me," as I once put it in a strip. She's a combo of the various parts of my personality and my experience of life. She's female in a medium dominated by males—from comics to Western civilization—because she is an outsider, an "other." Also, I am profoundly formed by my experience with women. My mother's ideals haunt me

as Assassinada's mom's drive her. Jung, Freud, my lovers . . . it's all in there. A copy of Leni Riefenstahl's "People of Kau," left to me by an important ex, linked with Third World experience in Africa to create a character device that made guile impossible for Assassinada. Her blush response makes triangles appear on her skin. She's an ineffectual everyman, directed by ghost Mom to be a champion, but unable to fill the bill. She's into Mom's stuff . . . politics, justice, Native American studies and the rest of it. In "Slidehouse" she tries to stop perverse corporate corruption only to become its victim. Ah, well . . . 'tis a story to think about. Wish I could have told it better. Her first appearance, by the way, was in an adaptation of *Marat/Sade* in which she was Charlotte Corday/Lee Harvey Oswald (!). Her original name was "Appassionata," a bow to my mother's spirit and love of Beethoven. A co-writer suggested the name change and it stuck.

What's your primary goal in maintaining your journals?

I was determined to understand my experience and learn how picture making could help me do that, for myself and as "graphic R & D" for others. When I went with Robert Weaver to a copy place to make copies of his incredible journals, the practice was vulcanized for the rest of my life. When Bob took out his checkbook to pay for the copies, he had to bend over it, holding his thick glasses just inches from the paper. It was the only way the man who had taught me to see could see. Epiphany. Weaver. Journals. See.

The Marat/Sade Journals and much of your subsequent works are about thoughts and feelings more than actions; would you recommend that other comics artists pursue similar approaches?

Comics are oversaturated with action. I am interested in internal matters. However, *Marat/Sade* is about an act: the killing of Marat by Charlotte Corday. It is played against a bloody historical period of killing. As the son of a killer (suicide, it is said, is the murder of the whole world), I am in opposition to killing. That position dominates my work. No to killers, whether they inflict physical or psycho-logical death.

What aspect of the comics medium is most in need of reform, and how would you suggest it be improved?

One, lose the term. It makes all our efforts those of fools and clowns. Two, grow up. Less juvenile attitudes. (Comics has drifted towards *infantile* attitudes, these days,

even more sadly.) Three, lose cartooning. No matter how brilliant cartoons can be or have been, cartoons impede seeing, reduce truth to ironic gags and encourage the dominance of words over pictures. Observation is the antidote to the reductive icon. Four, the independence from the marketplace must be maintained. The eagerness to sell to Hollywood or Sony or any other deep pocket entity destroys the freedom of the form to express the alternative viewpoint. And five, storytelling is overrated. Narrative can be very linear. Investigate other ways to communicate truth.

You have a vast army of successful former students: Dan Clowes, Peter Kuper, Scott McCloud, Bill Sienkiewicz, Kent Williams, George Pratt, Jon J. Muth, John Van Fleet, Bill Koeb; what did they get from you that is key to this success?
Most of the students responded to my passion for illustration, not comics. Almost all of those you mention have taken illustration standards to the media of comics on their own. I was somewhat unique in that I approved wholeheartedly of that effort, while other teachers dismissed comics entirely.

How would you advise students who are struggling to transform their darker, more disturbing emotions into sources of visual narrative?
Peter Weiss spoke of the seduction of personal darkness in his own (visual) work. During the Nazi years, Weiss ignored the horrors of the streets outside his closed doors. Later, in admiration for others who dedicated themselves to changing the world, he renounced his dark personal melodramas and tried in his playwriting to compare the two, hence: Marat versus deSade.
Marat:
"Against Natures silence I use action
In the vast indifference I invent a meaning
I don't watch unmoved I intervene
and say that this and this are wrong
and I work to alter and improve them . . ."

To illuminate darkness—in the person, in the art, and ultimately, in the world—is a worthy goal. One must see darkness to illuminate it, perhaps. Art— yes, and that includes "comics"—is that mirror, that crucible, that turns on the light without which we cannot see and reveals the chemistry that nourishes or poisons us.

I take offense at complaints about the "darkness" of an artist's work. Darkness is in the world. We artists "invent a meaning" and "intervene," it seems to me. Rather than providing trivial distraction, we are—to return to Otto Rank's ideas—those neurotics with a purpose, seeing behind the veil of mass denial, with something to do that keeps us from insanity or self-destruction. Something that may provide the same service for a readership or a society. (Say it with me, cast:) "The important thing is. . . ."

Learning to Get "Real"

Bill Sienkiewicz

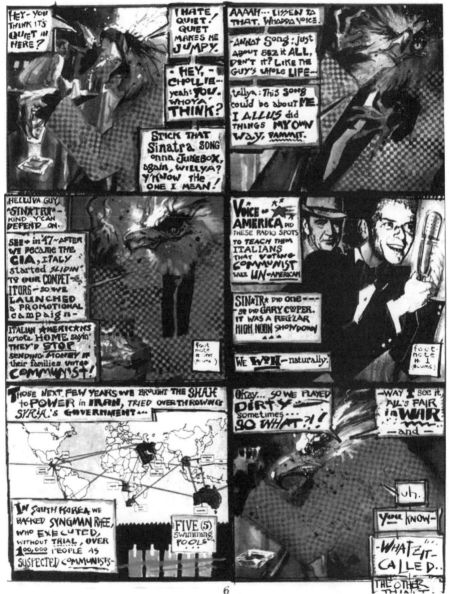

6

© *Bill Sienkiewicz*

What was your biggest revelation about the comics medium back when you worked on titles such as *Moon Knight* and *New Mutants*?

The revelation seems like such a simple, silly one now. And obvious. When I first started pushing out of the whole "clone" stigma, especially on the late mid-transitional issues of *Moon Knight*, I was upset that what I was doing somehow wasn't "real" comics. What Gil Kane did was "Real Comics." What Neal Adams, John and Sal Buscema did was "Real Comics." I was doing something different. I didn't know what, actually, or if it would be accepted or understood. After "Hit It!"—*Moon Knight* 26—came out, I looked at the cover of the issue and saw the corner symbol box with the character of Moon Knight with raised fist standing above the price and Comics Code. The word MARVEL was emblazoned above the figure. So it "hit me": if my work was actually in print, had my cover and interior art with my name on it, and if it had the whole corner box thing going on, and people read it, then suddenly, I allowed myself to feel that I had a valid way to do comics. Ergo, I was doing "Real Comics."

Hey, all those Real Comics guys I mentioned had the same corner box theme on their books, and their comics were indeed real by my reckoning. So by association, mine were real as well. It was a minor epiphany, as simple as it sounds now.

Describe the process of development from emulating to assimilating the work of other artists.

Study It. Copy It. Learn from it. Take what works and channel it through your own experience and abilities. Then: Let it go. Forget it, but know it as a part of yourself. It's a Zen thing. And someone will do the very same thing with your work. An endless cycle. It's the natural order of things.

How did your collaboration with writer/artist Frank Miller on *Daredevil* and *Elektra* differ from your experience with other writers?

Frank and I challenged each other by keeping it very flexible. Frank's script excited me and prompted me to try something new. Then my work would cause him to rethink and rewrite his script. We would go back and forth. It was all very organic.

What motivated you to write your own stories?

I'd always written my own stories as a kid. When I went pro, the division of labor (pencilers, inkers, letterers, etc.) classification was the defined way. So I was "classi-

fied" as a penciler. And since art was something I always wanted to do, I went for it, working with other writers to learn the craft of professional comics and the art of collaboration. My own stories may be less straightforward, denser, and more open to subjective response than most stories. More like tone poems, or lyrics. More David Lynch than *David Copperfield* (the book, not the magician). But I felt a burning absolute need to write *Stray Toasters*. And the need to create is incredibly important. It took so much out of me, because it was from the core of my being. To me, comics are an incredibly personal, and revealing form of work. I've done a great deal of advertising and illustration and design work over the years because I really enjoy many avenues of interest and places to play with the forms and expectations therein, but I've not given myself the opportunity to do another book completely my own. I'm really feeling the void, so I'm currently angling to open up some time to do work for myself again. And I have only the vaguest idea what I'm going to be doing, and that's just the kind of scary, beckoning exhilarating unknown *and freedom* that I love.

Toasters was extremely innovative and sophisticated when first published; to what extent were you concerned it might not find a receptive audience?

Well, at times, of course I hoped people would like it. I think that's just human nature. If not that, that they would respond to it in some way, and not ignore the hell out of it. But those were fleeting thoughts. Because to give those concerns any more credence would have been paralyzing. So to answer the question with that caveat aside, I was ultimately, in the doing of it, in creating it, concerned not at all.

For me, the big deal was actually getting it done and out there with my name on it. To succeed or fail on my own terms. I needed to just go for it, my way. Hold nothing back. I'd learned that the work will have a life of its own, and will attract like-minded readers, or not. So it was out of my hands. I let my expectations go.

What comic book conventions do you view as sacrosanct?

Actually nothing is really sacrosanct. Each work must be taken on its own merits. Does it succeed in what it set out to do? Not compared to something else, but in and of itself? Basically it must be true to itself. Readers can tell.

Oak cannot be pine, and pine should not be judged for being "not oak."

How are you currently utilizing computers in your work? Have you found ways to "humanize" the technology?

Currently, I'm back to painting or drawing most all the artwork, and scanning in any and all pieces and working on them on my computer before sending off the final version on disk. Original art may be one piece of artwork or a composite of twenty separate elements. So I suppose the fact that the work is done by hand helps it look more "human."

What do you perceive for the future of the comics art form?

For the foreseeable future, I can't see them done without being printed on actual paper. The feeling of heft, the tactile sense paper has is something people need, at least until enough generations pass and the familiarity with the tactile sensation disappears. And I think readers like the feel of holding something in their hands that won't "break" like a computer screen can. Comics have a benefit of panels being read in a linear fashion, but also backwards or in any order, each page rescanned and reread at the reader's whim, words and pictures being taken in simultaneously.

Aside from that, comics can inform readers, so I see them as a valid journalistic medium, as well as historical, political, what have you. Joe Sacco, Art Spiegelman, Garry Trudeau are purveyors of the best of those directions.

I also think comics will become even more a part of the entertainment "machine," certainly as far as source material is concerned. The capacity for comics to be accepted more as a valid art form will rise as more successful movies and games based on comics are produced. As usual, I think financial rewards will equal a level of respectability and desirability of comics as source material. Of course, not all comics will strive to be filmed. Many will continue to be produced, read, and taken in for what they are: an example of a viable and unique art form in its own right, and a medium as inherently valid and vibrant as any other.

Interview
The Need to Do Something Different
Dave McKean

Berkshire College of Art and Design emphasized conceptual thinking; has semiotic theory helped your comics career?
Definitely. Every choice comes loaded with implicit meanings and interpretations. I think this forces you to think carefully about your choices, and to be responsible for them. I am aware of what I'm doing, I'm trying to be accurate in what I want to say and in the emotional effect these images, and combinations of images, have on others. Mixing in factors such as "play" and "luck" and "randomness" help to keep things fresh and keep me excited, but without a clear sense of how these elements fit into the whole, they are only self-indulgent.

How have you benefited from working on established DC characters such as Batman and Black Orchid?
I think I realized early on that my aim was simply to be able to do the creative work I wanted to do and to maintain some sort of career doing that; that is, to be able to make enough money to live off that work. You usually start with two strands in your work, the personal stuff that is important for you to do—the work that encourages you to grow—and the work that pays the bills. The aim is to bring these two strands together. I think doing a couple of years on *Black Orchid, Arkham Asylum,* and *Sandman* just helped to bring those strands together quickly. My work was seen by a lot of people and made an impression quickly. I also realized early on that I don't belong in this area. I have no nostalgic feelings for these characters and so I end up fighting against them. I think Batman should be drawn by someone who really has a feel for the character, not by someone who really rather wishes it was something else. One of the few positive things to come out of that period was spending some time looking at real people, how they move and express themselves. I always intended for this realistic style to be a starting point, certainly not an end in itself. But as a way of stripping away my preconceptions about how comic book characters should look, it helped me move on to more expressive personal comics in *Cages* and *Pictures That Tick.*

The literal approach to comic book covers was practically an immutable law up until the time your first *Sandman* covers—

suggestive and symbolic—were published; how did you manage such a radical break from tradition?

It depends how you look at these things. I wasn't looking at other comic covers, I was looking at book covers and CD covers, so the *Sandman* covers are pretty tame by comparison. I had also started to do a lot of CD covers at this time, so I got more interested in design and typography. Also, the interior illustration was continually changing, and still very literal. I felt obliged to give the series some consistency and also a feeling of stepping through into Neil Gaiman's dreamworld. The covers were filters between the real world and this other version of reality. Also, I always treated the *Sandman* cast of characters as symbols. I always thought it was a shame they became rather templated and literal inside.

How did you come to use a variety of visual techniques, from lavishly textured paintings to delicate, economical line drawings, within the same book?

Obviously you can tackle different scenes in different ways, but usually the emotions in the story, or the context for the scene, implies an approach. I do like to try different styles, so that need to do something different will sometimes have an influence.

Your comics make extensive use of photography; what are its primary benefits for you?

My use of photography has changed over the years. Initially I loved the subtle information you got out of photo-reference, the subtleties of gesture and expression and light and shadow. I enjoyed working with actors or friends who would pose for me and contribute something to the characters.

Now though, I don't want the image to be dominated by the sense of the photograph. I still take reference photos or videos, but the drawing usually extends way beyond the literal proportions and over-fussy detail of the photograph. I'm after a concentration of sensation, but without relying on the stock shorthand of cartoons. Don't get me wrong, I love cartoons, but personally I enjoy trying to find fresh ways of dealing with my characters.

How do you envision the potential of photography to advance the comics medium even further?

I think it's a useful aid for observation and adding elements that are outside of yourself. I'd hate to feel that I know everything about how people move and talk

and how light falls on everything. I think that is why many comics look like you've seen them so many times before.

I also think photo comics are interesting. Since almost everyone takes photos and then uses them to tell stories, document a wedding or a holiday, etc., I don't know why there isn't a greater exploration of photo comics. One of my favorite comics creators is Duane Michals.

How have comics provided a training ground for your other ventures, such as children's books, interactive media, and motion graphics?

This is the one piece of advice I try and give art students: learn to write. That is, learn to organize content, to be aware of how people read information or stories. Comics are a wonderful medium if you think narratively and enjoy exploring an idea.

What do comics allow you to say that no other text or visual medium affords?

I think at their best, they are a powerfully personal medium. There is a direct intimacy in a comic, visual and literate, that can't be beaten, really.

Interview
The Whole-Brained Approach
David Mack

What is the most valuable lesson you've gained from your formal education?

Well, I didn't go to a specialized art school. I went to a university for five years. So that played a huge role in my work in that I was exposed to so many diverse ideas and interests. I started college at seventeen and I had already decided that I would be doing comic books. So I was able to approach each class from the perspective of gleaning something useful that I could directly apply into my work. My writing and art.

Ultimately, I graduated with a BFA in graphic design and a Minor in English. So of course I had to take all of the art classes from every level—photography, sculpture, painting, drawing, printmaking, art history, etc.—and many writing and literature classes. But I also took history, acting and theater, the Japanese language, mythology, world religions, karate, chemistry, anatomy, and physiology, where we had to memorize every bone and muscle of the human body, and we dissected people. So I was learning the internal structure and mechanics of the human body at night, while attending figure drawing classes by day to learn the form and volume and light and shadows of the external structure. I feel this internal and external approach to learning the human body was very helpful and impactful in my early formative years.

And graphic design was taught as a synthesis of type and image. I learned a great sensitivity to type in those classes and I try to apply that sensibility of type and image synthesis into my comic book work.

This diversity of disciplines and information broadly and deeply informed my work. Probably more so than if I would have gone to a specialized art school.

But I also learned to follow my intuition and instincts. I learned a right-brained and left-brained approach. I like to think of myself as whole-brained. Sometimes you just have to trust your ideas and follow them, even though you can't completely understand them beforehand. You learn that your ideas are smarter than you are, and the dots get connected in the process of the work. You can't always figure it out ahead of time. It is in the process that the real magic happens. So don't stop yourself before you begin. And don't wait for validation or approval from someone else before you do the work you need to do. You do it first, you write or draw it first, and it becomes real afterwards. The act of that writing and drawing is the act of making something from nothing.

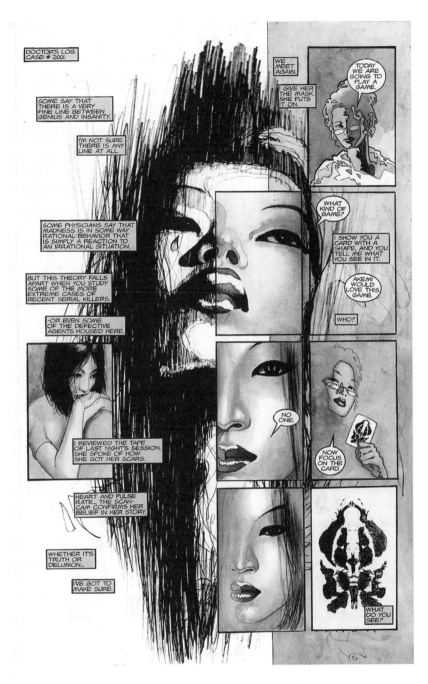

© David Mack

Something is born in the process: you are taking an idea from your head and suddenly giving it existence in the three-dimensional material world. When you practice it enough, you realize that concept is a blueprint for accomplishing anything. Making anything real.

In addition to story sequencing, your richly layered panels add another narrative dimension; how did you develop your collage approach to storytelling?
For each story I do, the style and nature of the art is dictated by the nature of the story. I begin as a writer first and use the art as just another tool of the writing. I choose what art style, art media, storytelling pace, and rhythm that is going to best communicate the tone and atmosphere and language of the story.

So there is a certain amount of rational or academic thought that goes into the planning stages. But at every level there is also margin for improvement, spontaneity, and intuitive decisions, and gut level choices.

And I love contrast. Much of the rhythm of the storytelling and the art media is based on contrast. Something simple and sparse looks good because it is next to something layered and textured. Something abstract looks good because it is contrasted by something more tangible. Much of the storytelling and layout and pacing of a comic book is like writing music. You are developing a rhythm that goes up and down on the scale and takes the reader's emotions and imagination with it.

How did *Kabuki* evolve?
Kabuki was my answer to my decision to do comic books. All my life I had made things. Stories, sculptures, paintings, drawings. And I had great passion for learning and doing. I love everything, and wasn't really interested in specializing. At a certain point in high school, teachers like you to fit your interests and passions into a box that you can at least major in, but I wasn't comfortable with the idea of only doing one thing to the exclusion of others. When I was sixteen I was applying for a university art scholarship. A teacher suggested that I put together a portfolio showing ten different media that I worked in. I had photography, sculpture, oil painting, watercolor, charcoal, etc. For the tenth piece I decided that I really wanted to do something that dealt with the nature of time and sequence. I loved film, and I loved books, and the personal nature of books, and I also loved to read comic books. So I decided that I would make a comic. And I did. I wrote and illustrated and lettered a fifty-five-page book for my scholarship submission. And in the process of doing

that, I realized that the medium of comic books is a format that I could integrate all other mediums into. And I realized that comics was the medium I could work in, because it had no limitations and it encompassed aspects of every other medium.

My work on *Kabuki* began in January of 1993 when I was twenty years old. I began publishing *Kabuki* in 1994. Having decided the medium I would work with, and having worked in the business for a couple years to learn the craft, I decided that I wanted to create a comic book in which I could incorporate all of my personal philosophies, my passion for learning, and integrate my everyday personal experiences. I loved autobiographical comics, but I was not yet comfortable with that idea. I wanted to tell personal truths but at a distance, through the unselfconscious comfort of a veil. But I did not want to fall into the trap of making the main character an idealized version of myself. So I decided I would make all of the surface details very opposite, and that way the universal truths could shine through. And I could tell the story through metaphor. This way, instead of reading the story and seeing me, readers could find their own personal relation to the story and see themselves.

So I made the main character the opposite gender. I set the story in a different part of the world, with a different language, different history, and different culture. I was in university at the time, and I was taking the Japanese language, and learning Japanese history and mythology in my classes and in my own travels. So I used that as a framework for the story. The structure of the story is the traditional structure and metaphors of the traditional Japanese Ghost Story that is the subject of many of the Japanese Kabuki plays.

Much of the first *Kabuki* story is myself as a twenty-one to twenty-two year old dealing with the death of my mother, just as Kabuki is coming to terms with the relationship and death of her mother in the story.

You've described your comics as "interactive."
For me, comics are a collaboration between the reader and the creator. For me, the artwork and story are not on the physical page. The physical page is just an artifact. It is a navigational device. It is the equivalent of a road map. And it is as different from the actual art and story as a road map is different from the actual geography that it is suggesting. By the nature of sequential art, the reader's mind is filling in what happens between the images that I present. The readers are bringing their own past experience and perspective. The artwork, the story, happens inside the readers' mind when they read the book. That is where the real magic happens. Between the panels. Around the pages. Between the turn of a page. I don't believe

my story or art is finished until someone reads it. And I believe it is a different story every time they read it. It rewards repeat readings, and you will see a different layer every time it is read. The reader is at a different stage in their life in the repeat reading, and will see a new texture in the story.

Kabuki's art has evolved with its character; how do you maintain your impulse to constantly reinvent yourself?
The character grows as I do. I have evolved personally in the process of working on the character's evolution. And that personal evolution, and exploration of new interests, is channeled right back into my work. I think of the Kabuki story as a biography of this character. And each volume is a different era in her life. Though each volume fits into continuity and builds on the previous volumes, I also make each volume, each era in her life, have its own unique visual atmosphere, and rhythm and theme.

What's your advice to artists who want to develop a self-owned comics series?
My advice is to just do it. You might first ask yourself what you want out of the project. What is the personal purpose and the nature of the work for you? Maybe write down a list of things you want to explore with it. And use that as the structure to build your story. But after you think about it, and ask those questions, make sure you follow through with it. Some people just talk about it and never start it. Some people start it and never finish it. Some people finish it and never show it to anyone or turn it into a book. If you just do it, and keep doing it, a lot of the answers to your questions work themselves out in the process. The process is where you want to be. You want to be in the act of it. Don't think of it as a noun. Think of it as a verb. And constantly be in the act of doing it.

Alternative Comics

The Education of an Editor

Monte Beauchamp

As I entered grade school and started reading, writing, and arithmetic, an education of a most peculiar kind began outside the classroom.

It started one Saturday in 1960 when the new *Tales to Astonish*, featuring "Groot, the Monster from Planet X," was ripped from my hands by a friend's father, rolled, twisted 'til it resembled a penny piece of licorice, then handed back to me with a warning: "If you ever bring a comic book onto this property again, I will beat the living daylights out of you." To say I was rattled would be putting it mildly.

Soon after, cartoons landed me in hot water again, this time for bringing *Mister Foney's Funnies*—gum cards that parodied products—into church.

Sometime in the fourth grade I became addicted to *Mad, Cracked*, and *Sick*, and my homework suffered badly for it. After I brought home a fall report card littered with Cs, Ds, and Fs, every cartoon mag vanished from our basement. Distressed, I ran out and got the new *Mad*. While absorbing its humor after dinner that evening, my father asked why I preferred "it" over *Archie*. "Because of the wild cartoonists," I told him.

Later that week, *all* comics were banned from our household. This, in turn, led to me crayoning my own *Mad*-inspired monster drawings.

On Christmas day of 1965, mom, aware of my Crayola cartoon creations, gave me a copy of Jules Feiffer's *The Great Comic Book Heroes* (much to my father's chagrin). Its portrayal of the dawn of the comic book industry, and the homespun efforts it encouraged the youthful Feiffer to make, inspired me to try to follow in that comics pioneer's footsteps.

Monthly, I began scouring secondhand shops for early editions; from dime stores I smuggled in the new. Libraries were no longer for homework, but for researching comics history instead.

Daily, I copied *Mad*, Marvel, and DC styles. I started all over upon the arrival of *Zap*. I immersed myself in all of them, but cautiously; their public personae made them seem more dangerous than drugs.

By twelfth grade I was a walking encyclopedia of comics and cartoons, but as a soon-to-be graduate I felt like an utter failure. A career in comics was what I wanted

but nearby colleges offered no such courses. Raised in a small river town, I couldn't see beyond small-river-town ways. So upon graduation, I abandoned (along with formal education) my dream of becoming a cartoonist.

That summer I hitchhiked across the country a bit, sleeping in cornfields, meeting kindred spirits along the way. Eventually, a job in cement construction beckoned me home. Several months later, I was foundrying at the local John Deere.

Whenever Alvarado, a fellow John Deere ex-employee, came home from college, he'd ask to see new drawings; but there never were any. "That's a real shame," he'd say as we blathered over beer. "Come on down to Southern . . ." BURP! ". . . and major in art."

Alvarado's constant badgering for me to join him in college didn't mix well with my blue-collar lifestyle. I grew conflicted, often pondering what life was for. Like the title of the latest Pink Floyd album, I felt as if I had landed on *The Dark Side of the Moon*.

Finally, I took Alvarado's advice.

He and I roomed together, majored in fine art together, and became graphic design majors together. We cartooned for campus publications together, and even wound up together as art directors in Chicago.

In the new-found world of advertising, to my surprise, there existed phenomenal cartoonists I'd never heard about before: Lou Brooks, Elwood Smith, and Seymour Chwast, to name a few. Here was work that was fresh and poignant, brilliantly styled, and radiant in its visual panache. Not only were these cartoonists paid well, but also their work garnered them respect. Brooks did Pop Art better than Lichtenstein; issues of *Pushpin Graphic* (featuring Chwast) excited me more than *Raw*; Elwood went way beyond *Krazy Kat*.

Totally inspired, I aspired to utilize such talent over the next few years, only to learn a disparaging lesson about Midwestern ad execs: nearly all wanted safe, homogenous styles; conceptual cartoon imagery ventured into realms most just never could.

In response, I self-published a one-shot fanzine called *Blab!*, and nineteen years later—with *Blab!* now in a deluxe, 10" × 10" color format—here I still am: mixing and mingling, blending and bending assorted styles, formats, mediums, genres, and techniques.

What has working with exceptional talent—including Brooks—in the pages of *Blab!* taught me? That by eliminating boundaries, the possibilities are endless.

And what does my own particular journey have to teach you? That without encouragement in the face of adversity, the possibilities may never begin.

Interview
Arranging Sights and Ideas
Gary Panter

You grew up in Texas; wasn't your parents' church opposed to making graven imagery?
The church building was devoid of imagery but everyone had a TV. Every little Church of Christ is independent and believes slightly different things. The main things are that you have to be totally immersed in water to cleanse your sins and that everybody else in the world is going to hell. It gives you a lucky feeling to be going to heaven while everybody else burns.

You became known as the king of the ratty line when you did comics for the punk paper *Slash*; how did this line come into being?
As a child I was very shaky. I don't have complete control over my drawing tools and arms. Perhaps it was drowning in the sink when I was one year old. I do remember drowning. Lucky for me, my dad beat the water out of me.

How do you keep your Jimbo character from getting old or stale?
I'm always afraid he is old and stale. Jimbo is an observer. He is not very willful. His drives are simple. He is not stupid, but he is no genius. I use him to observe the places I put him in, which are satirical social, technological, and control situations.

Comics are a major part, but not the only aspect, of your creative life . . . painting, sculpture, light shows, and more figure in; how does each nourish the others?
I really love to make all kinds of things. They are all part of the same thing: arranging sights and ideas. I grew up a fan of contemporary painting, which through the seventies embraced more and more outlets and activities.

Your art styles run the gamut from virtually classical to primitive; how do you rate yourself as a draftsman?
I'm a pretty good drawer. I am not amazingly facile, like many of my friends, but I am comfortable drawing and able to notice and capture a lot of flickering ideas that are easy to forget. My figure drawing is flawed and I am still trying to learn how to get Jimbo's feet on the ground in a convincing way. I can draw in many, many, styles and invent styles to serve ideas.

In your most recent work you have Jimbo traversing Dante's hell; why did you decide to make your "opus" a retelling of this classic?
It has been a lifetime of work thinking about the strengths and weaknesses of believing in god or the gods. *The Divine Comedy* is really analytical and smart regarding those topics. I read a defiant and rational and humorous and sexy subtext there. Also I am not well-educated, so it was a project that would allow me to read a lot. *Jimbo in Purgatory* is also about reading, particularly the wisdom of satires.

What would you say to a young artist who passionately wants to do what you do?
Don't expect to make a living from it. And get a good lawyer before you enter into any showbiz territory.

Learning from the Master

David Sandlin

I grew up in Belfast, Northern Ireland—my mom is Irish, my dad American—and I remember as a child being sent to the corner news agent on the Falls Road to buy mom her "scary stories." She loved pulp culture: Hammer horror movies and comic books with titles like *Journey into Unknown Worlds* and *Strange Adventures*. I think some of them were British reprints of American EC horror comics. Of course I always peeked at the macabre and morbid images within, but nothing really clicked until one day at the newsstand there was something just for me: *The X-Men* . . . Kirby, color, Marvel, America!

Jack Kirby's action panels and amazing collaged double pages were the first "art" I ever saw. Up to then, about the only stuff I'd spent any time looking at was my children's illustrated Bible. Kirby was just over the top: foreshortened figures with arms and legs popping out of the panels, faces that looked lived in, tragic monsters like the Thing and the Hulk. These images, combined with Stan Lee's snappy dialogue and irreverent humor, made me feel I was being shown the real America—action, optimism, shtick—complete with a subversive self-debunking hero/antihero. But even beyond the characters and dialogue, it was the color, the ink on paper, that got me. I could probably trace my love of printmaking and populist forms of art back to when I realized comics were made by the millions, for millions of people to see, yet they still seemed unique and aimed straight at me.

As a teenager, I'd been fascinated by *Mad* magazine, especially the satiric stuff by Jack Davis, Wally Wood, and Bill Elder. I was also really interested in music and reading a lot of the English music magazines like *Sounds* and *NME*. The comic-book characters and scenarios I'd drawn as a kid started to get mixed with renditions of David Bowie and Marc Bolan, along with more underground comix-inspired art I saw in the back of the music magazines. As I learned to draw more realistically, the comic-book stuff eventually faded away, except for a cartoony aspect inspired by Kirby's dramatic exaggeration.

In the early seventies we left Ireland and moved to Alabama. When I went to art school, I looked at Pop Art to try to understand America, and American culture. Of course I was interested in Warhol, Rivers, Oldenburg, Rosenquist; basically New York Pop Art. But something was missing. It was too cold. Then I found the Hairy Who and H.C. Westermann and Peter Saul, and their stuff made me feel like I was on the right track. To me, here was art about America that wasn't trying so hard to

be cool and hip. It was quirky, subversive, and smart-ass—not afraid to get down and dirty with popular culture. This art seemed to be made by fans, participants—it reminded me of what punk rock was doing at about this same, another form of art that was engaged and populist. It proved that formal innovation and content didn't have to be mutually exclusive.

I knew I wanted to make art, but when I moved to New York in 1980 mainstream art seemed totally disconnected from real culture. The artists were willing to appropriate from culture but not participate in it, and I didn't feel like I had anything in common with most of them. Fortunately I found *Raw* magazine. When I saw work by Gary Panter, Charles Burns, Mark Beyer, and Art Spiegelman I felt they were kindred spirits, artists for whom punk, the funky Chicago artists, even Kirby, mattered. I saw art that dealt with high and low in the same irreverent way. I was making drawings and prints and some paintings, and I was showing around in the East Village, mostly with Gracie Mansion Gallery, and I found like-minded artists in that scene too. I used silkscreen printing as a way to make cheap multiples—posters, bumper stickers, decals, small books—that I could slap up on walls and leave around places for anyone to see and carry home or put up wherever.

It dawned on me that in addition to loving the accessibility that comics offered through mass production, I loved the form, narrative storytelling. My next move was to create a complete world for the characters I was already using over and over, and from there, things started turning into books in addition to painting series. Since the early nineties I've been making silkscreen books, bits and pieces of which have also taken form as comics in various magazines, such as *Raw*, *Snake Eyes*, *Nozone*, *Zero Zero*, *Blab!*, and *Strapazin*.

In my paintings and installations I've tended to use narrative as a device more for symbolic commentary and provocation than for storytelling. However, in my books—since they are books—the images have a more linear thread. I admire the way writers like James Joyce, Vladimir Nabokov, and Samuel Beckett played around in their works, especially in using the unreliable narrator and making the reader interactive in the outcome of the novel. I've tried a number of experimental narrative devices in my *Sinner's Progress* book series. In *Road to Nowhere . . . Road to Pair-o-Dice*, for example, the reader is given a number of choices about how he or she approaches the story: The book is two-sided, so you can follow it from either end, and you even choose whether your protagonist is the truck driver (sinner) or the religious novelty salesman (saved). It is also interlaced with a board game through which the reader can drive the narrative by playing with dice and game pogs.

The most recent book of the *Sinner's Progress* series is more political than previous volumes and driven by current events in America. It's a power fantasy by the main character in the series and takes the form of a pulp comic, complete with cheap printing and a price to match. Since it's a comic book, I realized that I couldn't goof around with narrative like I did with the others; I had to follow a real story line. By way of research, I've been getting a lot of Jack Kirby's comics from the 1970s—stuff he did after I'd stopped buying comics as a kid—and I've become inspired all over again by his unique drawing style. And in his later work especially, the narrative atmosphere is still really powerful. It's less optimistic than in the early sixties and sometimes downright apocalyptic. But that's right up my alley . . . and it's never too late to learn from the master.

The Birth of *Leviathan*

Peter Blegvad

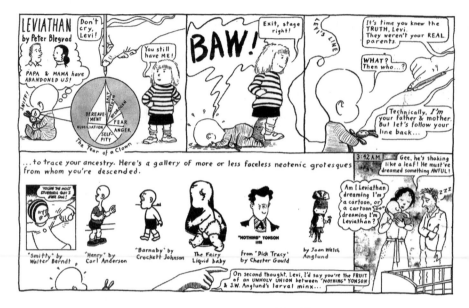

© Peter Blegvad

I'm the product of a union between an author and an illustrator, which may explain why text and image always seemed natural bedfellows to me. I like their symbiosis, how they combine to create objects that aren't quite the sum of their parts. I like artists—Marcel Duchamp is the paradigm—who flout the decree that art must not be "literary."

My father, Erik, has illustrated more than a hundred children's books. My mother, Lenore, has written several. My education began with their examples and encouragement. On the shelves of our home in Westport, Connecticut, circa 1963, were *New Yorker* albums, Steinberg's *Passport*, books by James Thurber, books illustrated by their friends William Pène du Bois, N.M. Bodecker, and Maurice Sendak, and by colleagues like Edward Ardizzone, Edward Gorey, Domenico Gnoli, Garth Williams, Tomi Ungerer, etc. My father, an anglophile Dane, exposed me to European graphic artists unknown in the U.S.: Ib Andersen, Sikker Hansen, and the great Robert Storm Petersen (popular and prolific cartoonist/working-class

hero). These guys were worshipped *chez nous*, as were whimsical artists like Roland Emmett and others who drew for *Punch* and *Lilliput*. And then there was the graphic visionary Palle Nielsen, whose *Orpheus and Eurydice* is a wordless linocut epic to stand with Lynd Ward's or Franz Masereel's work. They struck me as I was struck by the comics my friends and I had stacks of: *Peanuts*, *Pogo*, *Richie Rich*, *Archie*, *Weird Tales*, *Mad*, and the supreme achievement that is *Tintin*. We all drew imitations of our favorite comics (among which I particularly recall Don Martin's *Fester and Carbuncle* and a modest but poetic newspaper strip, *The Strange World of Mr. Mum* by Irving Phillips).

But most of what I drew, with my pal Huck, were epic comics about babies. In one frame a schematized tot would boast that he was less than a second old, while in the next he'd morph into an action hero in uniform, armed to the teeth, who'd be riddled with bullets, blown up by mines, plummet from planes and somehow always bounce back. In one memorable adventure of Huck's, his hero stormed heaven and toppled god. Despite their awesome feats and manly appearance (females rarely figured, and then only as an excuse for us to draw them naked) the true nature of the Übermenschen we depicted was this: they were infants in disguise who regressed at the drop of a hat.

"As a kid I drew.
All my friends did too.
But drawing was a phase
most of them outgrew . . ."

Thirty years later, in London, I wound up doing for a living what I'd done as a kid for fun, drawing a comic about a baby. Babies are natural "trickster" figures, straddling the border between cute and grotesque, form and chaos, between innocence and "polymorphous perversity." As St. Augustine put it, "If babies are innocent, it is not for lack of will to harm, but for lack of strength." Yet they're granted total exemption, *carte blanche*. We both envy and despise them for this.

How did *Leviathan* come to be? In 1990 a journalist neighbor came to dinner, happened to see some drawings I'd done to amuse my kids (toddlers at the time), and suggested I submit some ideas for a strip. The editor liked my prototypes—which depicted a faceless tot, a living *tabula rasa*—and, a couple of years later, *Leviathan* began his seven-and-a-half year run in *The Independent* on Sunday.

But there's another, maybe deeper source. In 1971, aged nineteen, I became so dysfunctional that my parents sent me to a therapist who told me I was going

through an "identity crisis." I was almost disappointed when he told me that I wasn't going crazy, I was simply *immature*. It then became my mission for many years to conceal my shameful immaturity from others and deny it to myself. The effect of this repression was that my immaturity grew monstrous down there in the depths and eventually erupted as Leviathan, the tot with no face, no I.D., named after an Old Testament sea monster. His was the image I gave to the complex of feelings aroused in me by the state of chronic infantilism which I now recognize is characteristic of our species as a whole.

"The world, it seems, does not possess even those of us who are adults completely, but only up to two thirds; one third of us is still quite unborn. Every time we wake in the morning it is like a new birth."—Freud, *Introductory Lectures on Psychoanalysis*

Interview
What's the "Big Idea"?
Mark Newgarden

**The Laffpix public service announcement on your Web site
emphasizes the "entertainment value" of cartoons; did you become
a cartoonist to make people laugh?**
I probably became a cartoonist to make myself laugh . . . or maybe just in a mis-
guided effort to keep myself from crying so often. The whole abstract, mysterious,
absurd concept of humor itself—in all mediums—has always fascinated me. As a
cartoonist I guess I've explored it as subject matter in and of itself, as much as I rely
on it as a mode of expression. What is "funny" anyway? Why is it that way? Or why
isn't it? I don't pretend to have any big answers to those kinds of questions but
when "funny" is funny, nothing is better. I find it a way more efficient and personally
satisfying means of communication than "not funny." Once you've succeeded in
having an audience agree with you on your own peculiar terms of what "funny" is
you naturally crave more of that; it's an intoxicating proposition.

What ingredients are proven laff-getters?
Suffering, regret, compulsion, humiliation, disappointment, betrayal, decay, death.
And big noses.

**Your work is pregnant, so to speak, with references to the past comics
conventions; is this an unlimited source of inspirational joy for you?**
The joy has its limits. Audience expectations of what comics are have changed a
whole lot over the past few decades. The tack that the underground comix pioneers
of the 1960s and seventies took—that the medium can accommodate a lot more
than the familiar set of generic conventions—has long since taken root. So the
game of playing with those old comics conventions for their own quaint sake is a
pretty limited convention of its own at this point. But many broader conventions in
content and technique persist and I think that's because they have a real inherent
value. A lot of them are powerful cultural conventions carried over from other
mediums and time-tested over the centuries. They persist precisely because they
work so well. Indeed, they are a treasured toolbox of sacred shtick to any practitioner
in any communication racket who knows how to make wise use of them. But you
need to have something personal and from the gut first to filter through them.

What makes a good comic? Conversely, what makes a comic bad?
There is obviously no quick prescription for what makes a good comic but there are a few key symptoms that persist: clarity, efficiency, precision, balance, visual intelligence, attention to structure, and some sort of integrity of content. But most importantly: having something up your sleeve worth communicating to your audience in the first place.

Bad comics usually have too little of the above ingredients—or sometimes too much.

Do you consider yourself a draftsman or storyteller? And can you be one without the other in the comics business?
I like to consider myself a cartoonist, which I suppose is some sort of alchemical mixture of those two disciplines. But I consider the "content provider" job to be the more crucial of the two by far, and the one I personally enjoy more as well. Your drawings shape and flavor the information; they need to be competent and clear enough to convey intent and interesting enough to attract attention, but your big idea is usually the reason for the whole endeavor in the first place. If not, you may be in trouble.

Of course, traditionally one can easily be one without the other in the comics biz—that's how most assembly-line comics were and are still made. In my experience in "the business" of comics outside those corporate venues, cartoonists are routinely penalized for all the extra work. Mass-market magazines may run comics more often these days, but they usually pay by the page space, not by the complexity of the effort. I've never earned anywhere as much money from making comics as I have from other sundry writing or drawing jobs in various media. But then again I don't know anybody foolish enough to get into doing comics to make a lot of money in the first place. If you want to make a lot of money I recommend entertainment law, white-collar crime, or real estate.

Should wannabe comics artists begin by launching a Web site, or is the old-fashioned method of making comics on paper still the best?
Wanna-be comics artists should begin by launching their brains first and foremost.

Once you think you are ready to share, there are way more venues, way more practitioners, and way less rules than ever before in the history of the medium—which is not necessarily as great as it all may sound. My guess is that it's a lot harder now to find an audience, much less keep one interested in you on a regular basis.

And regular, disciplined output for a return audience is the best way I know to fig-
ure out exactly who you are and where you want to go with your work. All the great
work in the medium was done for distribution to an actively receptive audience, or
at least for the expectation of one. Making comics is very hard work and it's hellish
and unrealistic to undertake that kind of work in a vacuum. So do your hard work,
get your stuff out there every possible way you can, stick with it, cross your fingers
and see what happens.

But keep your day job.

Graphic Novels

Revelations of a Pluralist

Chip Kidd

How did you become the impresario of comics publishing on a mainstream stage?

What I definitely am is lucky. The groundwork for what I'm doing at Pantheon had been laid a good ten years ago, with the publication of Matt Groening's early work and of course Art Spiegelman's *Maus*. Then there was something of a "regime change" at the imprint, and the comix "program," as it were, just kind of dried up.

In the mid-nineties Dan Frank, a senior editor here, told me that we would be publishing a new book by Ben Katchor (of whom I am a great fan). So I said "That's great. So . . . are we going to be doing this again?" And he said "I don't know. Should we?" To which I said "Definitely. And this is who we should publish next." You see, Dan was intrigued by Ben's work, but was otherwise new to comics. And Chris Ware is one of my very best friends, and I knew he was almost done working on *Jimmy Corrigan*, and the rest, as they say . . .

Your interests fall on both ends of the comics spectrum: alternative (Chris Ware) and mainstream (*Peanuts* and *Batman*). Is there a significant difference between the two?

There's an undeniable snob factor in the comics milieu that tends to divide people. The conventional wisdom says that you can either be into mainstream superhero stuff or the serious "alternative" artists but not both. As if we're supposed to pick sides. I think that's a real shame, because there is indeed excellent work being done in the mainstream arena, it just too often gets drowned out by the surrounding ocean of dreck. Which in my opinion is admittedly huge, but I don't see why we have to dismiss all of it altogether.

I think the great example of one phenomenon that overcame this is *Peanuts*. Schulz is the great unifier. I've found that he is the one cartoonist that everybody can agree on, from my seventy-year-old mother to your seventeen-year-old cartoonist who's squatting in the East Village.

What have you learned about comics through editing and designing books for authors as varied as Charles Schulz and Mark Beyer?
When you used the word "varied" you hit the nail on the head. I'm a great believer in what I call "pluralism" in terms of what we publish and what I work on. That is to say, as long as I love it, it can be anything: mainstream, alternative, traditional, unconventional, etc.

As for what I learned, it is what I learned early on in the trade publishing business: all books are different and all authors are different and you have to take your time to get to know each one and take it from there.

As a designer who tells stories through the juxtaposition of type and image, are you something of a frustrated comics artist?
Yes, I wish I had the chops to be an actual cartoonist, but I don't. I'm just not a good enough draftsman. It's not like I haven't tried, and who knows, maybe I'll give it another go in the future. But regardless, it's undeniable that comics have influenced the way I design.

What is the relationship between graphic design, as you practice it, and the design of comics?
Graphic design is graphic design, whether it's for a book jacket or a comics page. In my particular area of design, the suggestion of the narrative is more important than the exposition of the narrative itself, and that's where the difference lies. Comics have to tell a story. A book jacket has to get you interested in a story.

Are comics an art, craft, science, performance, or what?
They are all of that, and I would add sparkly. And a springboard to movies both high and low budget alike . . . whether we like it or not.

Interview
Acme Graphic Novelties
Chris Ware

What made you become a comics artist?
It's hard to say, but probably some blend of unwillingness on my part to cast off the last remnants of my un-constipated childhood inspiration, tempered by a genuine belief in the expressive power of comics as a visual language. I believe the way the adult mind apprehends and categorizes information is mirrored very directly in comics, which is sort of ironic, because comics are still frequently dismissed as juvenile, which has more to do with the expected content rather than the form, however. I think one of the reasons we adults can get overwhelmed and depressed is that we're always trying to make everything "fit" into our ever-sprawling conception of the world; we obsessively name and file away, rather than simply look, like we used to do as kids. Painters and sculptors can lead one back to a time of just looking, but comics can involve the mind *both* as a "categorizing" art and as a "looking" art. Or, more simply, comics are unique as an active visual art of reading, rather than one of just looking. Nowhere else do the aesthetics of a visual art so intimately rely on the reading of pictures, as opposed to just looking at them, I think. What the advantage of that is, I still don't know.

You are the most meticulous comics "designer" working today; where did this obsession come from?
Comics are fundamentally an art of composition, though sometimes I think they have more in common with music composition than with visual design. I really have very little interest in design, except how it relates to comics and typography; I'm just trying to compose something with as much variety, articulation, and texture as I feel in the natural world, with the same clusters of dense moments, open spaces, and repeating rhythms . . . and which I guess is a pretty old-fashioned and possibly pretentious, boneheaded thing to do.

What is most important in your work: the narrative story or the form?
The two are sort of inextricable, as I don't script anything in detail ahead of time, and frequently where I end up at the end of the page is completely different from where I thought I would; I sort of think of my cartooning like a creeping moss, or a vine, growing across the page, and it doesn't always grow where I want it to. Which is a weird and stupid way to work, I know, but I've tried it many different ways and

the results were always false and forced. Basically, I'm trying to write with pictures and allow the pictures to suggest and call up memories and associations that wouldn't otherwise occur with me just sitting around staring at the wall. This all said, I keep outlines and books of notes; I just don't write "scripts."

What would you say to those who claim that your work is rooted too much in pastiche?
I wouldn't know what to say. I can see all the little bits and pieces I've "lifted" from artists and writers I admire, and it constantly pains me, but what are you supposed to do? I'm not smart or talented enough to be one of those who arrives at everything fully formed; I doubt myself way too much to have the confidence and certainty necessary to work without hesitation. I just hope I'm not actually "rooted" in something like that, as you suggest. If I really am, I might as well quit now.

Your style is full of substance, but it is also an identifiable brand; what do you do, and can you do, to avoid it becoming too expected?
When I was younger, I worried about that sort of thing a lot, but found it always an impediment to working. Over the past three or four years, I've tried to shift my focus away from being anxious about visual reinvention to thinking about the shape of the storytelling, because, at least in my case, thinking too much about "look" makes for a brittle sort of result, and I want my cartooning to be analogous to the same sort of unconscious flow that writing or speaking has. This all said, however, the look of a comic story is inevitably reflective of the writer's or the character's conception and experience of the world, so I obviously do think about degrees of visual abbreviation, etc. I shift between two stories regularly, one of which is deliberately more experimental visually and the other more "literary"; in other words, in one story, the degree of experiment is slightly more of a concern than in the other. Regardless, I think it's a terrible mistake to think about style as something like a "removable appliqué" if one is an aspiring artist, writer, or even a cartoonist. That sort of thinking should only apply to people involved in the industries that revolve around fashion, where capricious shifts in the mass "taste" demand constant readjustment of the surface polish of a product.

Is there any autobiographical underpinning in your main characters?
Yes, they're all autobiographical; basically parts of myself, and memories of others and things I'd like to be and hope not to become.

Some comics are pure fantasy while others are metaphors for the real world; where do you come down in this dichotomy?

I've sort of shifted focus over the years in this, I guess; my early dumb "mouse" stuff was almost purely metaphorical, though I was frustrated by the limitations of that approach, so I started rather ineptly working in a more "representational" mode and haven't really stopped since. Maybe it's a mistake, though. I can't ever decide which is better, because I want to create something that has its own internal life, and just by doing something naturalistic, I'm already one step away from that, I think. Somewhere there's got to be a balance between the gem-like and the spaghetti on the floor sensibility, though. I see all fiction as pure fantasy, however—for me, it's the opportunity to bring people back to life, fix mistakes, or, more simply, set up a moral experiment and then see what happens.

Did you go to art school?

Yes, I studied painting, sculpture, and printmaking at the University of Texas at Austin and the Art Institute of Chicago.

What do you look at for inspiration?

I look almost exclusively to music and writing for inspiration, and at the work of other cartoonists who take their own stuff seriously, and frequently it's just for reassurance that doing whatever you want is okay . . . or, more accurately, paying attention to the ideas that seem stupid or wrong is okay, since frequently those are the ones that have never been realized before.

How do you strive to perfect your drawing?

At the moment, I'm not so worried about perfecting my drawing; in my comics, "drawing" is more like typography than real drawing, anyway. I'm most worried about making something that reads "real," if I can say that without sounding pretentious. I really worry about how it's all reading and fitting together more than anything else.

What would you say to a cartoonist who wants to work just like you?

First, I'd say not to, since what I do directly aims to smooth over the fumbliness and emotional handicaps of my own mind. Fortunately, however, the comic strip allows for an amazingly endless variety of approaches.

As for school, I'd recommend studying either writing or painting/drawing or both, but I don't know if studying illustration or design is such a good idea, as the education in those problem-solving disciplines generally stresses finish of product over any development of storytelling or personal expression. Then again, some fine art departments are so loopy that learning anything concrete about tools and image making is almost impossible nowadays. Who knows? I'm sure anyone going through either wringer could come out on the other end an honest person, because I can think of examples of both. Mostly, I'd recommend taking literature classes and life drawing, not to mention realizing early on that cartooning is one of the loneliest, financially unrewarding, and life-eating disciplines one can devote oneself to.

As for cartooning itself, I'd recommend paying attention to how one's characters "move," and to make sure that the gestures and rhythms of facial expressions seem true to real experience, and not Hollywood-influenced; this thinking should also extend to framing and the artifice of so-called "camera movement," the mechanisms of which can be highly corrosive if one doesn't pay attention to them. One should at all costs avoid the clichés of Marvel and DC and most manga, which have absolutely nothing to do with the experience of real life at all. There's little worse in comics than filtering an attempt at a serious story through one of these essentially insulting, assembly-line templates; it's like seeing one's own life played out under black light by spastic marionettes. The received ideas that populate these "comics" are almost worse than Hollywood stereotypes, though I find it encouraging that the clichés have all but become Hollywood structures now, which indicates that the superhero genre of comics has detached and become a parasite feeding off a more remunerative and artistically compromised form. It's the artist's responsibility to be aware of these trappings and try to eliminate them; the trick, of course, is not to lose your connection to your own stuff in the process.

Interview
A Novel Graphic
Art Spiegelman

In the Shadow of No Towers clearly has topical urgency; how did
you balance the personal with the news?
Each of the strips was a condensed journal entry of my month in the shadow of no
towers and I allowed the shape to be whatever it was going to take. But I did
acknowledge that the work had urgency without thinking of the work as making
any bid for posterity. The strips really were made in the spirit of the work that takes
place in the second part of the book, the early comics. They weren't made for some
ostensible future. They were made for a specific moment.

Those early comics artists were working for newspaper deadlines
and future-gazing was not part of their consciousness, but didn't
you have a sense that your strips would become documents?
When I was making these strips, I was sure that the sky was literally falling and we
would be dead soon.

Hence you allowed yourself a chance to make a couple of strips, but
by the time you reached ten, it sounds like you were surprised that
you were still around.
Yeah. And I quieted down as it was moving forward and maybe the strips became
more shaped in that sense as commentaries, but the original impulse, and what car-
ried me through the beginning of the project, really had to do with, "Okay, you're
not leaving New York, you're gonna be there when that next shoe drops, what are
you going to do till then?" I'm supposed to be making comics, so I had to do it the
best way I knew how, which is what those guys at the beginning of the twentieth
century were doing.

Was there a time after you realized that the shoe was not about
to drop that you became comfortable with the conceit you
were following?
I became comfortable with what I knew would be the process of trying to pick up
the pieces of brain that were in the rubble and trying to make some mosaic out of
the pieces, and that that would be the trajectory. It wasn't so much a conceit as try-

ing to figure out what it means to have time stand still—which is what that moment of the burning towers that keeps repeating on each page is—and time begin to move in fits and starts again, which are the little sequences in various styles representing facets and fragments that are kind of narrative in time again.

At the time we were all dealing with fear, anger, and sadness but there was also impressed on the whole tragedy a sense of sanctity and solemnity; did you feel the need to be solemn?

I think the word "awesome" covers that. By using the word not in its "Valley Girl" sense but in its real meaning and implications. If anything, I always try in my work to avoid maudlin sentimentality and sometimes I may err on the side of brash cynicism. But I don't want the work to be a tearjerker, so it veered away from the emotional horror in some ways. I let it be expressed but I didn't want to milk it, which is what I see as the American response to this.

Is this the reason for introducing the comic characters you use in the strip?

There's a brashness to comics, sure. And certainly at the beginning of the last century they didn't worry about political correctness or propriety. If anything, that's why comics were looked at as thoroughly pernicious sub-literature when they were born. Those Katzenjammer kids were perceived as terrorists.

Did this come pretty quickly for you?

It didn't happen on the first page, it happened as I was working. My conceit at the outset is that Ground Zero and Newspaper Row were right next to each other. But more accurately, I was taking my cultural sustenance from the old Sunday comics because I couldn't stand listening to music—it was too beautiful—I couldn't follow poetry—I couldn't keep the concentration level high enough to follow it—and if I turned on a TV it would immediately go to a news report.

Were the old comics an escape then?

They were cultural nourishment. The reason other people turned to poetry was to make sure that this civilization was worth saving, and even to get the comfort that other people went through rough times. I found all that, and more, in a culture that wasn't really meant to last. That really wasn't something I could have articulated the moment I was doing it, but now it is clear to me that when I was beginning to

shape this as a book, the "happy ending"—in *big* quotation marks—was when time starts moving, it moves back towards another time and I realize that people lived and breathed through their disasters the same way we are doing through ours.

Isn't that what we call nostalgia?
No, I think it's the opposite; it's kind of an epiphany. Making the past present has more to do with the title page of the book, which has a burning image of the towers that's in my head superimposed on a September 11, 1901 newspaper about presidential assassination and Emma Goldman being arrested; they had their own crises. *The Yellow Kid* was appearing as we were running up to our first colonialist adventure in the Spanish American War in Cuba and the Philippines, later revving up for World War I. While the world was ending, these working stiffs were going on expressing as much of their personality as could be funneled into those pages.

Obviously, everyone who reads it makes the connection between *No Towers* and *Maus*, but what are the differences?
This thing expresses my secular, diasporist, Jewish nature but this isn't about the Holocaust. My father was a victim of a drastic historical event. Thus far I am just a bystander. I'm like one of those Poles in *Maus*. I was not caught in an upper tower window; I didn't even lose a friend in the disaster. But I thought I was going to die that day, although I was obviously outside the perimeter of the grim reaper. Nevertheless, this wasn't a work that had the Olympian privilege of looking down on a closed book of some kind and seeing how it might have implications for the present, it was a report from the epicenter. These strips were never trying to be a full-blown narrative that even offers the pleasures of narrative in that sense. This book denies the expectations of people who have finally learned to accept *Maus*, which denies the expectations of what a book should be prior to that—and the way it does so is by existing in its implications, its fragments, and its connections. It's never intended as the smooth narrative ride that makes people come to me and say, very guiltily, "I loved your book." Narrative brings its pleasures. This book serves a purpose for me; it returns me to gestalting towards the work I did before *Maus*.

You mean like the autobiographical work about your mother's suicide in your book *Breakdowns*, or the more formal comics exercises therein?
The autobiographical work found expression in *Maus*, but what I had to sublimate and keep from being so visible as to disrupt the narrative flow in *Maus* were the for-

mal interests I had in the work that appears in *Breakdowns* that have to do with structure. And when I was dealing with large structures falling, and had access to this large vista of paper, those things determined the way I thought through and worked.

So you found solace in playing with comic strip form and architecture, and by returning to vintage comic characters that gave you pleasure in earlier times?
I did find myself rereading whatever *Krazy Kat* stuff I had around and looking at my McCay pages and things like that. And working on this large scale invited me to return to people who, back in the early days of comics, were allowed to work in that scale. In terms of form the reason this book couldn't be printed small, and the format became so weird, was that I needed to present the pages as I thought them, which was large panels collaged together.

Like artists that need to work in mural space.
It needed to be that. It didn't work when I reduced them down. The meaning was clear but the visual connectedness doesn't happen. Ultimately, the reason it became a board book was that it was the only way to get a size big enough smuggled into a bookstore where I didn't have to worry about jumping gutters. And once I've introduced, very overtly, the concept of *ephemera*, and what meaning ephemera might have in its afterlife—which brings up in the theme of these monumental buildings that become ephemeral, and this ephemera that became monumental—it's not about an Olympian overview that tries to take the measure of an event that is still unfolding.

As a book, this is a very specific new thing, and as a result, the new thing this book is doesn't even fit well into that newly formed graphic novel section. If anything it fits into a *novel graphics* section.

When you discuss the concept of ephemerality it is not really overt, it's a subtext of sorts that comes through after a very close reading of the work.
With any work worth its salt, you have to trust the author enough to take its measure. And if you apply too many preconceptions, you are not taking its measure. When you do enter into the book, the theme—what will last, what's ephemeral, what's timeless, what's passing, what scale this event really has, are all questions

raised within the work—is clear. I think its complexity is a gift. It's not an event that should be simplified and brought down to being a war poster. The other implications of the event are still unfolding, and this offers a way to approach them, because of its rawness. It is not being turned into an emotionally groomed and well-packaged event. Although as a book it is well packaged, it is meant to give pleasure in the midst of talking seriously.

Because it is a new form for you, how difficult was it for you to work within that large broadsheet-page size?
It was a great pleasure because it allowed for the kind of juxtapositions that were at the heart of the way I wanted to work. I definitely did do a lot of preliminary work but it didn't either come easily or hard. It was simply what I was doing while waiting for the other shoe to drop. And it was just making good use of my time trying to build something. The time pressure was there but I couldn't accede to it entirely, which makes me a poor candidate to do a daily strip. Some pages flowed out, much to my surprise, while others had to be reworked. I found that the process of doing that was the process of getting my thoughts into those little boxes so I could understand them.

So dealing as you have with this terrible event was, paradoxically, a blessing?
Whatever doesn't kill you makes you stronger, and for the moment I'm making plans for a future as if there will be one.

Interview
Memoir of a Revolution
Marjane Satrapi

Did you study cartooning or illustration before you left Iran?
Yes. I majored in fine arts at the general university. I wanted to make graphic design, but then they made everything by computer, and I got completely frustrated in front of the computer. I was really not good. Then I studied illustration. I just love to draw and love to write, and I thought that comics were really the best combination.

Did you become aware of comics in Iran?
I discovered comics really kind of late in Paris. I was twenty-five when I started reading some. It's like in opera. You have to go a couple of times to appreciate it.

When I read *Maus*, it was a very big revelation to me. Suddenly I realized that, Jesus Christ, everything is possible with this medium. There's so much freedom in comics. You can make so much. Plus, you are completely independent. Because imagine, if you want to make a movie, finding all these sponsors and agents and money, and these bad actors that have all sorts of demands. For making a comic strip, you just need a few pieces of paper and a little bit of ink, and you do it. You can do whatever you want and nobody is there to harass you. I really just did it because I had my story to say, and I didn't know how to say it, but once I started making it as a comic it was really obvious for me. I learned how to do it by doing it.

You created an image/icon of yourself in your book, *Persepolis: The Story of a Childhood*; was this something that materialized very quickly?
This came very quickly because I used to draw myself a lot, and after a while you're used to synthesizing yourself. I had to go with a drawing style that was the most efficient possible, that would register the emotion and what have you. This style treated me very well, because I am not a very good drawer. People say all the time that I have a "faux-naïf" style. Which is not true. There's nothing "faux" about it. It's just that I am unable to draw all the muscles and the veins and the blood going into the veins.

Is your telling of this story something you could have done ten years ago?
I could never have done it ten years ago. At the time I was living in Iran that was impossible, because I was living daily with what was happening. It's very difficult to

live something and have distance to be able to say it at the same time. I am not interested in a story that just shows misery and everybody cries for me . . . and I don't want any pity whatsoever. But little by little, my ability to tell the story took shape and I became more mature, also.

Maturity is an important mitigating factor.

I just started doing it at the moment that I started laughing at myself. When I could tell the story without having tears in my eyes any more, I could explain the absurdity of the situation. People were very concerned yet at the same time they were laughing, and the fact that they were laughing made them even more open, because people don't want to sit and cry. If I can make them laugh at the same time that I tell them something very hard, then I have touched people.

One thing I don't find in your book is a sense of victimization; even in the worst times, you've avoided this in your narrative.

My life is like anybody's life, and I have some dignity. I just want understanding. No compassion, no pity, none of that. I refuse to consider myself as a victim. So far I have the life that I want, where I want, the way I want.

What about anger?

I am very angry. That's the motor of my life. But I try to give a direction to my anger, and not become aggressive and bad. Instead of hating the people [in the regime] and saying they did this and they did that, I realize that the people who did these things are also themselves victims of something.

Interview
Out of the Inkwell
Kim Deitch

Your dad, Gene, was an animator; when did you start creating comics?
My dad was an animator, but he also did a comic strip for United Features in the mid-1950s called *Terrible Thompson*. He had a couple of books about the history of comics, too. Most notably *Comics and Their Creators* and another called *Cartoon Cavalcade*. I started reading and absorbing them even before I could actually read and kept rereading them into my teens. My father ran the New York office of UPA at the time he was doing *Terrible Thompson* and moonlighted on *Terrible* in the evenings. Well, when you're working on comics there's generally a certain amount of tedious busy work and you welcome a little company while working. This was certainly the case with my father and I think the period he worked on that strip, while it put a strain on his marriage, actually brought him and me closer together. I spent many happy hours with him at that time learning both about the lore of comics and the actual nuts and bolts of making them. He told me that if the strip succeeded, maybe I could some day be his assistant on it.

At this time he subscribed to enough out of town newspapers so that we received every comic strip coming out at that time. He also paid me thirty-five cents a week to cut out the *Popeye* comic strips and paste them into the pages of a copy of *The New York Post* to make a scrap book of that strip that he could read at leisure. I didn't start drawing comics at this time, though, as you can surmise, a major seed had been planted.

Did you go to art school?
I did go to art school; two years at Pratt Institute essentially for want of something better to do. I got by, but about halfway through I got drunk with a Norwegian seaman who regaled me with tales of dancing on bars in Hong Kong and all. Long story short; the end of my second year at Pratt, I shipped out on a Norwegian tramp for Savannah, Tampa, Galveston, Montreal, and all over Japan and Hong Kong. It was plenty of fun and I had an opportunity to develop my muscles and work ethic.

Your style, particularly back in the underground days, had an old-time animation quality; was this a direct influence from your dad?
My comics drawing style was influenced by animation but not quite in the way you suggest. In 1949, when we got our first TV, Saturday morning cartoons consisted

predominantly of old, silent *Aesop's Fable* cartoons from the 1920s. I watched them continuously and, to a lesser extent, Max Fleischer's *Out of the Inkwell* and Disney's *Alice in Cartoonland* series. So I was steeped on that very early stuff at a very young stage of my emerging consciousness. Later on, in 1956, my father became the creative head of a studio called Terrytoons. It was a huge plant in New Rochelle and had been in continuous operation since 1930. In this studio, now making modern art–style cartoons for my father, were many of the very animators who worked on those old *Aesop's Fables*! I got to know them and was fascinated by the historic continuum between them and those ancient cartoons that had been a big part of my childhood since age five.

Boulevard of Broken Dreams has roots in the early animation days; what was the genesis of the story?
One evening my brother and I were smoking pot and kidding around. Just for fun we started developing a story line based on a story we'd heard many times from various sources. This is it. In 1927, more or less, Max Fleischer threw a dinner for aging animation pioneer Winsor McCay. At some point during the party McCay was called on to make a speech and he started in making some visionary remarks about the future of animation (foreseeing, among other things, the coming of sound and color). But he soon realized he was losing his audience (there was plenty of bootleg booze flowing). At a certain point he broke off his remarks and said, (reports vary, but this is it in essence) "God dammit! The Hell with you! You guys have taken the art I created and turned it into shit! Bad luck to you!" So we took that anecdote, changed some names, threw Waldo, my cartoon cat, into the mix and had the start of a great yarn. Of course I was knee-deep in a lot of other stuff just then so it wasn't too likely that this one was going to happen soon, if ever.

Okay. The scene changes: I'm over at Art Spiegelman's place and, just for fun, I ran down this story opening for him. As I did so, the expression on Art's face changed and when I was through, he said, in essence, "You know, Kim, if you ever want to stop clowning around and do something that will make some money, you might want to consider actually doing that story." I went back and told this to my brother Simon. A few days later I came back and told Art I'd been talking to Simon and we decided we wanted to do the story and we wanted to do it in *Raw*. So those are the bare bones of the story's genesis.

Are there autobiographical characters? How much is based on truth?
There are autobiographical characters in the sense that I grafted a lot of the dysfunctional characteristics of the characters not from animators I knew growing up so much as the underground comix scene I had been living in for, at that time, the last twenty years. However, the fact remains that I got to know not only the old timers at Terrytoons but also all my life I had been around people in the animation biz. I got an earful of all the old stories about the business and was an eager listener. Also stories of the great Disney strike of 1942 and the strong stream of left-wing politics that helped to fuel it.

How different is the process of creating a strip versus a "graphic novel"?
Well, the biggest obvious difference is that one is a small thing and the other is not. But of course the big difference is that graphic novels are entering the realms of literature that go beyond graphic art and my influences are as much in the world of books and literature as anything else. To me this is the real excitement of the so-called graphic novel; the license it gives to tell longer and more ambitiously complex stories, preferably with better and more interesting character development. At least in the graphic novel this becomes a more active part of the goal.

How would you rate yourself as a draftsman? And is this more important than being a writer?
I think I have my good and bad points as an artist. I am not what one would call a natural artist. I do not have the inborn facility, so to speak. When I was eighteen my father told me frankly he didn't think I had the talent to be an artist. "When I was your age I could draw circles around you," he said, which was true. He went on to say he thought I had potentially good writing talent and suggested I go in that direction instead. I think he was right up to a point except that over time I have come to see that there is more than one kind of artistic talent and that inborn facility is not the whole story. Over the years I have grappled long and hard with my artistic deficiencies. I'll never be able to draw like Crumb, but that will never stop me from trying to compete with him and others in the mighty quest for artistic greatness. It's a struggle, but it's also a great game; a game *I love* to play. I may not be the world's greatest artist but over time I've learned to be a better artist and I'm still learning to this very day. That learning process has only gotten *more* interesting over time. For my money, the writing is just as important as the drawing. It's the

combination that really gets me going. When Jules Feiffer referred to comics as "movies on paper" in his book, *The Great Comic Book Heroes*, it struck a real chord in my poor brain.

What would you say to a student who wants passionately to become a comics artist?

I would, and do, tell young students wanting to get into comics that it is a great field with plenty of room for further creative exploration. In my opinion, comics, after their initial birth around the turn of the last century, got cubby-holed pretty much; certainly more than similar popular arts like movies and popular music. While they did develop graphically, the stories they told stayed, for the most part, relatively simple. I think the underground comix of thirty years ago contributed to getting them off that dime and set them free toward a surge of further creative development, particularly in the writing, that continues to this day. It is not an easy field either in terms of execution or in making a decent living. But compared to making movies the overhead *is* low. Keep the rent paid and get a few essential art supplies and you're in business. It'll be tough going, as most things worth doing are, but I can offer this consolation: it ain't boring. And I have personally found the work to become increasingly more interesting over time. When I first started out I didn't really like to draw comics, though I liked the result of having done one. Over time, I came to enjoy the actual process more. Ten years in I could actually say that I liked to draw, which frankly astonished me. Twenty years in I had come to love drawing comics. And now, no joke, I can honestly say that I love drawing and writing comics more than I enjoy doing any other thing in this world.

Interview
The Power of Old-Fashioned Storytelling
Rick Geary

How did you develop your distinct illustration style, which you apply to editorial work, lampoon humor, novels, mysteries, and children's books?
I don't believe that I have consciously developed a style. For any artist who produces a steady stream of work, a style—a personal way of looking at things—will eventually emerge. This doesn't mean that I'm not working toward something. I always have in my head a certain look, vague though it may be—a texture, a feeling, an atmosphere—something to work toward and rarely, if ever, achieve. I feel the same way about my few but significant artistic "mentors": Edward Gorey, for his darkness and whimsy, Gluyas Williams, George Price, and Al Hirschfeld for the purity and simplicity of their line—qualities to reach for, never attain.

Your period-piece works are impeccably detailed; how do you research and compile visual reference material?
I keep a large library of reference volumes that contain photos and engravings of nineteenth-century people, buildings, interiors, vehicles, etc. Also valuable are old catalogs from Sears, Roebuck and Montgomery Ward, for details of fashion and furniture and a host of everyday objects. I've also had to educate myself in the intricacies of harnessing horses to carriages and wagons. Of course nowadays, if I'm at a loss for some elusive piece of material I can always find it online!

You depict gruesome murders with a visual gentility, with the violent action often happening between panels; how did you decide on what seems to be a counter-intuitive visual approach?
It's an old truism that nothing is as gruesome as what you picture in your own imagination. I've always avoided the graphic depiction of gore and violence in my own work, not because I'm squeamish (I don't mind it in other artists' work), but simply as part of the detached and indirect quality of observation that I try for.

How do you explain your preference for captions, which you use extensively, often to the exclusion of word balloons?
I guess I've always had a distrust of the mechanics and contrivances of traditional narrative, so much of which is dialogue-driven. I gravitate toward the indirect and

the non-essential. The use of captions is necessary for the sense of detachment that I aim for, and is no doubt part of the Gorey influence. In addition, my *Victorian Murder* stories demand that I only use dialogue that can be historically authenticated. Consequently there is very little of it.

Of course, the adaptations I've done of classic works of literature gave me new appreciation for the power of solid old-fashioned storytelling.

How do you go about transforming a classic work of literature into comics form?

In adapting three novels—*Great Expectations, Wuthering Heights*, and *The Invisible Man*—and one play—*As You Like It*, never published—for the *Classics Illustrated* series, and several shorter pieces for *Graphic Classics*, I developed a several-stage method for going about it: 1.) Read the novel straight through. 2.) Read the novel again, while taking notes on the contents of each chapter. 3.) Read the novel again, using a yellow marker to highlight what scenes, incidents, and dialogue to include. 4.) Write out a page breakdown for the comic, using both the chapter notes and yellow-highlighted passages in the novel to concentrate the narrative flow into—in the case of *Classics Illustrated*—forty-four comic pages. I prefer to do this on a single piece of paper, so I can see the whole project at a glance. 5.) Sketch out a thumbnail version of the whole comic, using the page breakdown and highlighted passages to break each page into panels, indicate dialogue and transitions, and decide what dramatic weight to give one episode over another. 6.) Now all should be ready for the actual writing of the script.

What are the differences between adapting novels and composing historical facts for biographical comics?

With the *Classics Illustrated* and *Graphic Classics*, my only source material is the original novel or story, and my goal is to retain, as much as possible, the author's language and point of view. With the *Victorian Murders* and other non-fiction pieces, the problem is just the opposite: I use multiple reference volumes and gather information from wide-ranging sources, while I'm free to organize as I see fit and use my own "voice" in the presentation.

Would you recommend aspiring artists hone their visual narrative skills by adapting short stories?

Yes, I think that adapting short pieces of "classic"—meaning pre-WWI—literature is an excellent means of sharpening one's narrative skills.

Other tips?

I'm uneasy handing out advice, since I can't claim that my own career has proceeded by any kind of plan or even much forethought. When asked, I usually say: develop a personal point of view by producing as much work as you can. Show it to as many people as you can and, if no one will publish you, publish yourself.

Career Tips for Control Freaks

Ho Che Anderson

King *sketches © Ho Che Anderson*

For the control freak, there are few places better than comics.

Of course, that's not to suggest that other mediums can't also offer a high degree of control. In novels for example, the final arbiter of what makes it onto the page is the novelist, the right of "final cut" built into the medium's very design. And no doubt your average dictator might argue that controlling the masses offers a buzz no mere funny book could extend.

No, it's more that in comics, specifically the independents, there are so many outlets for the artistically minded control freak to exercise that tendency. The words in the captions and the placement of balloons, the images chosen to illustrate the

narrative and the nature and tone of the story itself, all the way down to the publication design and promotion of the finished product—all are areas in which the creator can exercise all the control their sphincter-like souls can muster.

It should be obvious I speak from experience. I've been a working cartoonist since I was nineteen years old, and from the beginning, one of the reasons the medium interested me was because of its ease of execution; pick up a pen and piece of paper and you too can effectively play God.

I suspect this love of God-play is the blood that keeps the hearts of many a cartoonist beating. Omnipotence probably has its shortcomings in the real world, but in the four-color one it's consequence-free and a mere pen stroke away.

This mentality permeated every page of the project to which I am most closely associated, the one I'll probably be discussing for the rest of my sorry existence, a comic book biography of Martin Luther King.

I began *King* in the summer of 1991. It was a commissioned job, a follow-up to *I Want to be Your Dog*, my first attempt at graphic storytelling.

Besides being a control freak, the other thing to know about me is that I'm a natural born storyteller. I've spent part of my career as an editorial illustrator, but as much as I love the concept of imagery that exists for its own sake, when I examine my motivations for its creation I find what moves me is devising pictures that tell a story or express an idea. And I immediately recognized that King's life was a great story, one filled with strong ideas. So, resigning myself to continued poverty, I sat down with a mountain of books and video footage and immersed myself in the life of a man who had died nineteen months before I was born.

As I read, images formed in my mind. I began to see the events I was learning about not so much as the twists and turns of a man's life, but rather as scenes to be staged, the raw material for my own private playground. King stopped being a man and became a character. My character.

If anyone reading this has ever created a character, you know after a while that they become flesh and blood in your minds. They begin speaking to you and dictating their own actions. And there's nothing most of us can do to stop them. Sometimes, even an all-knowing God needs to know when to just shut up and listen.

So it was with *King*. The character began telling me what to do. My MLK became a man defined in part by the events of his life, but also by my own fears and obsessions, my own desire to see him perform like the larger-than-life player that he was.

Research done, the time came to write my script. Through dialogue and stage direction I attempted to mold a human being's life into a compelling narrative. I began the process of shaping history.

Now, I've always had a love of history, both as a student of the world and as a storyteller in search of a story. There's something about the transformation of real events into drama that moves me in profound ways. Perhaps the fact that these things actually happened lends a certain depth and resonance that fiction can't always supply. But I'd only be guessing.

With script in hand, the only task left was to turn the words into images. And this is what comic books are all about: an entire world delineated by lines of ink against a crisp white board. Your job is simple: pour life into those lines, will them to exist beyond that which is seen on the page.

It's no easy feat. I spent the better part of a decade turning King's life into a series of panels and spreads, and I still don't know if I created anything worthwhile. The thing you never hear about playing God is that it can be a major pain in your ass.

In June of 2003 the third and final volume of *King* was released. The clerk at my local comic shop placed a copy in my hands, where it remained, almost welded to my fingers, for the next two days. That night I couldn't sleep; I laid in bed reading the book for the second time that day. It almost felt like someone else had done it, even as I marveled that the disparate drawings and paintings I had created on the dining room table had gathered and formed themselves into a book. The thing had a mood. There was King, my character, performing actions across a series of pages, scenes that I had first read about, then imagined, then pulled kicking and screaming from my mind. Years of work collected between two covers and eighty-eight pages.

There were times during those years that I thought it would never end. But even at its darkest, there was still enough of a buzz to make it worthwhile.

Why? Because I'm a control freak. And a compulsive storyteller. And for people with these disorders, the comics field is one of the best places you can be.

Miscellany

The Education of an Educational Comics Artist
Leonard Rifas

How broadly would you define "educational comics"? Would you include Keiji Nakazawa's *Barefoot Gen* along with *Dagwood Splits the Atom* and your *All-Atomic Comics*?
I define "educational comics" broadly, and would certainly include all three of these examples. Rather than constituting a single genre, "educational comics" encompasses a large constellation of related, and somewhat overlapping, categories. These include, but are by no means limited to, comics that deal with history, biography, and literature, and comics used for public relations, propagandizing, and proselytizing. "Educational comics" include some of the most widely circulated and most respected comics ever made, and educational cartooning has attracted the talents of some of the most artistically ambitious and celebrated comic book creators. Such comics are read all over the world.

A definition of "educational" comics as simply those that deal in "facts" instead of "fiction" only goes so far, because comics have combined factual and fictional elements in many ways. In the clearest case, the distinguishing features of an educational comic would include certain didactic purposes of the individuals and institutions that created and distributed it; the presence of specific textual cues that enable readers to recognize these publications as "educational" and as "comics"; and the particular uses which those who buy and those who read these comics make of them. Since the motives for creating and consuming comics are inescapably mixed and complicated, a categorization of comics that partly depends on identifying these motives will necessarily remain fuzzy. The quality of being "educational" can be found to some degree in any comic book.

How did you first become interested in comics as a learning tool?
That depends on what counts as "interested." When I was a kid, I had a variety of experiences with educational comic books, including Disney's *Donald in Mathmagic Land*, which I loved to pieces, and a free comic that came with my Gilbert Chemistry set that was just awful.

When I was twenty-one, I experienced a powerful "vocation" to create educational comics. The idea hit me suddenly and for about seven days afterwards I hardly had a single conscious minute in which I was not thinking about using comics to explain American history. I felt overwhelmed, not only because I had never been held so strongly in the grip of one idea, but also because I was aware that I had not yet mastered the necessary cartooning skills, did not understand the "public" whom I would be drawing for, and did not have any particular ready-made messages that I wanted to communicate. I have never thought too long or hard about where this frightening "call" might have come from and my relatively leisurely subsequent career as a cartoonist suggests that I did not take this strange experience as seriously as I might have. Still, I date my career as an educational cartoonist to that week.

What has been the underground comix movement's primary legacy to educational comics?

I came out of the comix movement, and what I gathered from that experience included the ideas that comics can be uncompromisingly honest, independent, and non-commercial. For me, the most important thing about comix was that they helped the medium become a tool that could be used democratically by ordinary people searching for meaning. Before the comix movement, a typical educational comic would show a scientist in a lab coat lecturing to children about amazing facts.

It would be hard for me to reduce the comix "legacy" to a single thing. I think Harvey Pekar's famous epiphany expresses a poetic truth: "Comics are just words and pictures. You can do anything with words and pictures." Underground comix helped people see that.

What are the main components for producing successful educational comics?

There are different kinds of "success." A comic can be commercially successful, artistically successful, politically successful, and so on. Some kinds of success are easily measured, but the goals that bring people to educational cartooning often make it hard to determine whether a comic succeeded.

The first of my educational comics that I count as a "success" was the one you mentioned, *All-Atomic Comics*. The drawing was amateurish, but I worked hard on researching the issues relating to nuclear power and on condensing the information for readability and reliability. It found a readership through antinuclear groups. On the one hand, the comic went through five printings plus several foreign transla-

tions, and was used by a popular movement that halted the construction of new nuclear power plants in the United States. On the other hand, the problems I described in that comic—such as nuclear proliferation, nuclear terrorism, finding a safe place to store nuclear waste, and the danger of accidents at nuclear power plants—remain to be solved.

Some of the components that can strengthen a comic's chances to attain various kinds of success include choice of topic, imprimatur (for example, the logo of a respected group that endorsed or published the work), writing (and all that entails), art (and all that entails), reproduction quality, distribution plan, and—especially for comics on current issues—timing!

Maus is now required reading for a variety of college courses; has there also been an increased demand for comics in the lower grades? Honestly, I don't know. When I started my educational comics company, one of the handicaps I was working under was a deep distaste for formal schooling. Soon after starting EduComics, I rented booth space at a teachers' convention, encouraged by my mother, who worked in a high school as a teacher's assistant. After that commercially unsuccessful experience, I did not make special efforts to market to schools. I lacked interest in the schools as a market because it would mean selling comics to some people who would force other people to read them. I preferred to be supported directly by my readers as much as possible, so it took a while before I was ready to cartoon for schools.

I created a comic for fifth graders about tobacco a few years back that went to every fifth grade class here in King County, Washington. Before that, I did a comic on AIDS that went to seventh graders. If I were to self-publish an educational comic for school kids today, it would encourage resistance to standardized testing. If I were more commercially minded, I would be self-publishing a comic that schools could use to instruct students on how and why to do well on standardized tests.

Are caricature and satire effective tools for the educational comics artist, or do they run the risk of oversimplification or misinterpretation? "Yes" to all of the above. An enormous gulf separates expert knowledge in almost any area from popular understanding. This creates opportunities for educational cartoonists to help people develop fuller understandings by translating research papers into simpler terms. Rather than taking expert knowledge as necessarily more reliable, though, educational cartoonists also have vital opportunities to help people more effectively challenge experts' interpretations.

My work does not usually rely on caricature, as I prefer to focus on weighing ideas and I dislike arguments based on attacking individuals. Still, I appreciate other cartoonists' caricatures, including the mean ones. Since "satire," by some definitions, relies on "irony"—the use of words to convey the opposite of their literal meaning— it carries a risk that some readers will miss the author's intended point. In many circumstances, cartoonists judge that risk worth taking.

Caricature can be used in many ways. A comic that tried to argue for a position largely on the visual basis that the people on the other side of the issue look mean or sneaky or dim would most likely be oversimplified and mistaken.

Fundamentally, how was *Seduction of the Innocent* wrong—and right—regarding comics as an educational tool for children?
Wertham gave a variety of arguments about comics' "anti-educational" effects. He made the interesting argument that exposing small children to short blocks of text surrounded by pictures before they had learned the habit of scanning lines of text efficiently caused "linear dyslexia," poor visual tracking skills. That argument did not hold up, but then again, no later generation grew up as deeply immersed in comics before learning to read as the one that Wertham and his fellow researchers studied in their clinic.

Wertham held in particular scorn comics-format adaptations of great literature, saying that such adaptations leave out "everything that makes the book great." Personally, I have not been fond of such adaptations, especially the ones that existed when Wertham was writing that book, but now that more years have gone by, I think we can point to examples of works in which a cartoonist has successfully recreated a story from another medium in comics format.

Wertham also had some things right. I like his refusal to confuse "education" and "schooling," and his insistence that kids learn a lot from their play, their games, their entertainments and their entire life experiences, not just when they are in working in classrooms. However, he pushed this point too far when he claimed that comics teach nothing that might be useful.

I also like Wertham's anti-censorship activism, and his stance that people older than fifteen should be free to read what they want.

Among the current crop of artists, who are the ones producing comics that are both educational and entertaining?
Well, rather than coming in annual "crops," cartoonists can be productive over many years. Will Eisner, the pioneer of American educational cartooning, continued until

his recent death to create important and exciting pieces like *Fagin the Jew*, and I expect his book on the Protocols of the Elders of Zion will also be a valuable work.

I hesitate to call the educational comics I like "entertaining," partly because I like media historian Erik Barnouw's definition of entertainment as "propaganda for the status quo."

Among the cartoonists currently making educational use of comics, Joe Sacco deserves special mention and has begun to receive the recognition he deserves. I just returned several good examples of educational comics to the library today, including Brian Michael Bendis' *Fortune and Glory*. The trouble I have with this question is that there are too many examples and I don't want to leave people out.

Where do you see the untapped potential for educational comics?

I have only begun to investigate creating Web comics. I called my first attempt *Feet First Car Smart Comics*. It advises people who are looking for a place to live to consider the ecological impact of their choice. I think about the potential of educational comics in relation to a larger world, and that world—this world—is in crisis. Almost every day, I see information that deserves wider attention and questions that call out for further investigation. Cartoonists can pass along those stories and record those investigations.

Would you recommend creating educational comics—perhaps pro bono for a worthy cause—as a viable way for novices to develop visual communication skills as well as build their portfolios?

I know of no better path than educational cartooning for a novice, part-time, or amateur cartoonist to reach an appreciative audience. Each city has many citizen groups that a cartoonist could join that would be glad to find a place in their newsletter or on their Web site for an original cartoon addressing the interests of their organization.

Educational cartooning can be an excellent way to cultivate verbal-visual communication skills, but that requires both patience and humility. By hooking up with a focus group of expert advisors—either volunteers or sponsors—you can learn many things about how people interpret your work and learn more quickly about the topic you are reporting on. It would be hard to get people to pay as close attention to an amateur work of fiction, or to put as much effort into recommending improvements. Not every cartoonist enjoys this process of revising a series of sketches. I have enjoyed the process immensely, almost every time.

In the years since I began doing educational cartooning, the level of work people have been doing in this field has grown higher and higher. Nevertheless, more than any other branch of cartooning, educational cartooning still offers opportunities for beginning cartoonists to get published and win acclaim.

Mini-Comics: Comics' Secret Lifeblood

Tom Spurgeon

Mini-comics are handmade comic books and efforts by publishers that adopt their properties, booklets of every size and shape that exist largely outside the established markets for comic books, graphic novels, and newspaper strips. The term "mini-comic" used to mean a single sheet of paper folded into quarters. Larger handmade comics were sometimes called "digests;" smaller ones "micro-comics." But "mini-comic" is the name that stuck, and has come to mean any comic of the homemade variety. Mini-comics can be as crudely fashioned as a single piece of paper folded over or as elaborately produced as any major publisher's graphic novel, depending on the inclination, skill, and resources of their creators. There are mini-comics as small as a teenager's thumb and others as large as pieces of poster board stapled together. Some feature silk-screen covers; others penciled drawings and no cover at all. The first rule of mini-comics is that creatively, there are no rules.

Handmade comic books have been a part of the creative community surrounding comics since the beginning of the art form. Fans of early comic strips and comic books were likely to make—and even sell—their own efforts to local neighborhood kids. In the 1960s and '70s, the confluence of several factors began to make handmade comic books a more viable artistic outlet. Mimeograph and photocopy technology allowed burgeoning comics creators to produce copies of their work with relative ease. A fan network of comic-book letter writers and interconnected fan clubs gave mini-comics creators a natural audience for trade and sale. Underground comix shook up perceptions as to what styles and modes constituted a viable approach to the art form. Finally, the change in the mainstream American market from a variety of genres to a heavy concentration on superheroes forced some to seek alternative outlets for offbeat work and others to look for a training ground through which to help enter the capes and cowls industry. By the 1980s, mini-comics had become their own "scene," complete with big names and breakout talents, an alternative to the standard comic book business to rival college radio-sponsored rock and independent film.

Today, cartoonists use mini-comics in a variety of ways. It remains a viable training ground for many up-and-coming artists. This is particularly true for those interested in entering the alternative or arts comic side of the market, where creating a mini-comic and creating a regular-sized comic or graphic novel is roughly the same process on a different scale. A high-quality handcrafted mini-comic is the

133

page from Too Negative *mini-comic;*
© *Jenny Gonzalez*

perfect combination of business card and résumé for those companies that treat cartoonists as authors who must create works out of whole cloth as opposed to skilled craftspeople hired to do a component job for an already-established title. "Name above the title" comic book artists such as Jessica Abel, Brian Ralph, Craig Thompson, and Kevin Huizenga all came to the attention of their current publishers through mini-comics they themselves made and distributed. Adrian Tomine, the successful cartoonist behind the title *Optic Nerve*, sprung onto the scene with a mini-comic so popular it was selling several thousand copies every photocopied issue. Even a single mini-comic in the right hands can help launch a career.

Comics may be unique among entertainment media in that many professional cartoonists continue to make use of the mini-comic long after they have gone on to do more formal comic books, graphic novels, and even newspaper strips. Artists and writers use the mini-comic as a way to disseminate works between major projects, preview upcoming projects at conventions or via mailings, attempt new techniques, or simply to have something to trade with fellow artists and fans. In a very important way, mini-comics have never lost touch with their roots as a way for cartoonists and comic book fans to communicate with one another using the medium they love. The industry's ability to respect *all* comic books for the quality of the effort rather than the size of the publisher shows up in conventions like the Small Press Expo in Bethesda, Maryland, where cartoonists meet with fans and each other and the personalized mini-comic is the most coveted and traded item. The industry magazine *The Comics Journal* devotes a column to covering the mini-comics scene and works reviews of good ones into its more mainstream sections. A fair number of online resources about mini-comics appear regularly on comics-related Web sites, and just about every comics-industry message board has a resident mini-comics maker, or twelve.

Perhaps most exciting of all, mini-comics have become a way for some specifically talented cartoonists to fulfill all their ambitions concerning comic book production. As the technology developed to produce mini-comics on something more than a handmade basis, so did an entire ethos of do-it-yourself creativity. Known more often simply as "DIY," this set of beliefs, often found in punk music and among fanzine creators, values the total creative freedom that comes with the artist controlling every single facet of making and selling the fruits of their labor. Some mini-comics makers have used this control to go beyond other comic books for inspiration and draw on ideas and concepts from artists' collectives, printmaking groups, and poetry chapbook makers. The Fort Thunder group in Providence,

Rhode Island, went from making mini-comics and rock posters in their shared industrial-building home to headlining gallery art shows and being invited to display in a recent Whitney Biennial. Robot Publishing's elaborately produced mini-comics in the late 1990s showed off their artists' animation backgrounds in a presentational style to rival any art book. The cartoonist John Porcellino has enjoyed a worldwide audience for over sixty issues of his *King-Cat Comics*. Porcellino's are very simply produced mini-comics consisting of a few typing pages folded into one another. Porcellino is considered by many of his peers and critics to be one of the most important cartoonists of the twentieth century for his elegantly drawn, diary-style comic book stories. Mini-comics have given Porcellino a chance to make comics his way, and the world has responded with accolades and a strong mail-order response every time a new issue is published.

The difference between a widely read mini-comic and one that is barely seen can have as much to do with effort and attention paid the ever-changing marketplace. In addition to trade shows and networking online, many mini-comics artists submit work to the online stores at *BodegaDistribution.com*, the Poopsheet Shop, and *Usscatastrophe.com*. As of November 2004, three distributors actively pursue mini-comics for placement in the comics retail market: Cold Cut, Global Hobo, and Shenton Sales. Most comic book stores who carry mini-comics will also work directly with the creators, frequently on consignment. Local stores often carry comics from artists in their area, and some of the bigger stores in major North American cities carry an array of mini-comics from around the world. Included in this category are shops like Meltdown in Los Angeles, Quimby's in Chicago, and Reading Frenzy in Portland, Oregon.

All stores should be contacted for their policies regarding submission for sale before anything is sent. It also never hurts to be creative. One mini-comics artist who did a mystery book sold copies at a mystery writers society meeting, while another who had her first book published in 2003 got her start by simply selling her mini-comics on the street. Like any self-motivated enterprise, distributing your mini-comics depends greatly on the cartoonist's ingenuity, hard work, and record keeping.

Mini-comics can be the first important step on the road to success in the comic book and comic strip industries. They can also be a destination of their own. Mini-comics have made the industry and art form stronger. These comics have given voice to many cartoonists who might not have been heard from otherwise, allowed others to hone their craft, and given still other artists and writers the chance to

experiment with formats and presentation in a way that some of the big companies are all too happy to adopt. The best thing about mini-comics is their continued existence means there's never anything stopping anyone from making a comic book. All you need to start is a piece of paper and something to make marks on it. Other than that: no rules.

Fort Thunder: a Comics' Art Collective

Dan Nadel

Fort Thunder was both a place and a feel—as much a physical art collective as a vibe that, since its 2002 demolishing, has permeated contemporary "alternative" comics, often approximating but as yet never surpassing the original.

Originally the dream playhouse of college roommates Brian Chippendale and Mat Brinkman, the space, eventually christened Fort Thunder, was found and opened in 1995—an expansive loft space in Olneyville, Rhode Island, a downbeat section of Providence, and a cultural mile away from the Rhode Island School of Design, from which neither Brinkman nor Chippendale ever quite graduated. Fort Thunder was a space for music performances, compulsive decorating, screen-printing, and general art making and living. In the ensuing years, more than twenty roommates would pass through, with seven or eight living in the ever-expanding space at one time. As the nineties wore on, it acquired a national reputation as a music venue, and Chippendale and Brinkman became in-demand poster artists. And simultaneously, the two also made—and created an environment for others to make—some truly groundbreaking comics. Younger schoolmates moved in, most notably Jim Drain, Leif Goldberg, and Brian Ralph, and made comics with varying styles and themes. All of the residents of Fort Thunder helped transform the space into a legendarily ornate space—complete with everything from bicycles to cereal boxes to action figures attached to every surface imaginable. A living sculpture, as it were. By most accounts, simply being there was inspiration enough, and the frenzied creative activity constantly encouraged everyone to keep making art . . . it was nearly unavoidable.

All five artists are linked by their insistence on the handmade aesthetic of the printed object—resulting in lavish silk screened covers, and even entire publications, as well as other comics of all shapes and sizes—and a certain Fort Thunder obsession with simply existing in a space. Nearly all have at one time or another created stories without real plots, just narratives of a "dude" walking around, casually exploring his space or engaging in an absurd conversation. But these weren't comics where "nothing" happens, but rather rich explorations of space, timing, and drawing.

Aside from form and theme, the act of drawing is crucial to all of the work, especially that of Mat Brinkman. Not since Gary Panter reinvented comic drawing in the late seventies has anyone worked quite so hard to make the drawing as paramount as the storytelling or placed so much emphasis on the act of drawing for its

own sake. Brinkman's comics often follow dudes as they do mundane tasks, but the sheer richness of his masterful draftsmanship and rich graphite spaces add a layer or two to any story he is telling. His character designs are remarkably complete and original takes on sci-fi and fantasy monsters, beings, and inhabitants of the universe. He is also a profoundly funny and talented gag cartoonist—his simple exchanges between monsters are telling examples of how well he understands pacing and cartoon dialogue. You read a Brinkman story to submerge yourself in his world. The 2003 Highwater Books collection *Teratoid Heights* collects his late-nineties mini-comics, and showcases his nearly anthropological eye to great effect.

Chippendale's work, like his old roommate's, is as much about relentless drawing—the act of quite literally carving out a personal visual universe on paper—as telling a conventional story. His *Maggots* mini-comics were veiled autobiography, taking the nameless protagonist through everything from breakfast to climbing around in, and exploring, the world around him. Chippendale's scratchy drawings are divided up into tiny panels, sometimes even dozens on a page, creating pulsating micro-beats in the pacing, not so dissimilar to his drumming in the noise/rock combo *Lightning Bolt*. Added to that is a formal layer of complexity: his panels are frequently arranged to be read "like a snake," in a continuing line, left to right, then right to left, and so on. If Brinkman is a mellow explorer of interior worlds, Chippendale might be likened to a more frenetic sprinter—everywhere at once, eager to just keep making.

Leif Goldberg, on the other hand, makes comics with explicit political and environmental themes. His homages to old Providence and fascination with fantasy cities make his work perhaps the most worldly of the lot. Goldberg has a sinewy drawing style, his elegant lines defining animals, aliens, and characters of all kinds. Recent issues of his self-published comic book *National Waste* have found him telling psychedelic stories of redemption and humor. He alternates between ink-wash drawings that create an almost photographic sense of space, and stark black and white renderings that create a maze-like surface on the page. Unlike the frantic drawing of Chippendale and the lush wanderings of Brinkman, Goldberg holds back, creating still drawings that slowly progress to a natural conclusion. He seems interested in pointed, though funny, homilies and metaphors. In that sense, he has something in common with Brian Ralph, the one artist in the group to have penetrated some of the comics mainstream. Ralph's 1999 breakthrough graphic novel, *Cave-in*, followed a young cave boy through an inner-earth world of trials and tribulations. While adhering to many of the Fort Thunder themes of wandering and

world-making, Ralph's artwork is the most cartooned out of the group: he creates well-defined, inky characters and places, closer than his scrappier comrades to the kind of streamlined action that Osamu Tezuka drew. But layered onto this deceptively straightforward style is real philosophical weight, and universal—though personal—themes of growing up, alienation, harnessing creativity, and self-knowledge. Perhaps making the Tezuka comparison self-evident, he has recently branched into children's comics with equal success.

And, to give one last example of the variety contained within the Fort Thunder umbrella, there's Jim Drain. Like Goldberg's, Drain's work is delicately drawn, and his comics *Alias Face* (1996) and *EIO* (1998) tend toward ambling narratives: A farmer has a revelation; Mr. Fiz Wiz goes to a movie, shaves, sweeps, and later cries; and so on. Best are Drain's own sort of gag cartoons and single-image vignettes. In *Gold Dust* (2000), one face asks, "Hot?" And another answers, "Yeah." *Afternoon Fever* has his signature (circa 2000) alien-like characters sitting on a stoop looking bummed out. Drain's drawings are all sinewy line and blank page, bearing no resemblance to his former roommates' more baroque renderings. Instead, Drain's work initially looks dashed off, but further examination reveals a careful attention to composition, expression, and line quality.

Fort Thunder may designate a defunct group, but the importance of what was perhaps unintentionally accomplished is hard to overstate. These artists helped to restore the power of drawing to comics and, by tackling any subject they pleased, gave artists a new permission to simply create picture narratives as they pleased—dudes in a dark room or whatever—no conceptual strings attached. They also helped restore a sense of awe to comics; reading a comic by any of these artists means experiencing a different aesthetic universe. Finally, through their insistence on treating comics as personal art objects, they earned a tribute issue of *The Comics Journal* (#256) and helped inspire a generation of publishers such as (the recently defunct) Highwater Books and anthologies like *Kramer's Ergot* to publish comics that look and feel like nothing else. Though all the Fort Thunder roommates have gone their separate ways, all continue to make comics, and recent work can always be found in the semi-quarterly newsprint comics anthology, *Paper Rodeo*, edited by Brinkman and Goldberg.*

* Issues are available for $1 from P.O. Box 321, Providence, RI, 02901. Pictures and comics from the old Fort are online at *www.fortthunder.org.*

The European Comic Book Industry: a Guided Tour

Bart Beaty

The common perception of Europe as a land in which the public treats comic books seriously is an exaggeration, but there is some truth to the idea that a number of significant differences exist between the comics culture of Europe and that of the United States. Many of these differences are based in history. While American comics publishers long held on to a monthly magazine format, comics were collected into hardcover books, called albums, in Europe since their beginnings. Because comic books in Europe remain in print theoretically forever—it is just as easy now to find Hergé's *Tintin* comics from the 1940s as it was then—the industry developed in a significantly different fashion. Among the key differences are longevity, availability, and the way that cartoonists are regarded as public figures.

When we think of the successful comics publishing industries in Europe it is clear that we are speaking primarily about the French-speaking nations of France and Belgium. These two nations are home to the largest and best-established publishers on the continent, and their production dwarfs that of their neighbors. It is fair to say that the easiest way for a Spanish cartoonist to be published in Spain is to be first published in France, where the French publisher will then sell the book rights to a Spanish publisher. In countries like Italy, Germany, Portugal, and Spain comic book stores remain rare, and the industry is generally small. In Paris and Brussels, on the other hand, comic book stores flourish, and comics are a regular part of the culture that can be found in every bookstore. Most European countries support comics production in some way, either through publishing grants, as in France, or through a concerted effort to grow the comic book industry with high-profile events. Comics festivals featuring lavish displays of original art can be found in towns like Haarlem, the Netherlands; Luzern, Switzerland; Lisbon, Portugal; Erlangen, Germany; Helsinki, Finland; and, the largest of them all, Angoulême, France. These festivals are supported by grants from national and local governments as an effort to attract tourists and bolster national prestige.

Though many of the largest publishers in Europe are located in France and Belgium, an increasing number of small-press, independent, or alternative publishers have also started to gain attention across Europe. The largest publishers (Casterman, Dargaud, Dupuis, Delcourt, les Humanoïdes Associés, Glénat) specialize in full-color hardcover albums. These are generally forty-six pages in length, and follow the adventures of well-established characters (Astérix, Blueberry, Titeuf).

These adventures fall into a number of broad categories, including humor, western, thriller, detective, historical fantasy, and exotic adventure. For generations following the end of the Second World War the albums published by these publishers were pre-serialized in the pages of comics magazines (*Pilote, Métal Hurlant, Tintin*), although that tendency was severely curtailed in the late 1980s. While many popular characters in Europe drive the sales of books, a significant difference between Europe and the United States is that it is uncommon (though not unheard of) for series to be continued by artists other than their creators. Thus, while *Superman* has continued long past Siegel and Shuster's involvement, *Tintin* stories ended with the death of Hergé. This has led to a situation in which the authors of the best-known and best-loved comic book stories are well known as authors in their own right.

Small-press authors, on the other hand, are not traditionally as well known, although there are signs that this is beginning to change. The European small presses (Avant Verlag, Optimal, L'Association, Sins Entido) generally specialize in black and white comics with smaller print runs. These publishers put far less emphasis on the development of ongoing characters, opting for a more novelistic approach to storytelling. Many of these emphasize innovative or cutting-edge visual approaches to design. The stories tend to be more autobiographical and experimental, featuring stories of regular people in realistic situations. When genre is introduced into small-press comics in Europe it tends to be as a source of humor or an ironic commentary on the nature of comics.

Although magazines that serialize comic books have become increasingly rare in Europe over the past twenty years, comics are still placed in front of the public in ways that rarely occur in the United States. For instance, it is not uncommon for large national newspapers to serialize an entire comic book over the course of several weeks or months. Popular comic books have been serialized in the pages of *Libération* and *Le Monde* in France, for example, as well as in magazines like *Les Inrockuptibles* and *Télérama*. These serializations expose the comic to literally millions of readers, many of whom will ultimately buy the collected hardcover edition based on this initial exposure. This type of pre-serialization, and the wide availability of comics in non-specialist bookstores, has the potential to push popular comics to sales rarely achieved in the contemporary United States. In 2001, for example, the newest *Astérix* book sold more than three million copies, while other titles also did extremely well: *Le Petit Spirou* (600,000), *Blake and Mortimer* (500,000), *Boule & Bill* (500,000). Even non-traditional comics by well-known artists, such as Jacques Tardi's *Le Cri du peuple*—a comic about the French revolution—sold more than 200,000 copies.

Ultimately the largest differences between comic books in Europe and in the United States can be reduced to the fact that from the beginning, European publishers treated comics as books to be kept in print, while American publishers regarded comics as magazines to be thrown away. This meant that Europe developed the idea that comics were something worthwhile, while Americans developed the idea that comics were worthless trash. The widespread availability of comics in bookstores in Europe has meant that the best-loved works have tremendous longevity. Stories with a high degree of quality continue to be perennial sellers, with parents—or grandparents—often buying children new copies of the comic books that they themselves read when they were young. European comic book publishers treat their work similarly to how book publishers treat their back catalogs, and this has led to a more stable industry that can often rely on past successes to underwrite new directions. While European comic book publishers remain somewhat risk-averse, they are less so than their American counterparts, as the diversity of genres published in Europe demonstrates.

Recent years have worked to bridge the gap between the United States and Europe in the arena of comics. American publishers like Fantagraphics, Dark Horse, NBM, and DC have signed agreements to translate European comics into English, as have American book publishers like Pantheon. These publishers have increasingly begun to mimic the European model by focusing on the bookstore market and by keeping longer works in print as book collections rather than as magazines. At the same time, European publishers have continued to translate American comics, including superhero comics, and there is some evidence that these comics—along with manga—are becoming increasingly popular. Ultimately, as the American industry moves closer to the European model and vice versa, it is likely that the cultural differences will be minimized. Ideally, this will be accomplished through the marriage of the positive elements of each industry.

Manga in America, Manga in Japan
Bill Randall

If Japan has the biggest comics industry in the world, and it never bothered to tell anyone, then how did it become big business in the West in so short a time? And why does it matter? One could compare Toyota's and Sony's successes in Western markets, but that would assume the Japanese cared about exporting their comics as much as technology. They typically believe foreigners won't be interested in something "so Japanese." Yet the opposite is true: when a handful of fans discovered manga and evangelized for it through the 1970s and '80s, a foundation was laid for small businesses to import manga alongside the increasingly popular Japanese animation. At first, Japanese companies didn't pay much attention, but now that they see money can be made, they've taken notice. Meanwhile, manga has come full circle: no longer an unusual hobby, manga is a mass entertainment outside Japan.

Manga developed to meet a very specific need at a unique time in Japan's history. The current industry began during the occupation after World War II, when cheap entertainment was scarce. Manga began to flourish with the seminal *New Treasure Island* in 1947. That comic, an influence on a generation of artists, was the breakthrough work of Osamu Tezuka. Always cited as the prime mover of the industry and art of Japanese comics, he earned the name "the God of Comics" and is only now beginning to be translated in the West. His career, beginning during the occupation and ending with his death in 1989 along with Emperor Hirohito and the Showa Era, outlines manga's trajectory in history. What began as exemplary children's books, *Astro Boy* chief among them, ended with complex, often problematic attempts at sophisticated narrative.

Tezuka's *Adolf*, in tackling serious themes of war and history by using a cartoony art style punctuated with throwaway gags, shows how far manga had come by that point, as well as how tied it has been to its low-culture origins. Between these extremes, Tezuka's comics mapped out the major genres, like boys' adventure comics, science fiction, fantasy, girls' comics, and historical fiction. He even tackled biography in his largely invented take on the life of Buddha, and literary adaptation, turning *Crime and Punishment* and *Faust* into comics. Though manga became a huge industry in his lifetime, he died well before his work began to appear in the West, something he had long hoped to see. Regardless, his influence defined many of the conventions in manga, including its peculiar grammar. Japanese comics can

extend for hundreds of pages and often linger on the setting rather than get on with the story. With this length, manga can create intricate, believable worlds.

Tezuka orchestrated another of manga's hallmarks: productivity. Any series may stretch to thousands of pages, largely because Tezuka pioneered the studio system. In the studio, the credited artist handles the characters and the assistants fill in the backgrounds, the details, and the machinery. While the artist often writes the story, sometimes a credited scripter takes care of plot or dialogue, and often enough the editors step in to make sure sales stay healthy. The whole process sounds like an assembly line, which it is, but it's worth noting that East Asian cultures in general do not encourage innovation for its own sake as much as the West claims to, and these cultures foster effective teamwork in ways that the West can only envy. Japanese culture has often been called "group-oriented" by Western observers: the studio system offers an example of this orientation in a creative context.

Nonetheless, some manga artists work alone, especially for the smaller publishers. While the huge publishers—like Kodansha and Shogakukan, who specialize in pleasing the audience—dominate the industry, a number of small publishers print the work of artists interested mainly in pleasing themselves. Chief among them, Yoshiharu Tsuge drew avant-garde classics like *Screw-Style* for the legendary magazine *Garo*, founded as a showcase for the equally important samurai and ninja stories of Sanpei Shirato, a committed Marxist. Many artists have followed in their footsteps. While some have taken more commercial turns, others, like Kazuichi Hanawa, have kept their focus when working for larger publishers. Some choose to remain obscure: Yuko Tsuno has spurned offers from larger publishers, preferring the world of smaller presses.

While such artists represent the best manga has to offer, they are not the ones opening foreign markets. Those artists would be the Eiichiro Oda, Akira Toriyamas, and CLAMPs of the industry. They create satisfying genre work with a cross-genre appeal, mixing romance, martial arts, or science fiction. Such works define manga for the rest of the world. Interestingly enough, their forefather is not Tezuka. Instead, it is Katsuhiro Otomo, whose epic *Akira* marked the first commitment to manga by a major American comics publisher. Because his main influence was the French artist Mœbius, he offered a more familiar point of entry for readers than the very alien comics of Tezuka. That his American publisher, Marvel Comics, let *Akira* languish in an unfinished state for years, shows how unlikely the rise of manga has been, and how far it has come. Now, even if it cannot keep growing, manga at least seems secure overseas.

Manga's artwork, sometimes detailed, sometimes simple, strives for easily readable forms with clean, precise lines. While many fans chafe at the mention of a "manga style"—big eyes, slim bodies, and "speed lines"—uniform styles do come and go. More standardized are the stories. Japanese publishers know how to market their product to increasingly specific groups. Comics for new mothers, young salarymen, and junior high students sit alongside those for pachinko nuts, as well as boys' adventure comics, girls' romance comics, short gag strips, the "dramatic" works of gekiga, and even "subculture" or "personal" comics. In short, one can find genres and styles for any taste, as long as one's tastes fit the confines of Japanese culture. That's a point worth underscoring, because these stories, so odd to our eyes, make perfect sense in Japan.

That takes us from the business end of things to the more interesting questions of culture and aesthetics. Having manga readily available offers fascinating insight into the different ways Western and Japanese artists tell stories, as well as offering a rich source for young artists learning their craft. Some artists imitate the artwork or characters, but more valuable is the structure. Even the worst manga have a lot to teach about layout and composition. Most manga offer more than just fantasies and wish fulfillment and most of them meet high standards of craftsmanship. Even the dumbest books have clear storytelling.

While such aesthetic questions are valuable, perhaps more interesting are the cultural ones. The Japanese don't make manga for export, so it's a window into the contradictions and assumptions unique to their very insular society. The attitudes about gender relations, family structures, and education all surface in varying degrees, in ways that may seem either fascinating or absurd to a reader unfamiliar with the culture. Perhaps the best example is homosexuality. Japanese girls and women's comics frequently center on romantic love between men, yet homosexuals in the culture don't share the freedoms they would in the West. Why this seemingly double standard is not a contradiction has elicited fruitful commentary from any number of scholars, and an interest in such issues can deepen our awareness of what assumptions we have in our own culture, not just Japan's.

Ultimately, such questions far outweigh any consideration of the business of manga. Along with anime, manga have become the most significant pop cultural export from Japan, and one of the only widespread pop cultures not to come out of the United States. Any consideration of the business of manga should always come well after a look at the unique culture and circumstances that allowed it in the first place. And all these questions should come after a look at the work of the artists. After all, they have created in just a scant sixty years a vast, fascinating universe in comics, a remarkable gift to the form.

Section II:
Widening the Field

Comics in Art and Illustration

Interview
That Old-Time Religion
Elwood Smith

Obviously you love vintage comics; is your love what prompted you to develop your illustration style?
Absolutely. I was born in a small town in Michigan in 1941 and grew up studying all the great Sunday newspaper comics like Billy DeBeck's *Barney Google*, Elzie Segar's *Popeye*, and Walt Kelly's *Pogo*. I even got in on the tail end of *Krazy Kat*, which ended when its creator George Herriman died in 1944. I soaked up the pages of the *Detroit Free Press* Sunday comics like a blotter.

What are your other comics heroes?
Chester Gould's *Dick Tracy*, Schulz's *Peanuts*, *Alley Oop*, *Little Lulu*, *Katzenjammer Kids*, *Mutt and Jeff*, all those wonderful, original artists of the forties and fifties—a time of such an amazing variety of original voices. I also liked Batman, Captain Marvel, and Superman, but they didn't pull me into their world like Rube Goldberg and his cohorts did. When *Mad* magazine first appeared, Jack Davis knocked my socks off, but his drawing skills were beyond my ability. Thank God . . . his imitators are legion.

Does your style, which embodies these comics artists, govern how you solve a design problem, or is the style simply your voice and the problem is the problem?
Seems like I've pretty much absorbed the style and it has become my voice. My approach to solving the client's problem may be somewhat influenced by my style—that is, I don't normally think in large, graphic design shapes—but usually I think up an idea first and then begin the drawing. Sometimes, though, my inability to get the drawings the way I envisioned them will lead me to another concept, one that is often more original and unexpected than my first effort.

MOUSE?

RODENTIFICATION
PART 1 BY E.H. SMITH

MOUSE?

GEORGE HERRIMAN, THE CREATOR OF KRAZY KAT DIED APRIL 25, 1944. I WAS BORN MAY 23, 1941 AND I CAN'T REMEMBER A TIME WHEN I WASN'T CRAWLING ACROSS, LOOKING AT AND, FINALLY, READING THE SUNDAY COMICS. MY FAT BABY KNEE BONES WERE SMUDGED WITH IMAGES OF KRAZY, POGO, MICKEY, POPEYE, BARNEY GOOGLE, SNUFFY SMITH AND THE INCORRIGIBLE KATZENJAMMERS. THEY SEEPED INTO MY BLOODSTREAM LIKE A VIRUS, LYING DORMANT UNTIL I MOVED TO N.Y.C.

YOW!

GRRR

SYMPTOMS FIRST APPEARED IN LATE 1977. I FOUND MYSELF REPULSED BY MY TRUSTY OLD RAPIDOGRAPH. ONLY GILLOTT OR HUNT PENS WOULD DO. HATS BEGAN FLYING FROM HAIRLESS HEADS AND TALK BALLOONS MATERIALIZED TO ENCIRCLE EXCLAMATIONS LIKE "YOW" AND "HUH?" MY FRIENDS DROPPED AWAY AS I BECAME INCREASINGLY INVOLVED WITH CLOWN SHOES, WHITE GLOVES AND STINKY FIVE-CENT CIGARS.

ONE DARK AND STORMY NIGHT, AS I SAT AT MY DRAWING TABLE, ALONE, UNWASHED AND SPEAKING IN PUNS, LOU BROOKS, DISGUISED AS A RODENT, APPEARED AT MY DOOR, A HORSE BLANKET SLUNG OVER HIS SHOULDER.

HUH?

LOU UNWRAPPED THE WELL-DRAWN BLANKET (HE SWORE IT BELONGED TO SPARK PLUG IN THE '40s) TO REVEAL THE CONTENTS: SEVERAL TOM WAITS LPS, A BEATEN UP HARDCOVER OF RUBE GOLDBERG CARTOONS, TWO BRANDY SNIFTERS AND A BOTTLE OF VINTAGE INDIA INK.

THE PIANO HAS BEEN DRINKING...

THE NEXT DAY, WE EMERGED FROM MY 23rd ST. APARTMENT, AS THE MORNING SUN PEEPED THROUGH THE CABBIE HAZE. "CABBIE HAZE?" LOU SAID, A BIG SMILE ON HIS INK-STAINED FACE, "YOU'RE GONNA BE O.K., KID!"

© '97 E.H. SMITH

Are there limits in terms of what type of content your style can appropriately handle?

I don't often get calls for "serious" subjects like rape and torture. I also don't do caricatures worth a damn, so I don't get those calls either. Occasionally, editors and art directors view my work as too "down home" for certain projects but I do get work from *The New York Times* and *The Wall Street Journal* and their readership is about as "uptown" as it gets. I think my style can handle a broad range of subjects, but I don't think Marshall Arisman spends much time looking for me in his rear view mirror.

Your work is very kinetic; do you think in terms of motion?

Oh yeah, I'm a kinetic kind of person with lots of nervous energy. I think my work reflects that. If you visit my studio you'll see the carnage. Heavy safes and tumbling anvils fall from above on a regular basis. I live in a scary world.

How versatile is your approach in terms of problems that you are given?

My style has served me well. It has slowly evolved over the years, but the work and I are now very comfortable sharing the same space. And now that I'm getting into animation, all the years of refining my style has paid off.

Given that your characterizations are ready-made for comic strips and animations, have you ever developed a repertory of characters?

Not really. I have some characters who show up regularly in my illustrations, like those nervous rabbits peering over hills and from behind bushes. I like to stick faces on suns and moons, getting them to react to the events taking place below. They add an immediacy to the action, helping the reader to get into the thrust of my intentions—and, one hopes, the author's intention, as well—even before they've had time to view the entire illustration. Over the past year I've been creating some characters for my animation projects. The Little Green Monkey is my current favorite. He's probably going to be hanging around for a while.

What would you say to a student who wants to illustrate, but also wants to be a comics artist?

Focus on becoming a comics artist. Leave the illustration to me. I need the work.

Seriously, I'd say go for it if you have the desire. Artists like Ed Sorel have effectively crossed back and forth over the fine line separating cartoon strips and illustration. Unless an artist wants to draw comics written by others, they'll need to write. They'll need to come up with stories. They'll *really* need passion, dedication, and a willingness to work hard. Talent, of course, but if they have a genuine, full-blown need to create their own world, a young artist doesn't need any advice from me.

Representational Art to the Forefront
Robert Williams

How did you acquire your drawing skills?

It was a propensity with me as a child. Even in elementary school I was a marginal draftsman. The teachers all commented on it and I found I was elevated from the rest of the students just on account of the fact that I could draw a little bit. And once I realized there was a fine arts world out there I started majoring in art. I took all the classes I could in junior high school, high school, and college. I would root out old books on art history. I pursued and searched out just about anything that had the word "art" connected with it. The study of art history is very important for a cartoonist.

Comic books got me interested in graphic representational art. Comics were a "bad" influence. They had a lurid, exciting quality, an energy that really fascinated me. And that got me interested in graphic representational art. I would study anatomy, facial expressions, and story situations.

And in my early teens I got involved with hot rods and motorcycles and car magazines, so I naturally fell into that wake that was established by Von Dutch. By luck I ended up working for Ed Roth, who had something of an underground think tank at Roth Studios down in Maywood, California, airbrushing monster T-shirts and doing decals. He made me art director, and I had tremendous freedom. I was encouraged to be as imaginative as I could.

I'd say my three biggest influences are probably Salvador Dali, Wallace Wood, and Von Dutch.

What role did your comix work play in your development?

Well, through Ed Roth I met Stanley Mouse, who was a competitor as a hot-rod T-shirt designer in the early sixties, and through them I met Rick Griffin, and eventually Victor Moscoso, Gilbert Shelton, R. Crumb, and the rest of the underground movement. When the psychedelic period came, I fit in perfectly. I found a lot of kindred spirits. And once I got involved in *Zap* comix I realized that there were an enormous number of artists who were disenfranchised from the fine-arts world. And this, of course, later led to the development of *Juxtapoz* magazine.

Where do you draw the line between highbrow and lowbrow art?

The snobs who accept you or reject you are the ones who draw the line. Those people determine whether we're highbrow or lowbrow. We're subject to the cultural authorities.

One of the top curators in the world was Walter Hopps, who recently passed away. He's the guy who put together shows on the West Coast back in the sixties with Ed Ruscha, Billy Al Bengston, Ed Kienholz, that whole slew of formative artists who've gone on to international fame. Walter Hopps was very well versed in what's called lowbrow art. He was always abreast of what the hell's happening. He stood almost totally alone in his understanding that there's another dimension and depth to American culture that isn't just the foamy top head of the beer that's fine art. But that man was such a rare, rare exception. Infiltrating and indoctrinating the hierarchy of the art world is an enormous feat, and sometimes I don't know if it's even worth trying.

But on the other hand, *Juxtapoz* has wormed its way up to second place in newsstand sales of art magazines. Its circulation is about 65,000. *ARTnews* is number one with an 83,000 circulation. *Juxtapoz* outsells *Art in America* and *Artforum*.

Now *ARTnews* says there's no competition because there are two different categories, but I think in the years to come, these categories are gonna blend together. If *Juxtapoz* has got that much distribution, influentially, it's obviously gonna start overlapping into almost all the art schools.

Have you seen evidence of a shift?

Yes, and you can see it in the material that shows up in the other art magazines. You can see a gradual shift to cartoon imagery that isn't blatantly Pop Art in art shows now. There are some top artists that read *Juxtapoz* who are definitely influenced by it. I know a number of them.

One thing that's very disturbing to me is that a lot of artists in the fine-arts world are parasitic to comic book art and cartoon imagery. See, cartooning doesn't play well with the rather uneducated group of people who make up the "cognoscenti" of the art world. Cartooning contains a vocabulary, a pictorial syntax, a graphic language that the snobs just aren't aware of, but when these fine artists formally present themselves they don't refer back to *Zap* and EC Comics and this whole great, rich visual tradition that has happened in the United States and Europe for the last hundred years. Instead, they come up with the lame story that they're an extension of the Pop artist. They've still got to fall back on the orthodox tradition of Andy Warhol and Jasper Johns and people like that. And

that's just not the case. That's happened in several large art shows already. And it's heartbreaking.

Your magazine features comics artists, but why does it exclude their comic book work?

If you show sequential panels, all of a sudden your magazine becomes a "funny book." *Juxtapoz* is trying to bring representational art back to the American forefront, and the worst thing we could do would be to throw comic books in there. We're very interested in underground comix and comics imagery, but once you start to show sequential panels that are meant to take you to another panel, then you start to dilute and weaken the strength of the picture, because the story is more important than the picture itself. So we leave that job to comics publishers.

How do you determine who to feature in *Juxtapoz*?

We look for a certain amount of imagination, and a certain amount of skill. And it certainly helps if they've got a certain following already. We go out of our way for female and minority artists, of course. But we're always looking for artists who would dare to stick their neck out. It's very, very hard to find artists who have a lot of *guts*, who aren't just trying to placate an audience to make money.

What's your advice for cartoonists who want to be exhibited and featured in your magazine?

First you have to realize that it's a very rough situation. And you have to develop a bohemian attitude of, I might starve, but I'm a real artist. If I fail at this, nonetheless I expressed myself and I know in my own heart I was good at it.

And a lot of people aren't gonna make that transition. A number of artists featured in *Juxtapoz* are illustrators, and when this goes sour for them, they move on to the next thing. They have a mercenary personality. They don't have the integrity that's gonna keep them on the road.

It has to be a labor of love. Your compulsions are what are going to guide you.

The nobility of suffering aside, you're painting a very bleak picture.

Well, let me say this, and this is a lot more optimistic. I went to art school and became an artist in the late sixties. In a class of forty people, maybe two or three who got a bachelor of fine arts degree could probably make some kind of living in the arts. Now I would say it's 20–25 percent. That's an enormous amount. It sure as

hell isn't 100 percent of the people with BFAs. But the market is much more open to innovation now than any time in my life. So it's a very positive time. I'm hoping it'll get even better.

And I've always looked at it like this: hardship is the artist's best friend. If it weren't for hardship *everyone* would be an artist. Just about everyone thinks they have an artistic nature, doodling and whatnot. So adversity can work in your favor. Younger people, who have tenacity and stick-to-itiveness, can use the influence of comics, can develop abstract thought in their subject matter, and can open up whole different worlds. But they're not gonna accomplish that doing tikis and rehashing Bettie Page and stuff like that. It's gonna take imagination.

Section III:
Education Illustrated

© Dan James

© Nicholas Blechman

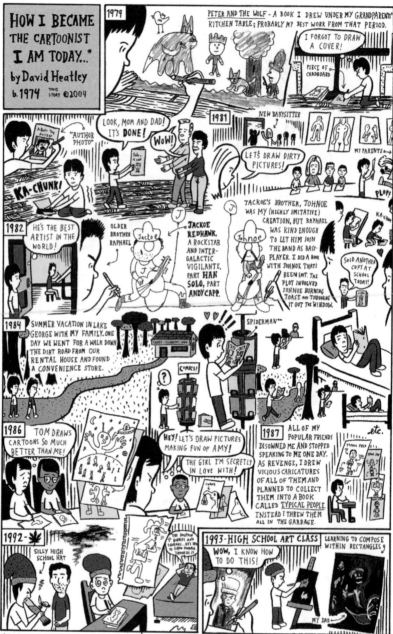

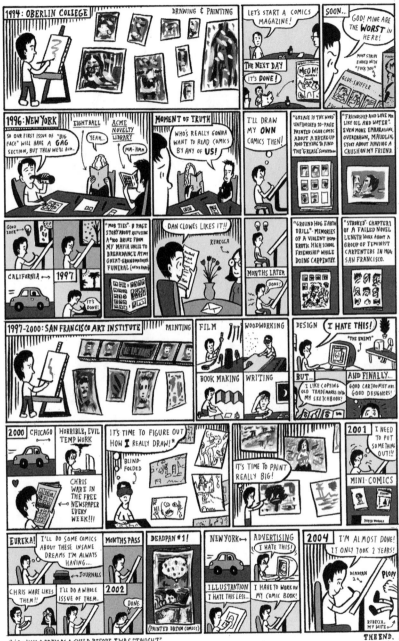

© David Heatley

Rick Meyerowitz

Section IV:
The Comics Profession

The Business of Comics

Surviving the Convention Circuit

Heidi MacDonald

By choosing a career in the comics field, creators have opportunities that no other line of work offers. One of them is the chance to meet their audience in a very public way: comic book conventions.

These events have become part of popular lore with numerous talk show segments and sitcoms showcasing the high number of attendees dressed as Stormtroopers and Klingons; but in truth they are a vitally important part of the comics business for finding and promoting your work.

Whether because of the modest level of fame that comics brings, or the often-fannish nature of the material, cartoonists and conventions seem to go hand in hand. It's unlikely that fans of Brad Pitt or Madonna, say, will ever get to meet their heroes in a casual, one-on-one setting. Authors may do book signings, but getting to see a Stephen King or Joyce Carol Oates is a rare occurrence. In contrast, at a comicon (as they are known) you can meet and greet the creators of characters from *The Simpsons* to *Wolverine* to *Spider-Man* and have brief conversations with them, or even get a sketch. This accessibility of even comics' greatest stars is part of what gives the business such a friendly, inviting nature.

For people in the business, cons, as they are also known, provide a terrific chance to catch up with old friends and make new ones, as well as pick up art, tchotchkes, and even comics, old and new.

For the creator, the convention circuit holds both unique opportunities and unique pitfalls. Understanding how to use them to promote your career is essential, but it's easy to get sucked into the social whirl as well.

The first thing to understand is how to use conventions as a means to break in to the business and then get more work. Editors and art directors from comics companies large and small attend the major shows: the San Diego Comicon and the larger Wizard World shows. While getting a pitch read at a show is unlikely (and Marvel and DC flat out refuse to take unsolicited submissions any more), publishers

usually set aside time for portfolio review. While it's unlikely that anyone will get a job assignment out of a portfolio review, the most talented folks will get a business card and an invitation to stay in touch with an editor. It may not seem like much, but most of the work from comics hopefuls at the shows is of such a low level that editors are sincere when they see something with talent and creativity.

The bad news is that it may take years of hanging around, slowly improving your work, and even getting into indie publishing before you can actually make the leap to paid comics professional. The good news is that it can happen. The ranks of the comic world are full of people who just hung out long enough and worked on their craft to the point where they finally got a break.

Once that initial contact is made at a convention, it needs to be followed up on when you reach a new level. Sending a care package of work every once in a while is not a bad idea; it may get tossed in the trash, but someone may see it, too. Speaking as a former editor, when I saw a good portfolio or a well-conceived indie book from a writer, I made a mental note of it and followed that person's career. Quite often they ended up breaking in, and some of the people I followed from school are now quite successful in the business.

However, it's important not to wear out your welcome at a show. You may think you've established a terrific relationship with Eddie Editor. That doesn't mean he wants to go to dinner with you and stay up all night drinking in your room. A polite, professional hello and update is appreciated; an on-the-spot dissection of why one of the editor's current projects sucks is not.

As in any work-related situation, pitching at conventions is an art. Someone who is talented but rude and obnoxious isn't going to find many doors thrown open before them. Courtesy, modesty (false or genuine), and the ability to take criticism are essential.

And a word on that criticism: the ranks of comics' greatest artists are full of stories of editors who told the budding virtuoso that "you'll never work in comics." The determined few took that as a challenge and made it to the top—some of them even bearing grudges against the crusty editor who dared to be blunt.

Thus, it's easy to take portfolio review too seriously. However, if you keep hearing the same complaints over and over again—need to study anatomy, need to learn perspective, your storytelling is weak—then there's probably something to it, and this is an area where you need to put in some work.

No one likes to be criticized, but keeping an open mind and listening to fair criticism without crying, withdrawing, or getting defensive is a sign of future

professionalism. That isn't to say you shouldn't be ready to speak for yourself either, since portfolio reviews are full of legendarily clueless comments. However, if you're going to present yourself as a brash tyro, be prepared to have the chops to back it up.

That's how to approach a show as a beginner. Once you have a project, whether self-published, indie, or mainstream, cons provide a place to promote them and your work. Most conventions have an "Artist's Alley" area where, for a modest fee, you can buy a table at which to sell your work. Established artists usually take commissions for sketches at the show, and for the better artists, this can be a nice supplemental income. If sitting behind a bare masonite table on a concrete floor isn't quite your cup of tea, you can take out a booth on the main floor; it may be much more expensive but it will showcase your work in a more elegant setting. Once you up the ante, however, be prepared to put some work into it. A few color photocopies pinned to a curtain aren't a booth display, or at least, aren't a *good* booth display. Putting together a good-looking booth can be expensive and time consuming; however, a top-notch presentation will draw more people and promote the project to its best advantage.

It's important to remember what was said at the top of this chapter about access; to the fan at the show, you are the star. Sitting behind a table making small talk with fans who range from stunning and intelligent to people who haven't seen the sun or the inside of a shower for months is a tiring affair; you need to like to meet your public. However, there are multiple payoffs here. A pleasant experience with a creator can turn a casual fan into a lifetime fan. Having to shake the hand of everyone who buys your work doesn't seem like the road to easy street, and it isn't. But for every loyal fan there are at least two casual fans. If you're going to go to the show, be prepared to make new fans.

Of course the flipside of this is that the con is a chance for the artist in his or her lonely garret to get some props. Creating is a solitary job; cartoonists are lucky in that they have so many opportunities to get out and sign autographs. As more than one comics pro has told me, "This is our rock concert." The best part is that unless you're a Neil Gaiman or a Jim Lee, once the show is over you can go buy ice cream in your pajamas at the local "Foodtown" and go home; no one is going to be bothering you and the *National Enquirer* is unlikely to print compromising photos.

That does lead to one of the hidden pitfalls of con-going, however. While promoting your book, having business meetings, and visiting with colleagues is an indispensable part of your business, it also means you aren't at home writing or

drawing. I've met many an artist who went back to their hotel room when a show closed to stay up all night inking or drawing to meet a deadline. Also, with the sheer number of cons being held, the time spent preparing for and recovering from the shows can put a serious crimp in output.

Comics lore is full of tales of artists who spent so much time partying at conventions they blew all their deadlines. Once you fall behind, it's almost impossible to catch up. Be wary of overdoing it. There are currently about a dozen shows considered major in the United States. You don't have to do all of them. On the plus side, being choosy about which shows you go to will make your infrequent appearances even more special and well attended.

A few words that shouldn't be necessary but are. Follow what is known as the "5-2-1" rule at a con: strive for a minimum of five hours sleep, two square meals, and one hot shower a day. This will make things a lot more pleasant for you and the people around you.

A comics show offers a chance to talk shop, keep up to date, and promote your work. But you shouldn't forget about the intangible "fun" factor. As comics grow in reputation, all kinds of people show up at cons and you will make connections you never expected to make. It's also more memorable, somehow. As cartoonist Dean Haspiel puts it, "Even though all the editors live in New York, where I'm based, San Diego is the place to meet and greet. You go drink a beer with someone in San Diego, you get a job."

Comics conventions are a good place to meet your heroes, your fans, and a lot of people dressed as Stormtroopers. There's a pretty good chance you'll make friends at a con who will last your entire life at a con. Scott McCloud calls the annual San Diego con "the gathering of the tribes," and as I said, there is something unique about the comics community. Everyone likes to meet others who share their interests, but there's something about hanging out with other cartoonists that will enrich both you and your work.

Popularizing the Comics

M. Todd Hignite

Comic Art cover art and design by Seth;
© M. Todd Hignite

While it is a great relief that the endlessly diverse comic book medium has now arrived at the point in our culture that any defensive justification of the best work is entirely unnecessary, this is not to say that confusion regarding the strengths of the art form—comics' constant bedfellow—doesn't make one a bit wary. Comic books receive an increased degree of widespread popularity every decade or so in entertainment columns, nearly always at least tangentially related to the marketing of superhero properties, which are at this point a small genre within the medium. Such press coverage is misleading to the general reader, as the most important work has occurred outside that genre, both artistically and from an entertainment standpoint, for at least the last twenty years. For the format to achieve a sustained popularity based on its unique achievements, attention need lie consistently in the formally and conceptually sophisticated narrative art that is being created in the art comics arena. This refreshingly seems to be the case recently, but the critical and popular reception of the medium remains fraught with misunderstanding due to its inherently nebulous artistic qualities and cultural stature.

In the past, most work of interest within commercially dictated set genres—dominated mainly by superheroes, but also, at one time or another, humorous animals, crime, and romance—came from smuggling personal visions into a formulaic set of acceptable story and character conventions. This was done primarily through telltale stylistic flourishes and formal invention, if only occasionally the complete package of art and narrative. By embracing the disreputable trashiness of the then cut-rate industry, disenfranchised artists found a working space through idiosyncratic interpretations and impressive subversions of tropes, and such coded, fetishized, hidden meanings continue to resonate; indeed, they represent a great appeal of the format prior to the American underground.

However, it is obviously preferable for artists to work without such commercial imperatives, or even the slightest editorial restraints with regard to subject matter, approach, or format, as is the case right now. The comic book has been bound by a commercial history, and all that entails, but now it is moving into a pure art form, and all that entails. Always highly self-reflexive, comics are no longer tied to genres, as none remain fixed. For example, even within the art comics arena, the autobiographical movement that dominated ten years ago has now completely splintered. Alternative markets have been developed over the last few decades that preclude such overtly market-driven imperatives. So now, as within any mature medium, all genres are available for use in part or whole, and the best contemporary cartoonists, like all true artists in any medium, use them freely, smartly making art that functions on multiple levels simultaneously.

This changing nature of the art form merely exacerbates the confusion with which it has always been received. Comics are perpetually "in-between," characterized by constant friction between the visual and textual, mass consumption and personal expression, rigidly dictated subject matter and artistic liberty; in fact, it is this constant spark that has made the medium so unique. Completely free of past constraints, current popularization then rests on the perilous perch of art. Cartoonists and their champions have won the fight for acceptance on unhindered artistic achievement, so now the hybrid medium is faced with how to exist within the art or literary worlds . . . or both. The defining in-between qualities have historically proven equally problematic in more respected arenas, where misunderstanding also abounds, for instance:

❯ The museum world: Exhibitions predictably rely on a narrative that presents comics within the context of more easily digested strata of artistic production. While this undeniably proves a useful way of understanding painting, viewing individual original pages independent of their narratives evokes only a fractional comprehension of successful work within the comic medium.

❯ Academia: That content is created by self-aware individual artists with goals similar to artists in other mediums is misunderstood and frequently dismissed in favor of the mass nature and reception of the print medium as the crucial aspect of all production. Explicating contemporary comics through the overarching lens of "culture studies" inevitably stalls out pretty quickly.

❯ Within the industry itself: Much critical literature remains a short-sighted, incestuous snarl in which spiteful one-upmanship is mistaken for criticism.

In order to garner lasting and meaningful widespread attention, the still-young medium must be understood on its own merits and continue to diversify and expand into the broader culture from within. Thankfully, the only choice now for those invested in the comic book is to continue pushing forward, exploiting the undeniable conceptual sophistication and fluidity of the form and holding out hope that critical and popular acceptance is certain. There's no turning back, but presupposing the continued relevance of print comics, whether in pamphlet or book form, the medium is currently in a state of flux.

Does the future then reside with the self-produced booklet, traditional comic pamphlet, or high-quality hardcover, marketed for mainstream bookstores rather than the oft-derided "comic store ghetto"? Collections available to the general

reader, properly organized and placed in bookstores, are of undeniable importance, but a key will be a new generation of venues—which have the courage to reflect the true zeitgeist of the medium as well as its history—rather than the stereotypically myopic comic book shop. As unrelated as art comics are to standard (or un-standard) superhero fare and to "art" in a gallery setting, attempting to understand them as "books" in the traditional sense is equally stunting. The visual language of cartooning and the history of comic art should be taught both as a specific discipline and in relation to, and in contrast with, other popular and fine art forms. This can be done by navigating the huge number of narrative, formal, and conceptual approaches; cultural impetuses and uses; and by understanding that, even though now accepted as an art and literary form, the medium is a constant interloper within historical definitions of those disciplines. The promise that the most impressive achievements will be coming in the next decade means more varied formats, better criticism, and greater awareness of the medium's rich past. For the first time, then, popularity will be stemming outward organically, and continued growth seems positively inevitable.

Growing Pains

Eric Reynolds

Recent mainstream acceptance of comics by the likes of Dan Clowes, Chris Ware, and Joe Sacco—including film adaptations, major book deals, museum exhibitions, and academic focus—has resulted in the codification of the term "graphic novel." It may have a nice ring to the untrained ear, but it's an unfortunately pretentious description that has taken over the publishing industry because it has a more-respectable connotation than "comic book." Yet graphic novel is a misnomer when it comes to something like Sacco's *Palestine*, which is non-fiction reportage. What's more, while Clowes' work is indeed literary, it is rooted as much in comic traditions. Ware's construction is even further afield from the traditional novel, owing as much to the syncopated rhythms of music as any visual medium. True, they are all graphic, but the terminology suggests the hand of marketing departments operating without input from the authors themselves and ignoring the unique properties that comics offer apart from prose or film.

The long-standing and proud "comic" traditions in cartooning, from *Punch* to *Mad* to *Zap*, have given sway to more ambitious formal approaches, expanding the form both literally and figuratively, pushing the term "comic book" and its associated format—the twenty-four- or thirty-two-page stapled pamphlet—increasingly to the edge of anachronism. This is despite the fact that most of the art form's most sophisticated practitioners at least in some ways seem to regret the trend.

I recently asked Sacco, one of the most respected journalists of his generation, in any medium, whether he preferred "graphic novel" to "comic book" and he said, "By a long shot, I prefer 'comic book.'"

For better or worse, however, alternative and underground comic books have slowly begun to make the traditional comic book obsolete in its own market. It is an anachronistic format, with a reliance on periodicity and origins in the newsstand market, a rigged game if ever there was one, requiring you to flood the market in hopes of boosting circulation to be able to attract the kind of national advertising that allows you to operate everything else at a loss. These just aren't realistic goals given the labor-intensive and time-consuming nature of creating quality comics, which requires skill in several disciplines and an ability to make them all work in harmony. It's not unusual for an alternative comic like *Eightball* or *Optic Nerve* to now take over two years for an issue, and the newsstand business is not set up to accommodate bi-annual publication schedules. In addition, there isn't enough of a

critical mass of excellent comics like *Eightball* or *Optic Nerve* to sustain a retail base of their own (which is where graphic novels have come in, but more on that in a moment), so they are relegated to the comic-book specialty market, which is usually indifferent at best or hostile at worst towards anything that doesn't maintain equilibrium in the states of arrested development that most of these shops were founded to indulge in the first place (see Comic Book Guy on *The Simpsons*, a stereotype that any comic book fan in America will recognize immediately).

The irony of the increasing marginalization of the traditional comic book is that, for most creators, the traditional comic book format is a perfect financial route, because it usually allows one to get paid faster. Most publishers don't pay until publication of the work or at least until the work has been turned in, so submitting a twenty-four-page comic book is an easier way to get by than working in two-hundred-page cycles. But most alternative or underground cartoonists simply can't maintain the kind of schedule that is crucial to establishing any kind of momentum in comic book shops.

Publishers are keenly aware of this as much as anything in the "graphic novelization" of the American comic book industry (which could be considered a "Europeanization" of things). Inherently wider market aside (due to available distribution channels), book collections also have a better scale of economy to them than comics. And if that weren't enough, the market is driving itself now: many fans have grown accustomed to waiting for book collections, slowing sales on traditional comic books. And for those consumers who are learning to buy their graphic novels from the bookstore market, in most cases there are no traditional comic books to be found, so the format isn't benefiting from the added exposure the medium itself is getting.

As a result, comics are in the midst of the most dramatic paradigm shift in the way that they are packaged since an entrepreneurial newspaperman named Max Gaines took one of his tabloid Sunday newspaper comics sections, folded it in half, stapled it, and called it a comic book over seventy years ago. Growth at the book trade level will continue to steer publishers toward going straight to graphic novel whenever the cartoonist's personal situation will accommodate the economic realities (one of the most critically acclaimed cartoonists of the last twenty years, *Louis Riel* author Chester Brown, recently announced that after two decades in comics, he will no longer serialize his work first in periodical form).

But to sustain themselves, publishers will need to rewrite the book on the way contracts are entered into and payments are processed. The way things have existed

up to now, cartoonists cannot afford to create graphic novels. Whether the medium will grow enough to be able to accommodate the kinds of financial advances necessary for an artist to subsist on while working on a book will likely directly influence the number of great projects released in the coming years.

If the comic book is to survive, it will almost certainly fall to the traditional, mainstream publishers that the industry was built around to save it. The literary and narrative potential of the long-form "graphic novel" is finally being reached but is very much at odds with the format, genres, and industry that have been in place for seventy years. The assembly-line process for creating corporate comics, on the other hand, lends itself perfectly to the comic book format and the serial nature of a comic book series is better suited for the melodramatic and soap operatic elements of the stories. Yes, this can still result in the occasionally respectable fan-favorite, something that excels in its craft and is worthy of collecting later in more permanent form. But the vast majority of the work created is a product of its time, crafted by journeymen who are hacking it out for a living on a strictly work-for-hire basis and it is work that few consumers will feel a need to purchase a second time in a more permanent format. Most monthly comics are soap operas that chug along with the same tenacity as *Days of Our Lives* and are beholden to the same bottom-line results, none of which are particularly germane to art.

The mainstream companies—Marvel, DC, and Image, notably—have always flooded the market with both traditional comic books and random collections of mediocre product, presumably in an effort to increase their fool's gold (market share), diluting the quality of books available and confusing prospective newcomers. How many *Wolverine* collections does one really need, anyway? A company like Marvel seems to think the answer is at least as many as the market can bear, and maybe more. Publishers need to have an editorial vision in deciding what to collect or they will dilute the growth of the graphic novel and perhaps cripple the comic book at the same time.

As it stands, it looks as if the graphic novel is here to stay and the comic book is on its last legs. With any luck, both will survive, but not without some growing pains.

The Creation of Comics

Bring out the Dead!

Craig Yoe

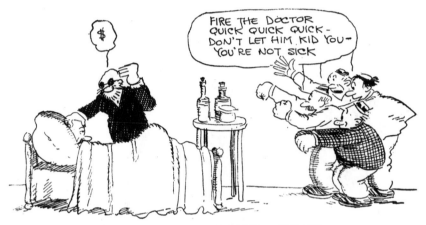

Rube Goldberg

Walt Kelly

Heinrich Kley

Yo! Those who don't study the 'toon past are doomed to not repeat it!

And that's a bad thing because the only good cartoonists are dead cartoonists; with maybe one or two errant exceptions. And *you* could become one of the few Living Great Cartoonist Anomalies, but you've gotta dig up the dead cartoonists' work and study it, hell, *steal it*, and call it your own!

Lionel Trilling got it right: "Immature artists imitate. Mature artists steal." You're going to have a great time, too, being a mature grave robber . . . er, "*arteest.*" There is both profit *and* fun in digging up comics past.

There's the 1930s funky, foul, flippant One-Eyed Sailor, Popeye, by E.C. Segar. There's Thomas Nast courageously crosshatching corruption in his political cartoon punches from the Civil War on. Nasty!

When you can duplicate the slick trick inking of Wally Wood's 1950s sci-fi comics give me and every other art director a call; we've got plenty of work for you that's been left undone since poor Wally shot himself in the head after a lifetime of suffering the slings and arrows of, well, art directors.

Go back even to "The Beginning" and study Töpffer. He was a schoolteacher, of all things, and pretty much invented comics back in the 1830s. It could be easily argued that comics never got any better than Töpffer 'toons. But you could try. Once you've seen his seminal comics, build upon 'em and try and top Töpffer.

Wanna draw gross cartoons? You gotta study Basil "Bean Beak" Wolverton of the 1950s. *Life* magazine said Wolvertoons were from the "Spaghetti and Meatball School of Art." Sign up now for classes!

Conversely, do you dig the idea of delineating cute bunnies? You gotta study rabbits drawn by Walt "*Pogo*" Kelly. Cootsy-woosty bunny-wunnies that would make even the most cynical hard-ass go, "Aww-w-w!"

Wanna zing 'em with biting satire? Chew on the concoctions of Harvey "*Mad* comic books" Kurtzman!

Does the idea of creating macabre cartoons haunt and excite you??? Charles "*Addams Family*" Addams' panels from *The New Yorker* must wallpaper your studio walls. And be a placemat on your dining room table. Put an Addams cartoon on your computer desktop. Lift your toilet seat and see an Addams cartoon glued there. Snag an old Addams book off the Internet and read it while you drive.

Your head bone is a computer and you have to constantly scan and put in its memory Addams cartoons and a gazillion other great cartoonists' images so you can download when necessary.

Bonus tip: Wanna get lucky? Read the bittersweet, romantic, poetic, *Krazy Kat* by George Herriman to your potential paramour. Guaranteed: you'll be getting some olive oil on your popeye in no time.

You'll be amply rewarded by studying another old cartoonist genius who's gone onto his reward, Rube Goldberg. This wacky cartoonist drew zany, convoluted inventions that performed simple tasks like sipping soup. His name is even an adjective in the dictionary. You'll hear "a Rube Goldbergian contraption" used during congressional hearings when one politico is railing against another for complicating things that should be simple.

I especially mention Goldberg because he talked about studying the cartoonists that worked before him and declared, "I shall never forget the excitement I experienced when I first took hold of *Puck, Judge, Life* magazines, and inhaled the fragrant aroma of printer's ink, galloping over the shiny pages in the intriguing shapes of humorous figures by T.S. Sullivant, Zim, Albert Levering, Keppler, Gillam, Gibson, and others. I literally held the magazines close to my face so that I might inhale the talents of those cartoonists whose work I admired with an adolescent ecstasy."

All the deceased ink-slingers cited could *really draw*. Screw your "Art Brut" approach. You mean you can't draw worth shit?!? Well, cartooning is already on the verge of being obsolete and you don't want to do anything to help hurry the demise. Learn to draw, really draw, Bucky!

To do that, study the work of great cartooning draftsmen. Study the bizarre drawings by German genius Heinrich Kley. Study the fabulous femmes of Frank Frazetta and the beefier ladies by Frazetta's pal, Roy G. Krenkel. Both of the later Brooklyn-ites surely studied the sexy drawings of Australian Norman Lindsay. Those guys all have "realism," but don't think for a second that there's not great draftsmanship in Carl Barks' cartoony *Uncle Scrooge* and Jack Cole's silly surrealistic *Plastic Man*, man!

And then if you want to eventually end up with a simple style, eyeball Ernie "*Nancy*" Bushmiller. He could have drawn with the best of them if he had wanted to, but chose to keep it simple, yet sublime!

Just because "cartoonists" like Scott "*Dilbert*" Adams and Cathy "*Cathy*" Guisewite and a tribe of "indie" "cartoonists" have gotten away with not being able to hold a pencil to save their ass does not mean you'll pull off the same sorry scam. A pox on these posers!

Note well: a Frazetta or a Kley would tell you not to only study great comics but study the figure actually "From Life." In other words, spend quality time draw-

ing naked people; is this such a horrible thing to ask? Now, drawing models in the altogether is a different subject all together. But, because of its importance, dedicatedly practicing life drawing while studying dead cartoonists must be mentioned.

You must amass a huge collection of cartoon work of the Masters who have crossed over. It will drive your roommates nuts, but your towers of original source material must fill every square inch of your pad. *!%$ your roommate's criticisms; if you're doing it right you'll even get a condemnation from the %$@ Health Department! You must have piles and piles of moldy old cartoon hardbacks, yellowed clippings of daily comic strips, stacks of rotting comic books, boxes full of mite-infested old humor magazines filled with panel cartoons. You must have shelves and shelves of DVDs of old scratchy black and white animated cartoons from Winsor McCay's primal *Gertie the Dinosaur* to the psychedelic sensuality of *Betty Boop*.

These bookshelves should not be fancy-schmancy. They should be made from rough old scrap wood and beat-up bricks rescued via dumpster diving. You see, every penny must go to getting more and more schtuff. You must spend all your money on this. Clothing, food, and shelter is overrated; you must buy 'toons!

Your place must be filled with cartoon pix the way Uncle Scrooge's three-story money-bin vault was filled with pictures of dead presidents. Scrooge used to shout about his money, "I love to dive around in it like a porpoise and burrow around in it like a gopher and toss it up and let it hit me on the head!" You must have the same insane zeal about your collection.

Now when all this treasure is around you can begin to create. You'll draw hands with four fingers, having learned that from Ub Iwerks (the creator of Mickey Mouse; who the *hell* was Walt Disney?!?!). You'll draw funny noses while your nose is buried in a book by Milt Gross. You'll draw big feet sitting at the feet of the dude who drew the first successful daily comic strip, Bud Fisher. (And—after all is said and done—big feet are what makes toons funny! Rather, big feet equal cartoons. Cartoons equal big feet).

"For Further Study" (as they used to say in my grade-school textbooks): max out your credit cards and hock *all* the worldly goods of your own *and* your roommate and buy . . . O*R*I*G*I*N*A*L A*R*T! With the actual art you can closely study the preliminary pencil lines, run your finger over the ink, feel the thickness of the paper, see what the Old Dead Cartoonists left in . . . and scratched out!

Your roommate is now plotting how you will join the Dead Cartoonist Society, but quickly now: take all your treasures and hold them close to you as you channel those dead geniuses. Now you will create great comics.

I leave you with the immortal words of Wally Wood who had file cabinet after file cabinet filled to overflowing with clippings of The Old Masters and said, "Don't draw it if you can copy it. Don't copy it if you can trace it. Don't trace it if you can cut it out and paste it down."

So, Young Cartoonist: Plunder the Past and Funny the Future!

Street Smarts

Colin Berry

There's a moment early in *Wild Style*, Charlie Ahearn's 1982 feature film documenting the roots of the New York graffiti movement, when the director quick-cuts between a set of murals, tags, "bombs" (heavily-painted designs), and "burners" (bold, bright ones) done by the genre's earliest practitioners. Among the crazy letterforms and snaking logos, several familiar faces peek out: Donald Duck, Dick Tracy, Popeye, Snoopy, Richie Rich. For viewers who had never seen graffiti (or New Yorkers who saw it constantly), these visages were probably comforting, if a little unexpected. By the late 1970s, the comic characters in American newspapers and magazines had become as mainstream as fast food. We had learned to trust them. What the hell were they doing here, hanging out on vandalized subway cars? What kind of company were they keeping?

The answer is a complex one, and necessitates some back story. Though their modern births are separated by almost a hundred years, at their roots comics and contemporary graffiti are—like blues and jazz—essential American art forms with much in common. While it's true that graff borrowed from comics in its early days, the two genres—like Zoro and Rose in *Wild Style*—complement one another, fortifying and challenging and cross-pollinating each other since the nascent days of spray can art. And while each genre's influences have changed—contemporary graffiti "writers" are more likely to be familiar with Sailor Moon or Witchblade than Charlie Brown or Dick Tracy—the dialogue continues.

In spirit if not precise chronology, graffiti and comics share the same genesis. Like comics, graff began with scribblings on cave walls, its forebears attempting (first) to record what they had seen, and (second) to achieve immortality, to announce, "I was here." Both graff and comics can trace their ancestry to Greek temple walls, Giotto frescoes, and bunkers and cells in history's militaries and prisons. Both struggled mightily for legitimacy in their early years; and both were shunned—comics by academics who saw them as vulgar and unrefined, graffiti by property owners and the art community, who saw it as vandalism or trash. Both made it through these checkered childhoods, though, and have been legitimized handsomely. In all likelihood, the first comic drawings were graffiti and, late in the second half of the twentieth century, the original graffiti artists looked to drawings they found in newspapers and comic books for inspiration.

"The first comic character painted on a train was in 1974," recalls Eric, who painted with Dondi's CIA crew in New York City. "Tracy168 did a big Yosemite Sam with his name right next to it. It was a watershed event, and afterwards comic book characters became a staple of graffiti subculture."

Some historians have traced the strongest momentum to Cheech Wizard, the creation of Vaughn Bode, an underground comix artist and contemporary of Robert Crumb and Gilbert Shelton, whose Mr. Natural and Furry Freak Brothers helped define the pot-smoking, freethinking late 1960s. Published serially in *National Lampoon* and anthologized by Fantagraphics, *Cheech Wizard* starred a foul-mouthed, faceless character with a minimal appearance—just a star-covered hat and a pair of legs—who, along with duck-billed Earth Eye and sexy Suk Suk Sun, turned up in the works of many early New York writers. Bode's simple, easily executed shapes evidently appealed to spray can artists painting furtively under cover of darkness.

"Bode's cartoons are beautifully drawn, replete with thick outlines and soft contours that possess a simple and delicious graffiti-like aesthetic," explains Zephyr, one of graff's East Coast grandfathers, on the Web site run by Bode's son, Mark. "They are wickedly funny and sometimes just plain wicked, the characters running the gamut from whimsical to sardonic." Like Yosemite Sam, Cheech is a renegade, a rebel—the very embodiment of graff itself.

But Bode's figures, which have passed to a new generation of writers, weren't the only designs to find their way into graff. "Me and my brother had an attic stuffed with old DC comics," recalls Twist, one of graffiti's most successful crossovers into the fine art world, whose works have appeared in the San Francisco Museum of Modern Art and the UCLA/Armand Hammer Museum in Los Angeles. "I copied and studied *Flash* and *Plastic Man* in the margins and on schoolbooks. Before that, I was copying Don Martin in *Mad*." Knowing this tells you much about Twist's work.

Eskae, an illustrator and Bay Area graffiti writer who was a fan of *Heavy Metal*, sympathizes. "Growing up, I loved comics," he remembers. "I would copy them religiously into my sketchbook, study the line work, the form, the structure of the panels, the flow from frame to frame. I couldn't get enough of them." As Eskae proves, some budding writers are more interested in the more artistically styled comics than the soft, smooth lines of humor-based cartoons. Some love the rippled-muscle styles of *X-Men*, *Spider-Man*, and assorted Marvel Comics characters; others favor the sci-fi worlds of Mœbius or Richard Corben.

And not all graffiti artists look at comics before learning to paint. Los Angeles muralist and writer ManOne came to the genre only after writing graff for several years, and stumbling across graphic novels by Simon Bisley and Mike McMahon. "*Spawn* taught me different ways of shadowing, different compositions, and *Sláine* was full of color," he said, "It gave me ideas for characters, but also background colors and fill-ins for my letters."

"Many artists come up with their own original characters, but there's never been any shame in lifting other people's work," said Eric, from CIA. "It's an acceptable part of the culture."

Though they attract different enthusiasts, graff and comic art are alike in their refusal to slip into the mainstream; as one genre takes greater chances, the other follows. A comic like Rob Schrab's *Scud: The Disposable Assassin* tweaks what a graffiti artist may know about line, figure, or composition, while graff, its bombs and burners carrying the DNA of Latin American mural arts, provides comic artists new perspectives on narrative technique. The strong social and political arc to ManOne's murals—which themselves evoke the wordless "head" strips of 1960s poster artists Rick Griffin and Victor Moscoso—impart their message within a limited space (one wall versus several pages) to a non-captive audience (walking past versus buying a book). For these reasons, graff must be bolder, brasher, more electric and more angry, its readability balanced with an edge . . . just like comics, in other words.

The boundaries are beginning to blur. Giant, a writer-turned-tattoo artist living in New Mexico, publishes his and other artists' sketchbooks and zines at his imprint, Skullz Press. ManOne is developing his own sketch/comic book design for Aerosol Press, which has other collaborations in the works. And a recent alliance between Skwerm (Brooklyn), Frek (Hong Kong), and Sasu (Tokyo) for Nike's Presto TV campaign was one of several projects that have kicked graff into uncharted realms of animation and commerce. "Graffiti's so broad now," said ManOne. "It covers a lot, from fine art to typical street art. It's a different generation. People used to grow up looking at comics, but nowadays they grow up looking at graffiti as well. The two will always be tied."

His thoughts recall another scene in *Wild Style*, when Zoro is defending his passion: "Being a graffiti writer is about taking *chances*," he explains, "taking *risks*, from the police, from your own moms, from your friends. You got to *take on* that bullshit." Except for his worries about the cops, of course, Zoro could easily be talking about the next great alternative comic artist, a quarter-century later: studying, sketching, training her (or his) keen eye on the streets.

Write Ways: an Unruly Anti-Treatise

Dennis O'Neil

Here we are, meeting for the first time on this page. I'm the wizened old pro and you're the eager neophyte comics writer seeking advice. (Aren't you?) What you'd like to ask is, How do I work with artists?

I'd like to be able to help. Type out a heading, something like: "The Comic Book Writer's Guide to Collaborating with Artists."

Then, if I could, I'd tell you all you need to know about this topic: Point A, Point B—et cetera, et cetera, until you went on your way brimming with new info, secure in the realization that, by heaven, you've got this one hacked.

But I can't because if that info exists, I don't have it and have never heard of it. But I can give you my mantra: There is seldom one absolute, inarguable, unimpeachably right way to do anything.

What this means, when the subject is writers working with artists or artists working with writers, is that you'll have to discover your own rules, if any. Most likely you won't end up with rules as such, but rather a working arrangement that drives neither you nor your collaborator to dreams of mayhem, which may be the best you can hope for.

You probably won't agree on everything and you may not even agree on much. And, unless you somehow luck into an honest friendship with your partner, one that allows a candid exchange of opinions, you may not even be aware that you disagree. But despite any differences of opinion the two of you share, you can still do really good work if you can at least concur on this: the most important thing is the story.

This means, for instance, that your goal should not necessarily be writing captions in a prose style that would make Henry James swoon with envy and, for further instance, that your collaborator shouldn't bend all his efforts toward producing a full-page drawing of a guy in a cape doing something spectacular that's guaranteed to fetch a handsome price when he sells it at a comic book convention. If Jamesian English and full-page superheroics serve the tale you want to tell, if they allow you to tell it as clearly, concisely, and excitingly as possible, fine. But they should be the means, never the end.

You may not have much control over exactly how your final product is achieved. If you're working for an editor, he or she may dictate how you're to proceed. There are two ways most commonly employed to begin the process that results in a comic book. Over the years they've come to be known as The Marvel

Method and Full Script. The Marvel Method, perfected by Stan Lee and his early Marvel Comics collaborators, requires the writer to begin by writing out a plot and add words when the penciled artwork is finished.

When I worked for Stan in the mid-sixties, plots were seldom more than a typewritten page, and sometimes less. Today, writers like Doug Moench might produce as many as twenty-five pages of plot for a twenty-two-page story and even include in them snatches of dialogue. So a Marvel Method plot can run from a couple of paragraphs to something much longer and more elaborate. Good old trial and error will indicate how much or how little you, the writer, should give to your artist. Some artists want every "i" dotted and "t" crossed, others prefer no more than a rough outline. Any way that prompts the artist to deliver pages with the story told in evocative graphics, with room for you to write sufficient dialogue and include all necessary information, is the right way. Any way that doesn't is the wrong way.

Full Script, which dates back to comics' earliest days, may have even more permutations than the Marvel Method. I've never met any two good writers whose full scripts looked exactly the same. Every writer seems to evolve a personal format. But while it may be that no two writers do them exactly the same, they all bear a strong familial resemblance. I've seen one of Jerry Siegel's Superman scripts, probably typed some time in the early forties, which really wasn't much different from the thousands of scripts that visited my desk when I was editing a few years ago. Every full script does the same tasks, gives the artist some kind of indication of what to draw and adds the words that will be in the captions and dialogue balloons. They're all first cousins to television and movie scripts and, in fact, a writer could use the familiar film script format to write comics and probably nobody would complain.

So what'll it be, Marvel Method or Full Script?

As I mentioned above, the choice may not be yours. Your editor (whom you should learn to regard as a being with godlike wisdom and awesome power) may have a preference and if he does, end of discussion. If he doesn't . . . well, you do what you do in most life situations: grope forward and hope for the best. If your artist is an experienced professional, whose work you've admired not for the execution of the drawings—those be-caped guys who occupy whole pages—but for the pacing, clarity, and flow of the visual narrative, you might want to try the Marvel Method. If you're the more experienced storyteller, you might get better results going the Full Script route.

Thus far, I've been discussing procedure and ignoring that elephant sitting in the corner whose name is Collaboration. According to my computer's dictionary,

collaboration is "the act of working together with one or more people in order to achieve something." So, you might be asking, is the artist allowed input into my plot? Can I dictate exactly what kind of pictures he should draw? Again, there are no universal answers. During my first few years in comics, I seldom knew which artist would be handed my script and if I did know, I'd probably never met him. That was pretty much how it was back then: the various tasks involved in producing a comic book were segregated, with everyone beholden only to the editor.

After a while, I did get to know some of my collaborators through meeting them at parties, conventions, and in the hallways of the publishing companies, and eventually I knew most of them. But I seldom involved them in my work or involved myself in theirs. Occasionally, one of them would have an idea which I almost always incorporated into a story, and sometimes I gave them visual references culled from magazines and the like, especially when the story had Asian martial arts elements, which were pretty esoteric at the time. And when Neal Adams and I were doing the so-called "relevant" stories in *Green Lantern/Green Arrow* in the early seventies, Neal and I talked a bit about the series' content. But that was the extent of my actual collaboration with artists until I did a couple of stories with Frank Miller at Marvel in the eighties, when we had the luxury of some lunchtime brainstorming. It was pleasant to actually work with someone on a story, if only because writing can be a wretchedly lonely vocation. But as you realize by now, a close partnership isn't at all necessary.

Unless, of course, your editor says it is. I did a couple of jobs for an editor who seemed to want his creative people to come as a package, a portmanteau being that could be called a writer-artist. He's probably not the only editor in the world with this preference.

So if you, the writer, can ally yourself with an artist you can trust, you might make yourself a bit more salable, have some fun, and do some good stuff in the process. Such alliances seem to be, for some reason, inherently unstable and not many seem to last more than a few years, but then nothing lasts forever . . . ask anyone who's ever been deeply infatuated with another person. And if you can get a few good years from any kind of arrangement, you're probably a winner.

If you can't, well . . . remember the mantra: There is seldom one absolute, inarguable, unimpeachably right way to do anything. You'll have to find your own methods, and if it's important to you, you will. After all, comic book writers have been figuring out ways to please editors and synchronize with artists ever since Max Gaines published the first comic featuring all original material in 1938. What makes you think you're any different?

Throwing the Book at Comics Artists

Tim Kreider

> *"I respect the hell out of cartoonists, because they have to be good at two entirely different art forms, each of which takes a lifetime to master." —Novelist Myla Goldberg*

In the world of alternative comics almost everyone is an *auteur*, who both writes and draws his or her work, and most of those people come from backgrounds in art. It's a much more plausible scenario for a student at the School of Visual Arts to pick up a copy of *Optic Nerve* and start thinking about the possibilities of comics as an art form than it is for anyone to drop out of the Iowa Writer's Workshop after reading *V for Vendetta*, shaking his fist and saying, "Fuck this literary *bull*shit—I'm gonna be a *cartoonist!*" Maybe this is just because everybody in the world likes to think they could write if they just gave it a try, whereas pretty much anyone can tell you at a glance whether or not you can draw. Or it may have to do with status; it is still much less prestigious to write comic books than to write short stories or novels, mostly because your career choices as a writer of comics are to write either: 1.) stories you'll probably have to publish yourself that no one but your friends will ever read or 2.) stories about Thor. Perhaps for this reason, the writing in comics is still subjected to far less stringent critical scrutiny than the art, even though it is the more indispensable element of the work. Ultimately comics are a narrative art; a great story with inadequate illustrations can still be considered a flawed masterpiece, but a bad story beautifully illustrated is a waste of everyone's time and talents.

Of course drawing is essential to a good comic, but "drawing" in comics doesn't necessarily mean naturalistic rendering. The fetishistic admiration for competent draftsmanship among fans and critics—"chops"—has blinded a lot of them to real artistry. Thus Frank Cho can be considered a "better" artist than, say, Tom Hart or Sam Henderson simply because he is technically the more accomplished draftsman. But look at Tom Hart's blobby little guys, full of rage and pathos, or Henderson's spastic, pop-eyed figures flailing their wiggly arms in hysteria or exasperation. Contrast these characters, imbued with such personality and life, to Cho's exquisitely rendered women, gorgeous as centerfolds, expressionless and empty-eyed, cartoon Olympias without humor or character. This fixation on "drawing" is a little as though *The New York Review of Books* was praising authors' faultless spelling and grammar. Which is not to say that crude drawing is by definition better than

polished; there is a difference between unconventionality and incompetence (although artists in all media strive to disguise the latter as the former). Roberta Gregory's drawings are crude because they're expressionistic, the whiplash scrawls of crude emotions like humiliation, bitterness, and lust; Aline Kominsky-Crumb's drawings are crude because that's the best she can do.

The standards for writing in comics, on the other hand, are far lower than in the mainstream literary world. Comics authors are too often rewarded with critical acclaim for their ambitions as much as for their achievements, congratulated just for *trying* to produce "serious" work—even if that work is the kind of clichéd, derivative fiction, abstruse academic exercise, or warmed-over journal material that would get more or less diplomatically beaten out of apprentice fictionists in any undergraduate writing workshop. Adrian Tomine is an excellent cartoonist, but if he were working in prose instead of panels he would be regarded as a minor minimalist, a footnote to that trend's vogue twenty years ago. Craig Thompson's *Blankets*, much overpraised on its release, is an unexceptional bildungsroman, and in spots the narration seems to be transcribed verbatim from high school journals. Many of Harvey Pekar's stories are not true stories but the sorts of anecdotes, observations, and snippets of dialogue that a writer might jot down in his notebook for later use in finished work.

And there are a surprising number of cartoonists who seem ignorant of basic, Comp-101 lessons that ought to be second nature to anyone who writes for a living: Show, Don't Tell; Omit Needless Words; the rules of Aristotelian dramaturgy. Chester Brown, one of the best writers in comics, during a period of artistic floundering between the *Ed* and *Playboy* stories, inexcusably foisted off on his readers a story about the writing of his last story, a lame-assed meta-fictional dodge that many a novice has tried and failed to get away with. He simply didn't know any better.

Of course it's not fair to talk about "writing" in comics only in terms of storytelling, dialogue, or prose style; writing in comics is more than a matter of words. It's easy to show that Alan Moore or Lynda Barry are great writers simply by quoting their prose, but less easy to explain why Jason or Brian Ralph, whose comics are wordless, are too. (Although, interestingly, even Rorschach's or Maybonne's monologues look too fulsome printed out on the page, divorced from their accompanying illustrations. The catalytic effect of imagery on text seems to be similar to that of music, which can make song lyrics that would look trite on paper pierce the heart or soar.)

Decisions like composition, panel size, and pacing all constitute the "writing" of a comic; Alan Moore's match cuts and Chris Ware's excruciating *longueurs* are as

integral to their work as the jarring metaphors and "maximalist" prose of postmodern literature. And there are some things that can be more deftly and beautifully done in comics than in any other medium. In John Porcellino's *Perfect Example*—arguably the best novel about adolescence ever written, period—the main character goes into the garage to get out the lawn mower, where the words "garage smell" hang in the air, evocative of a long paragraph's worth of subtle, nostalgic odors. The elegance of this takes my breath away.

Nonetheless, at the risk of sounding like a snobby smarty-pants, I'll insist that comic writers still need to learn the craft of writing and immerse themselves in book books as well as comic books. An education in writing and the liberal arts is not just a bonus, good for getting literary references and recognizing artistic allusions. It's not really necessary to know that Dr. Manhattan's perception of time in *Watchmen* is similar to Billy Pilgrim's in *Slaughterhouse-Five*, or that page fourteen of the first issue of Ivan Brunetti's *Schizo* is an updating of "Suburb" from George Grosz's *Ecce Homo*; this is really no more than a game of bachelor-of-arts trivia. The point is to have read enough to know the difference between good writing and bad, and to know enough about art, philosophy, history, religion, politics, psychology, biology—in short, about the world—that you to have something to say. Walter Bagehot wrote, "The reason why so few good books are written is that so few people who can write know anything." Hence the disproportionate number of comic books about twenty-something slackers with troubled relationships as opposed to the number about, say, Palestine. This is not to advocate that anyone who writes comics should hit their parents up for $100,000 to buy an English degree.* But if comics are ever going to be taken seriously as a literary medium, comic book writers need to know Dickens as least as well as they do Ditko, just as comic artists should study Gray's anatomy as well as Kirby's.

Of course once you've mastered all the technical aspects of your craft, there still remains the larger problem of becoming an *artist*, someone whose perceptions are truthful and interesting and worth sharing. In his novel *Straight Man*, Rick Russo speaks a taboo truth known to anyone who's ever been in a writing workshop: "Very often the flaws in a story are directly traceable to flaws in the author." Joe Matt's issue of *Peepshow* about making a porn-video mix tape isn't embarrassing because it's about making a porn-video mix tape; it's embarrassing because he shows no

* I went to a prestigious writing program and its main benefit was that, almost twenty years later, some of the people I met there will still pick me up at the airport.

insight into his own behavior; he simply records the process as obsessively as he mixes the tape. (The most revealing moment in the issue is when Joe fawns over his cat, who flees, and his cloying affection turns to petulant anger.) A story can be worth reading even if its protagonist fails to learn anything, but not if its author does. At best, this kind of story can be a diagnosis; at its worst, it's only a symptom. The same painful truth applies to any other art, including drawing: it's evident from Frank Cho's art that he's looked at a lot of girls, but it seems equally clear that he's never really seen one. This is more than an artistic failure. Some rare ones among us, like John Porcellino, seem to be born artists, with keener eyes or more sensitive nerve endings than the rest of us, but most of us have to become artists the hard way, through what we witness and suffer and learn. "I can help you learn to reveal your soul through your voice," Megan Kelso's singing instructor once told her, "but I can't guarantee that you have a soul worth revealing."

Common Sense on Giving Offense:
A Brief Guide to What You Can Get Away with

Robert Fiore

Ever notice that the least controversial thing you can say about anything is that it's "controversial"? Ah, but you are hardly interested in such Andy Rooney-esque philosophical matters. You, young cartoonist, with a head full of ideas that are driving you insane and a world full of bourgeoisie to *epater*, you who at your precocious age can see the simple and obvious answers to all the troubles that have vexed mankind for millennia and are magnanimously prepared to share your insights with the poor blind fools, what you are wondering is how you get away with it.

Comics come in two flavors, book and newspaper, and each handle controversial material—which we define herein as material that can get people pissed off—in widely divergent ways.

First, comic books.

In mainstream comic books the Comics Code Authority, the huge horrible ogre that once enforced innocuousness with an iron fist, has been reduced to a pitiful little pink-haired rubber troll, more honored in the breach than in the observance. Marvel Comics doesn't subscribe to it at all anymore, DC still does but flouts it in a "You got a problem with that, buddy?" manner. Content standards range from ABC to HBO, i.e., regular comics adhere more or less to the standards of prime time television and in "mature" lines you will find dirty words and brief nudity. Really, the biggest restriction on content isn't censorship but mainstream taste; you can tell any story you want as long as it's about superheroes.

In the world of independent or alternative, do as you will is as near the whole of the law as makes no difference. The publishers are as solicitous of your artistic freedom as they are loath to pay you a lot of money up front. The only real limit appears to be obscenity prosecution. The most notable case in recent years was a troubled young fellow in Florida who drew just about every crime on the calendar, including the now completely indefensible "sex involving children," in a manner too crude to convince much of anyone that artistic expression was what they were seeing. That he got convicted of obscenity was not altogether surprising, but an overzealous prosecutor branded him a sexual offender, with all the draconian conditions that now brings with it. With a Republican administration in office there's always the possibility of an anti-porn crusade, and sexually explicit comics might well come under scrutiny.

Now, newspaper comics.

The rule of thumb in incorporating controversial material in conventional newspaper comics is, You Can't. Comic strips are expected to be suitable for publication in a family newspaper, and the family of that family newspaper is presumed to be headed by the Reverend Billy Graham and his wife, Betty Crocker. Comic strips are normally turned in six to eight weeks before they're published, so you're not going to slip anything past anybody. An example of what normally happens to the comic strip controversialist would be the case of Bobby London, an erstwhile underground cartoonist with a retro style who was engaged to breathe life into the moribund *Popeye* strip. Six years into his run he thought he could liven things up with a story line that touched on the issue of abortion. Goodbye, Bobby. For all the publicity around Aaron McGruder and *The Boondocks*, the trend in comic strips is towards wholesomeness. The big success story in newspaper comics in recent years has been *Zits*, which is basically what parents want to think teenage life is and what teenagers want their parents to think their life is. A cartoonist intent on envelope-stretching would be far more likely to find creative freedom in television animation than the comics page.

So those who do engage in controversial material on the comics page are a privileged group indeed. How do you develop this kind of license? There are basically two ways. One way is to become well enough established that you can afford to piss people off, an avenue that by definition is not open to the beginner. The other is to have a strip whose *raison d'etre* is controversy, the most notable examples being the aforementioned *Boondocks* and Garry Trudeau's *Doonesbury*. Because they're supposed to be edgy, editors who subscribe to them are prepared to take a little heat. Trudeau and McGruder both established themselves in college newspapers and came to syndication with a certain notoriety. If what I read is true, a lot of you young rapscallions are listing to the right these days, and if you find yourself on that particular slant there probably is room for a *Doonesbury* of the right. Oh, there are one or two strips with a conservative slant, but they're lame as hell; come up with a good one and you'll be able to write your own ticket. One way or the other, you'll have to convince a syndicate that you're capable of generating enough income to be worth some trouble. As a rule, controversy is something that a newspaper strip can survive, not something that enhances its value.

Contradictions of Character

Ward Sutton

When I think about what makes an interesting character, in comics or any medium, all I have to do is go back to my childhood influence: *Spider-Man*.

Superheroes in general offer a good model for character structure—conflicting alter egos. For example, Superman is also Clark Kent. The same guy who is the muscle-bound, handsome, all-American hero in the bright costume is also the meek, bespectacled guy in a business suit who never seems to be around when anything exciting is going on.

But the two sides of his character remain separate and distinct: Society reveres Superman; Clark Kent fades into the background. Superman faces the pressures of saving the world, Clark Kent only has to write some stories for the Daily Planet and, well, keep people from finding out he's Superman. Superman attracts the girls; Clark Kent does not.

Spider-Man, on the other hand, is much more complicated. Sure, like Superman, Spider-Man has his alter ego: Peter Parker. Spider-Man has super-strength; Peter Parker is a bookworm. But Spider-Man also has an array of contradictions within his character. He is a hero who does good, but many people see him as a menace or even a criminal. He has amazing powers, but he is filled with teenage angst. He's trying to save the day, but he also has to pay the rent.

It's these contradictions—not the fancy costume or superpowers—that make Spider-Man a compelling character. And Spidey's not alone.

Tony Soprano isn't interesting just because he's a gangster. He's interesting because he's a ruthless killer who is also a caring family man. He's a tough guy but he needs to see a shrink about his emotional problems. He operates by a code of honor but he's also depraved.

Bart Simpson isn't interesting just because he's a funny-looking cartoon boy. He's interesting because he's both cocky and vulnerable. He's cynical yet passionate. He's a little boy (relatively powerless) who ends up doing exciting things (powerful).

For a character to be successful, we (meaning the audience) have to really like him or her. This doesn't mean the character has to necessarily be "good"—sometimes the "good guys" can be painfully boring. We like Hannibal Lecter, Darth Vader, and Cartman on *South Park* even though they all do and say bad things. Just because we like a character doesn't mean we think he or she is "good," and vice versa.

What makes us like the "bad guys"? Again, the contradictions within. Hannibal Lecter is both maniacally homicidal and charmingly sophisticated. Darth Vader embodies "the dark side" yet has a suppressed humanity and love for his son. Cartman is a cute fat kid who's also a potty-mouthed bigot.

We like characters with contradictions because they reflect the fact that we feel contradictions within ourselves.

Screenwriting guru Robert McKee likes to point out that a character is a work of art, not a human being. This is important to remember when creating a character. Characters must be believable, but that doesn't mean they have to be totally realistic. Realistic can be boring. The goal is not necessarily to create characters that seem cut from real life; the goal is to create characters that are unique and especially compelling beyond real life.

To make characters stand out from someone you'd see on the street, infuse them with contradictions.

For example, think of a policeman, a public servant who enforces the law and catches criminals. Add a .44 Magnum, some fed-up cynicism, and an anti-authority attitude and you've got Dirty Harry. Or instead, take that policeman and give him a pleasant, laid-back attitude, no gun, and no criminals to catch and you've got sheriff Andy Taylor of Mayberry.

If you're working in comic books, cartoons, or animation you can further express the contradictions within your character, visually.

For example, comic author and artist Chris Ware has created a brilliantly depressing Superman-type character who is flabby, aging, and saggy. Whereas we are used to seeing a superhero drawn with stark, bold line work, bright color, and Aryan musculature, Ware's character, often used as a metaphor for the sorry state of the human condition, is drawn with fine lines accentuating bodily imperfections, typically with dour, shadowy coloring.

On the Web, where simplicity is key, Flash animator Xeth Feinberg has created the cult-fave cartoon character *Bulbo*. *Bulbo* is an homage/send-up of 1920s, *Steamboat Willie*-era Mickey Mouse. But as opposed to Mickey's saccharine sweetness and drawn-by-committee polished look, quirky Bulbo has been known to be seen on skid row and has a rougher design that looks part hand-drawn, part computer-created. Black and white Bulbo's look is warts-and-all: buck teeth, a garish polka-dot tie, and only one round ear as opposed to Mickey's pair.

The visual design of TV's animated *Powerpuff Girls* is clearly an extension of the contradictions within the characters. Blossom, Buttercup, and Bubbles are

sweet-talking little girls who are also powerful crime-fighters. They are drawn in a unique, stylized way: as cute, petite pixies with manga-like doe eyes, but with bold, heavy, superhero-sized line work.

So remember, if your characters are drawn—and written—with contradictions, audiences may very well be drawn to your characters.

What's Love Got to Do with It?

Trina Robbins

opening spread from Candy #59, *January 1956*

There was no love lost in Golden Age superhero comics, because that's how the adolescent boy readers wanted it. Comics of the 1940s reflected the feelings of young boys, who are not particularly fond of girls. Although the superheroes in these comics might have had token girlfriends, the girls just got in the way. They were pests, like Lois Lane, always sneaking around, trying to find out a fellow's secret identity.

Even when the girlfriends were sidekicks—Bulletman had Bulletgirl, Rocketman had Rocketgirl, Hawkman had Hawkgirl—they were a pain in the neck, too weak to really fight, and constantly in need of rescue. Typical is a splash page from *Doll Man* No. 37, December, 1951. Doll Girl lies tied down on a table, about to be sacrificed by an evil druid wielding a huge knife, while in the background Doll Man ("The world's mightiest mite") flies to save her.

Boy fans of the 1940s preferred girlfriendless Batman, whose boy sidekick, Robin, was the sole object of his affection.

Teen comic books, which started with *Archie* in 1941, hit their stride during the postwar years. They attracted adolescent girl readers with stories revolving around cute teenage girls with cute names like Candy, Taffy, Sunny, and Melody, who were billed as "America's Favorite Teenage Girl," "America's Sweetheart," and "America's Typical Teenage Girl." And they brought love to comics in the form of the Eternal Triangle. Betty and Veronica fought over Archie; Patsy Walker and Hedy Wolfe fought over Buzz Baxter; Millie the Model and Chili fought over Flicker (later renamed Clicker when editor Stan Lee realized that the combination of L and I sometimes looked like the letter U). The nice girls, like Betty and Patsy, reflected the average reader. They were middle-class girls-next-door, while their rivals, like Veronica and Hedy, were rich bitches.

But once Betty got Archie, or Patsy got Buzz, nothing much happened. The boy might be on the receiving end of chaste kisses, usually on the cheek, leaving behind perfect lipstick prints, or the happy couple might share a soda at the choklit shoppe, or cut a rug together at the Sock Hop. But nobody was serious, and marriage was out of the question; these kids were still in high school.

Love grew more intense in the romance comics, which started in 1947. Joe Simon and Jack Kirby's *Young Romance*, the first of the genre, sold 92 percent of its print run. In pages soggy with tears, the heroines met Mister Right, lost Mister Right, found Mister Right again and married him. Teenage girls and young women loved it! Simon and Kirby added more titles (*Young Love, Young Brides*, and *In Love*), and sold over a million copies each month.

Other publishers hopped on the successful love comic bandwagon, and from 1948 to 1949 the number of romance comics published jumped from four to 125. The almost completely female readership devoured stories with suggestive titles like "Back Door Love" and "Soldier's Pickup." There were variations on the theme for everyone, from *Hi-School Romance* to *Career Girl Romances*. Even horsey girls found their man in such titles as *Rangeland Love* and *Cowgirl Romances*. By 1950,

Newsdealer magazine noted more females aged seventeen to twenty-five were reading comics than males of the same age.

Along with romance, these comics delivered a postwar message. During the War, with our boys overseas, women filled their positions on the assembly lines, in the factories, driving trucks and buses, even drawing comics (more women drew comics in the 1940s than ever before). The war ended, the GIs came home, and they wanted their old jobs back. Women had to be coaxed out of the workplace and into the kitchen, and love comics were one of many propaganda devices used to do the trick. The messages in such stories as "Doorway to Heartbreak," "Romance on the Menu," or "Last Chance for Love" was that a girl found true happiness only when she married the right guy, settled down, and raised a family.

For a decade, love reigned supreme in comics, but by the early 1960s superhero comics started taking over the newsstands again. Love comics publishers tried to fight back by modernizing their stories for the new generation, but stories like "Call Me Ms" read like what they were—attempts at hipness by clueless forty-year-old guys. One by one, romance comics languished and died. *Young Romance*, the comic that started it all, also ended it all, in 1977.

The new superheroes took a tip from the comics they had supplanted, and combined tights and capes with suds. Reed Richards (Mister Fantastic) and Sue Storm (Invisible Girl) of the Fantastic Four were already engaged in 1961, at the start of the series. After a long engagement they married in 1965, and had a baby in 1968. Peter Parker finally married his sweetheart, Mary Jane Watson, in a much-publicized special issue of *Spider-Man*, in 1987. Superman married Lois Lane, no longer a pest, in 1996. All three couples remain married.

And Batman still has his Robin.

As in romance comics, the course of true love for Silver Age superheroes did not always run smooth. For years, Ben Grimm (The Thing) loved blind sculptress Alicia Masters, who recognized the beautiful personality beneath his outer shell, which literally resembled a brick house. Alas, he eventually lost her to fellow-Fantastic Four member Johnny Storm (The Human Torch). Yellowjacket and The Wasp, minuscule members of the Avengers super group, married, divorced, and reconciled. The Hulk married his longtime love, Betty Ross, only to see her die tragically of radiation poisoning.

Despite their combination of passion and punches, mainstream superhero comics over the past forty years failed to attract a large female readership. Today, most young comic-reading women buy independently published comics, nicknamed

"indies," where they find more women cartoonists than ever before. These books, notable for their lack of superheroes, also lack romance. They reflect the more world-weary attitudes of their third-wave feminist readers, no longer the wide-eyed virgins of the 1950s.

There's lots of sex, but little love, in women's indie comics. Debby Drechsler's and Phoebe Gloeckner's comics are often about childhood sexual abuse. In Laurenn McCubbin and Nikki Coffman's *XXX Live Nude Girls*, the blitzed-out female protagonist is described as "the one who crawls in and out of strangers' beds, confuses sex for love and love for weakness."

In their 2002 graphic novel, *Pretty Like a Princess*, McCubbin and Coffman present their contemporary version of romance comics. The story, aptly named "Despair," offers no happily-ever-after. Not only has the heroine's "castle in the sky . . . become a double-wide in a trailer park," but "Prince Charming . . . hasn't touched her in weeks except to slap her face. . . . She gained five pounds and he blacked both her eyes."

Leela Corman's 2002 graphic novel, *Subway Series*, is a post-feminist answer to the traditional teen comics' Eternal Triangle. High schooler Tina cares about Evan, but he has a girlfriend, so she fools around with James instead. Tina takes the train to James' house in the suburbs, where he pressures her to have sex. Instead, she mollifies him with blowjobs, and rides the lonely night train home alone. Eventually she gives in and has sex with James at a party. He immediately informs the class bitch, who hates Tina, and will spread the news to the whole school. Evan, who cares for Tina (but he has a girlfriend!), overhears. Later, he asks Tina, "What were you thinking, sleeping with him?" She responds, "I just wanted to get it out of the way, okay?"

Who needs a heart when a heart can be broken?

Section V:
Comics Studies

Teaching Comics

Interview by Gunnar Swanson
The Four Tribes of Comics
Scott McCloud

A friend of mine refers to your first book as *Overanalyzing Comics*.
[laughs] Fair enough.

I see an implication there that you're not supposed to analyze certain things. I wonder how much of that is connected to an inferiority complex—you know, the unlived life is not worth examining.
I've thought for some time that there are probably about four different unnamed tribes in comics, schools of thought. I've been carrying this around in my pocket for ten years and I've never published it because it's dangerous. It's one thing to classify different kinds of panel transitions and another thing to start classifying people. It gets misunderstood and misused very easily. I try to talk about it in terms of actions or ideals and I always end up talking about actual people, human beings, and at that point I think, "No, this is probably going to do more harm than good."

But the four passions . . . you can think of them as the four campfires people gather around, or four centers of gravity. One of them is an "iconoclastic" passion where it's truth reigning over beauty: the idea that in order to reach something real you may have to bring in something fairly raw and something unpolished. The iconoclastic tradition values the raw honesty and immediacy of comics and feels that something that achieves a certain amount of societal acceptance is likely to also achieve a certain amount of sterility and is often consumed by the interests of the elite and by powerful institutions and whatnot. And that tribe, say in the form of the great underground comix or some of the more iconoclastic comics of today, has produced tremendous work based on that idea, that there's no higher value in art than honesty and that to overanalyze something is dangerous in many respects. It can kill the immediacy and the organic simplicity of the form. Having something that is raw and untamed and despised, there's something precious there that we shouldn't throw away too easily, in hopes that it might be hung someday in the Guggenheim. And a certain amount of vitality does always drain out of something that becomes embraced by popular culture, and maybe it is time to move on if what

you're looking for is something genuinely new and raw. By the time it's on the cover of *Time* magazine then it's probably dead. I understand that. And I think it's a perfectly valid point of view.

Then there are the "animists," people in comics and, I suppose, people in art generally, whose idea is to bring the work to life in an organic, alchemic sort of way that can't possibly be explained, who want to produce an experience that's truly real. In the case of the narrative arts like comics, these would be storytellers, those who think of their stories as arising from some deep, unnamable place. If you hear an author, for instance, talking about how he was surprised at what his characters did—waking up in the morning and saying, "What are my characters going to do today?"—then you're talking about an animist. These are people who don't feel that art can be explained and who measure their art very much in the reactions of their audience, which puts them in opposition to the iconoclasts where the audience doesn't necessarily matter.

Then there are the "classicists," those who believe that there is a standard of craft and beauty that can be learned, that there are skills, that there is a standard. They want to create something that could be dug up in two thousand years and can be looked at and still be seen as something beautiful. In some ways, therefore, they embrace a common standard of beauty, which puts them in opposition to the iconoclasts because the iconoclasts find popularly accepted standards of beauty to be a symptom of societal oppression. Instinctively. They'd never use words like that because that would be pretentious.

So between the iconoclasts and the classicists you have a truth/beauty axis, right? Well, the animists are about content and the other end of that axis is form, so the fourth corner is the "formalists," who are interested in whatever form they're working in, in learning how it ticks. They keep conducting experiments. The formalists—and this is pretty much the gang I found myself with—are very loyal to the form over the content, they don't mind creating something that may be utterly unreadable or un-listenable, providing it's interesting. There's no such thing as an unsuccessful experiment as long as when you're done with it you're smarter than you were when you started. They can be accused by the animists and the iconoclasts of creating something that is somewhat sterile because when you're creating any work of art from the basis of intellectual exploration you're bound to wind up with something that may walk and talk like a person but it has no heart, it's dead inside. So they're on opposite ends from the animists.

These four schools determine to some extent what the shared history of each tribe is. If you ask for the history of comics from each tribe, for instance, you get vastly different answers depending on which tribe you're talking to. The formalists might go on about ancient forms of sequential art, totally ignoring the actual continuity of the culture of comics, going on about Egyptian wall paintings and whatever, like I do. The iconoclasts would tell you that pretty much everything was shit but that Harvey Kurtzman did some good stuff with *Mad* magazine and then there was some more shit, and then the undergrounds came along and then they turned to shit, and so forth. The animists tend to be the most parochial—formalists tend to be the most eclectic—so they will go on about whatever little subset of comics they come from. History begins there. So if they're superhero artists, then history began with Kirby and Ditko. And then the classicists will talk about the history of fine representational art and fantasy. They'll see comics as part of this broader thing of creating fantastic art and they'll start talking about a bunch of dead illustrators nobody's ever heard of. But it will all begin with Michelangelo, most likely.

So I'm forever seeing these tribes manifest themselves, even in behavior as simple as who wants to go out and talk about comics after the convention and who wants to go out to the bar and get drunk.

Anyway, it's a big, giant, gnarly, molten subject at best that I continue to mull over. But I've never published it because, as I say, I think it's potentially toxic.

I think film and TV have gone through a development where they were at first cheesy entertainment, and then embraced by people who wanted to make art out of them. So you had several movements of European art film, and finally the French New Wave, embracing the cheesiness of film as the center of the art form.

Two different groups, two different tribes pursuing two different passions, can seem to be the same movement when they seem to have a common interest for a time. What you just described is iconoclasts on the one hand, finding joy in junk culture's side effects and, on the other hand, a group of formalists seeing artistic potential that may be a little bit more lofty. Well, both of them are upsetting the apple cart, both of them are trying to change a medium so both of them seem to be on the same team for a time but ultimately they're going to split . . . you know, like the Dadaists devolved into an argument about which was more Modern, a locomotive or a top hat. Eventually you're going to realize that these people are fellow travelers but they have different passions in the long run.

I think half of Art Spiegelman's personality is iconoclastic, where the other half has a formalist bent, and the two halves are always doing battle with one another.

You self-identify as a formalist . . .
I'm totally a formalist. In fact I'm a bit of a freak. Most people have a major and a minor. I'm a 100 percent formalist.

But you make a large and articulate argument in *Understanding Comics* for what you just identified—and I think accurately—for the animist point of view.
Formalists can impersonate animists. But our passion is always going to be form. In fact, Art Spiegelman was impersonating an animist when he did *Maus*. There was a caption in the first draft of *Maus* in the shape of a railway ticket and he showed it to cat yronwode, who was also an editor of mine. She told me this story. As she was reading it she said she liked the caption in the shape of a railway ticket and Spiegelman said, "I'll take it out." She said, "Why? I just said I liked it," and he said, "Yes, but you stopped reading." Even though he's done many comics before where the whole point was to stop your reading every ten seconds to think about the form, this was a case where he wanted you to think about nothing but the story he was telling. So he was a formalist impersonating an animist. You never have animists impersonating formalists but you have formalists impersonating animists.

What do you think of comics as a major at school? Do you see this as the hopeful future of comics or would someone be better off in art or multimedia or graphic design or writing or something else?
I have a couple of answers to that. What you're likely to get out of formal art education, like comics majors that we're beginning to see, depends on what your passions and goals are. It comes back to the idea of the four tribes. If you have very classical ambitions then your primary job in that context is to acquire a skill set and to work on honing those skills—honing your craft until it meets the standards you've set—and to learn about other standards you might not have even known about, and learn how to achieve those. If your goals are those of an animist and you simply want to tell your story, then your goal is to gain enough skill that it doesn't detract from your story, but your ultimate goal is just to deliver that goal to the minds of your readers. If you're an iconoclast then formal education may not be for you. You might be able to learn some things that would help you in your work but

it is possible that it would not help and actually ruin you a little bit. And if you're a formalist, then school is always a fun place.

No matter what kind of comics you want to make, you still need to learn a wide variety of disciplines. A comics writer and artist—somebody who wants to write and draw comics—needs to be director, cinematographer, actor, set designer, costume designer, writer, cameraman . . . all of these things. And comics has as broad of a base of applicable subject areas as anything, so if you were to go to a major liberal arts college that has courses in all sorts of subjects, then they can all help you. Take a course in Shakespeare. Take a course in set building. Take a course in film theory. And you'll find that all these things are ultimately applicable to what you're doing on the page. So it's certainly a multidisciplinary art. That may be true of a lot of different arts. It's just that they're seldom approached that way. If you're going to be a writer maybe you should just spend twenty-five years on the road taking odd jobs and living in a variety of places. If you want to be a good one.

Part of what you're arguing for is a broad, liberal education and knowing about all sorts of aspects of the world. But, if you're identifying a present major that does those things, it sounds like film school with some drawing classes might be what you're talking about.

There is an advantage to a very focused curriculum—let's say a school specifically designed to educate you about making comics—and that is that the student body will be composed of other people who have similar goals, and that can be very exciting. The competition between students can be exciting. The camaraderies, the rivalries, the atmosphere of having dozens or even hundreds of kids who have the same notion in their heads. I'm sure that can be an extremely positive experience. I don't think I was particularly enriched when I went to college and I had basketball players on my floor in the dorm. I don't know that it taught me anything that I hung out with basketball players. Except that I was extremely short. [laughs] It would have been interesting if I had had nothing but comics artists around, but then my experience would have been stunted in other respects.

I've noticed some academic programs have chosen to call themselves sequential art majors, not comic book majors.

You realize that there's a precedent for that, don't you? Most media have a common name and a somewhat loftier, usually longer, term for special events and institu-

tions, and formal treatises. We love watching movies but when we begin to make them we make "film." Or we immerse ourselves in "film theory." So comics is going down a similar route. We'll have our academies of sequential art and those that are part of the academies will go out in the real world and make comics.

How does someone get a start these days? Do they just make comics and put them out there?
I think that's the long and the short of it. No matter who you are, no matter what ambitions you may have, it always helps to have created something on your own, to not wait for permission, to simply make something. Print it. Put it out. Sell it. I think that's enormously valuable. I think you'll be a better cartoonist and I know that the editors that have any brains at the large comic book companies very much respect somebody who is willing to go it alone. Providing the work is good. If the work isn't good I can't help you. There's nothing I can suggest to help a mediocre artist find work in an industry that's increasingly populated by very talented artists. We have more talent in comics today than we've had for many years.

Interview
Dedication, Commitment, Talent
Joe Kubert

What qualities do you look for when accepting students to the Joe Kubert School of Cartoon and Graphic Art?
The most important quality necessary is a commitment, a very strong commitment on the part of the person who wants to come to the school. That this is a decision that they've made not only out of curiosity or because they think it might be good for them to make a living at it. It's a matter of dedication.

How do you judge their commitment?
Judgment is based on whether their effort lives up to that part of their commitment. Very often a person coming to the school doesn't realize how difficult it is to acquire the abilities necessary to be a part of this cartoon profession. Those who say, "Well yeah, this is what I want to do" suddenly midway will find out, "Well, gee, I didn't realize that it was going to be this hard to learn all the things I have to learn!" The average student who attends this school maintains a schedule where they're sitting at a drawing table eight to ten hours a day, six to seven days a week.

The other part of this is that there's a ten-course curriculum that's given to every student who comes here. The student who's accepted cannot select that which they want to study. Every student who comes here must apply themselves to the given courses—the ten-course curriculum that everyone must take—*and* must pass. Now that presents a problem for a lot of people. Some will come here with the thought in mind that they want to be a penciler. They don't want to do anything else but be a penciler in our business. Well, that's not acceptable to the school, simply because there's no way that we can assure them that they're going to make a livelihood over an extended period of time merely by focusing on that one area—one narrow area—of the comic book field, or the cartooning field.

It's during their time here in the school, in the classes they're taking, that they're very carefully observed to make sure that the part of the motivation that they said they felt at the time of their interview is still there, and is there strongly enough for them to be able to go ahead and just work at this. There's no other way that anybody can attain a level of professionalism and ability to do this kind of work. There is no other way except by sitting at a table and drawing . . . and drawing . . . and drawing.

And this is all to help them prepare for the realistic rigors of producing a monthly comic book?

That's correct, or for *any part* of the commercial art business. Anybody who comes into the business is immediately saddled with a deadline. You *live* with deadlines all your life while you're in this profession. You can't suddenly say, "Well, I don't feel like working this month" or "I'm going to take a vacation" or "I took a job and I know I told 'em I was going to finish it on Monday but I'll finish it on Wednesday instead." Well, that person is very quickly, very soon, out of the business.

Your own approach to comic book illustration tends toward the realistic; what other styles are taught at your school?

Style in and of itself means nothing to me. Take the simplest kind of drawing you can think of: a *Peanuts* strip. There couldn't be anything simpler than *Peanuts*—or Mickey Mouse for that matter—yet it communicates so darn effectively on a variety of levels. Well, you can call it a good style. To me, I just think Charles Schulz was a good cartoonist.

Style is really a compilation of an artist's feeling about the work that he's doing at any given time. Styles change. Most of the great artists, great cartoonists that I know, are constantly changing, constantly looking for new ways to approach the work that they're doing.

Also, style is really a dilution of all the things that we see and experience and all the things that pass through our minds that we translate into our illustrations. The way I would gauge the effectiveness of a piece of cartooning work is, Does it communicate to me? Does it say something to me? Because in actuality, that's what a cartoonist is. He's a communicator. He's a storyteller. And if he does that clearly, simply, effectively, then he's a good cartoonist.

And how do you go about evaluating good visual storytelling?

First of all, it has to be inviting to me visually. There are some drawings, some cartoons I see that, just in picture form, look ugly to me. I'm not talking about subject matter. Subject matter can be anything, the tortures of the damned. But if it's done in such a way that it touches me in terms of recognizing that this looks correct, that it's communicating a particular kind of story to me, that's fine. If the drawings are renderings that are akin to a medical illustration, that's good for medical illustration but to me, it's not what the cartoonist should be doing, and it takes on a veneer of ugliness for me, and it repels me as far as wanting to read it is concerned. However,

if the drawings translate as something that looks right to me—that I can get a feeling about what is immediately happening from the character or from the expressions on the character—I want to *read* that. If I want to read it, to me that's a sign of a successful comic strip.

Do you encourage experimental narrative?

Absolutely. Again, we don't try to dictate style. There are no two artists who draw alike. No matter how similar they are they still don't draw alike; they don't *think* alike. The effects of drawing are as dissimilar as people's fingerprints. So no matter how much somebody tries to emulate somebody else's quote-unquote style, they're still not going to get what that person is doing. So we try to encourage our students to develop their own look, their own voice. Paul Levitz, the publisher at DC, has said that the artist who has generated a voice for himself, a recognizable voice, is the kind of artist they're looking for. And this really struck me as correct.

At graduation, what do your students take with them in addition to mastery of their craft?

What they get first is the approval of the school that they are now ready. Not every student who comes to the school is able to attain that level of competency to be able to graduate. But those who have graduated from the school are doing so with the commendation of every one of the instructors they have had. And after twenty-nine years, the school has become very recognizable in the field.

Plus, they have made contacts, not only with the business as a result of what they've done here at the school and the interviews that they've had while they attended the school. More important than that are those people who have been sitting next to them, their fellow students. When a student graduates and gets a job, the first one that he calls upon is his fellow student. So these are valuable assets. Having sat next to somebody for a couple of years, this guy knows how this other fellow works and that he knows what he's doing.

Do you recommend apprenticeships?

It depends. It depends on the situation. It depends on the ability of the individual. There are some people who graduate and still perhaps feel uncertain and if they can gain from an apprenticeship, that's great. The only problem there is that as an apprentice, you can't really make a heck of a lot of dough. It's hard to support yourself on what an apprentice gets paid.

What direction do you see comics taking in the future?

Ten or fifteen years ago, no one ever dreamed that comic books would have the beautiful kind of printing, on the paper that they have now. When I started out in the business, color registration was so far off that when the comic book was published and there was only a quarter of an inch spread between the reds and the greens, we thought that we were lucky.

What about comics education? Do you see Internet correspondence courses becoming more prevalent?

Oh, yeah, definitely! I have an ongoing correspondence course. And suggestions have been made about the possibility of conducting these lessons via the Internet. It's completely feasible today!

I think that the whole field can only expand. Who the hell knows what the next step will be? But I know it will be exciting. It will be great. It will be something to look forward to.

Some "Contemptible" British Students

Roger Sabin

Little Nympho in Slumberland © *Brian Bolland*

When I think of "the education of a comics artist," I think of Dan Clowes' hilarious strip *Art School Confidential*. If you don't know it, it's a semi-autobiographical take on life in art school, in which our hero suffers the indignities of life-drawing classes involving "hideous hippie models," and of dealing with socially inept tutors who prey on female students. At the close of the strip, he turns to the reader and warns: "Never mention cartooning in art school because it is mindless and contemptible and completely unsuitable as a career goal!" **1** The strip is currently being made into a movie by the same team that brought us *Crumb* and *Ghost World*, which can only be a good thing.

With these negative thoughts on art school in mind, and because I happen to have worked in such an institution for the last ten years of my life, I thought it might be fun to take "The Education of a Comics Artist" somewhat literally and track down some graduates who did indeed make cartooning their "career goal." The aim would be to see if they had as miserable a time as Clowes, whether they felt that cartooning was seen as "contemptible" and what, if anything, they felt art school contributed to their education. Therefore, let me say at the outset that this is not a "scientific" piece but it does, I hope, point to some interesting questions involving what we actually mean by "education."

The art school in question is a British one, namely Central Saint Martins College of Art and Design in London. It was once two colleges, which merged in 1989: The Central School of Arts and Crafts (later "Art and Design," founded 1896) and St Martin's School of Art (founded 1854). They've offered different courses at different times, but today the specialties are fashion, graphics, performance, and fine art. None of the colleges has ever run a degree or a module in cartooning, to the best of my knowledge. **2**

This British context is important because the character of UK art schools has long been romanticized as being unique. In the words of the best book on the subject, Simon Frith and Howard Horne's *Art into Pop*, "The modern British art school has evolved through a repeated series of attempts to gear its practice to trade and industry, to which the schools themselves have responded with a dogged insistence on spontaneity, on artistic autonomy, on the need for independence, on the power of the arbitrary gesture." **3** This set them apart not just from the staid traditional universities, but also from art schools in other parts of the world—especially the United States. It also meant, in the words of the authors, "art schools are the natural setting for ideas of counter-culture." **4** As such, you might expect would-be cartoonists to be affected by this kind of atmosphere. And you'd be right.

Let's take an example of a student from the 1960s. Posy Simmonds studied Graphic Design at Central between 1964–68. Thereafter she made her name in newspaper cartooning, especially her acclaimed satire on middle-class leftist values, *The Webers*, in *The Guardian*, before turning to children's book illustration. In the 1990s and 2000s, her best known works have been adult graphic novels, in particular *Gemma Bovery*, a reworking of Flaubert's classic as a modern tale of personal politics versus lust. Through her career, Simmonds has won many awards, topped off in 2002 by one of the UK's most prestigious honors, an MBE.

At college, Simmonds' course was typography-orientated, though she had already developed an interest in cartooning, having grown up, she said, in "a house full of *Punch* magazines." **5** Although she recognizes that in Britain, as a whole, the attitude to cartooning was largely negative, at Central it was characterized by indifference: "The course didn't connect with cartooning; it simply wasn't talked about." Over time, therefore, she had to invent strategies to get around this: "I used to twist the projects in order to get my drawings in."

There were other aspects of being at the school that were more important in terms of her future development as an artist. In particular, she is quietly passionate that the timing of her stint as a student was crucial to her politics. "It was 1968 and all that," she explains, referring to the student revolts that followed the "May Events" in Paris. "We had sit-ins and mini-rebellions—though it was much worse over at Hornsey Art College, where they had a full-scale occupation." Such actions were infused by various hues of anarchist and socialist ideologies, but also included discussions of how art should be taught. Simmonds remembers the experience with nostalgia: "You have to bear in mind that having fun was a big part of it, and I remember fabulous parties and seeing the Animals play live in the underground car park."

There were side effects to being at the school, too. For example, the traditional art college end-of-year degree show, to which members of the general public are invited, became key to setting Simmonds on her path to professional cartooning. Her drawings were on display, and were spotted by a former graduate of St Martin's, Mel Calman, who himself had made a highly successful career in newspaper cartooning. It was he who encouraged her to pitch ideas to the dailies.

Another corollary was that the school provided raw materials for some of her future strips. "There was one tutor who became the basis for an early character of mine, 'George Weber the Structuralist,' a well-intentioned intellectual. That was great fun to do." Unbeknownst to her, the staff at the school would buy *The Guardian* regularly to spot the references. Another "raw material," of sorts, came in the form of her future husband Richard Hollis, a typographer of note whom she met at Central. His contribution to the typesetting of *Gemma Bovery* would be greatly praised.

Our second example is a student from the 1970s. Brian Bolland studied for a one-year postgraduate qualification in graphic design at Central in 1973 to 1974. His meticulous line and gift for capturing facial expressions made him a minor star of the underground before moving on to boys' adventure comics. His work for the science fiction weekly *2000AD* catapulted him into the premier league of creators—

especially for his version of *Judge Dredd*—and thereafter he was headhunted by the major American companies and became part of the "British invasion" that helped revitalize the United States industry in the 1980s and nineties. Today, his original artwork featuring characters such as Batman and Wonder Woman can fetch tens of thousands of dollars.

Bolland evidently enjoyed his course. "I was able to develop an appreciation for a variety of artists and animators, especially the latter. Everybody from Tex Avery to Eastern Europeans like Jiri Trnka and Karel Zeman." [6] Being at Central also offered him the opportunity to get involved in unofficial projects with students of like mind, such as contributing to student publications. One example was the underground-influenced satirical magazine *The Galloping Maggot*, for which he produced some of his earliest comics work. "I did a strip called *The Mixed-Up Kid*, which compared to some of the other stuff [that] was more slickly drawn, but not half as funny."

More than this, Bolland found that, unlike Posy Simmonds, his course was very open to the idea of cartooning. "It didn't discourage me from comics at all. In fact, I spent the whole year producing one comic book, a self-indulgent thing called *Suddenly at 2-o-Clock in the Morning*. Although general attitudes to cartooning among lecturers don't seem to have changed much since Simmonds' day ("It was hard to find anybody interested"), individuals were certainly very important in encouraging him. "When I went for my interview for a place at Central there was one tutor there who was keen on some of the satirical magazines that contained cartoons, like *National Lampoon* in the United States and *Hara Kiri* in France. I could tell that he was the one who got me accepted [into] the course."

Suddenly at 2-o-Clock became something of a calling card. The geographical proximity of Central to the hip London countercultural publishers was certainly of benefit. "Quite a lot of it got reprinted in the underground comics and magazines of the time such as *Cozmic Comics*, *Frendz*, and *Oz*." One strip, indeed, became notorious. *Little Nympho in Slumberland* was an "erotic" spoof on *Little Nemo* and featured a heroine who had trouble keeping her clothes on. Feminists were outraged. "Thirty years on—or even ten years on—that strip was still cringingly embarrassing for me. But looking at issues of *Oz*, I can see that sex and nudity were common currency. That and the fact that at college we all spent many hours drawing nude life models meant that *Nympho* didn't seem that offensive at the time. I was just drawing what I knew."

Our final example is a student from the 1990s. Laurence Campbell studied Graphics at Central Saint Martins between 1993 and 1996. His cartooning career is still developing, and though he admits he's not in the same league as Simmonds or Bolland, he's a regular contributor to *2000AD* (including *Judge Dredd*), and has illustrated comics for Image and Caliber in the United States.

"Comics weren't heavily encouraged on the course," he explains. 7 "But I did learn a lot from being introduced to the styles of different graphic designers." The 1990s was "the decade of design," after all, and Campbell cites David Carson and design group Tomato as influences. "All of that was stuff I could use in my comics, even if it wasn't always obvious. Subsequently, a lot of people have labeled my work as being graphic design orientated, rather than illustrative, which I think is true in terms of my interest in composition, layout, and so on."

Like Bolland, Campbell was busy producing comics while still a student, though in an unofficial capacity. Like Bolland, also, he found it useful to collabo-rate: "One strip I did with a fellow student involved her drawing characters from a female point of view, and me taking the male perspective. That was great fun, and was published by Caliber in *Negative Burn*." Was he aware of Bolland and Simmonds? "Oh sure. What aspiring cartoonist wouldn't be? Bolland's *Dredd* was iconic, so it was a particular thrill for me to work on that character. But I only learned they had been to Central much later." Campbell now splits his time between professional comics work and tutoring at the college, where he said he's sympathetic to aspiring cartoonists, but encourages them to look outside comics for inspiration.

What conclusions can we draw? Would our three case studies have gone on to do the work they did without going to art school? Would Simmonds have devel-oped her political perspective? Would Bolland have produced his underground comic? Would Campbell have introduced graphic design elements into his work? It's impossible to say. But all three seem to have responded well to the art school experience, and circumvented any view of comics as "contemptible" through ingenu-ity as much as anything else. Certainly, they must have suffered their Dan Clowes moments. But at the very least, school allowed them a space to experiment. And perhaps that's what education should be about.

Cosmonaut X by Laurence Campbell
© *2005 Rebellion A/S. All rights reserved.*
www.2000ADonline.com

Notes

1 Daniel Clowes, *Eightball* (Fantagraphics, 1991).

2 The views expressed in this essay are the author's own, and not those of the college.

Apart from my three chosen examples, other alumni from the college(s) to have made a professional career in either comics or cartooning (more broadly defined) include: William Sillince (*Punch, Yorkshire Post*, etc.), Alfred Bestall (*Punch, Rupert the Bear*, etc.), Peter Brookes (*The Times, Spectator*, etc.), Mel Calman (*Daily Express, The Times*, etc.), Gerald Scarfe (*Private Eye, Time*, etc.), Matthew Pritchett (*Daily Telegraph, Spectator*, etc.), and Charles Peattie (*Independent, Private Eye*, etc.).

3 Simon Frith and Howard Horne, *Art into Pop* (Methuen, London, 1987), 29–30.

4 Ibid, 48.

5 Posy Simmonds, interview with the author, February 13, 2004. For more on Simmonds, see *www.lambiek.net/simmonds_posy.htm*

6 Brian Bolland, interview with the author, November 12, 2003. For more on Bolland, see *www.lambiek.net/bolland_brian.htm*

7 Laurence Campbell, interview with the author, February 28, 2004. For more on Campbell, see *www.pixelsurgeon.com/interviews/interview.php?id=105*

To the Heart of the Medium

Will Eisner

To the Heart of the Storm
© *Will Eisner Studios, Inc.*

What kind of training or education did you have?

For the comic medium, I was very much like all the rest of the people who started when I started. There was no special training; there were no classes or studies in this medium at all; there was no organized discipline. Most of us went to art school to study other things. I studied painting for a while at the Art Students League, I studied anatomy there, then I went to a school to study commercial art, but I never studied comics.

My preparation for this medium was really self-taught. I was an avid reader of short stories. I grew up in the thirties, the prime short story era of our culture, of the century. And so I read pulp magazines very avidly. It was a very popular medium of the time. I saw comic strips, of course, and I studied art—artworks in galleries—and that was essentially the broad mix of my education. I ultimately went into this because of the fact that it combined two mediums, two disciplines that I felt I was quite good at, and that was art and writing.

Did you have any mentors?

The three major influences on me were: Milton Caniff, who did *Terry and the Pirates*; George Herriman, who did *Krazy Kat*; and the fellow who did *Popeye*, Segar. These people taught me how to do three different things. The pacing of stories I learned from Caniff, the engagement of the reader visually, with graphics, came from Herriman, and the *Popeye* illustrations were really an instruction on how to deal with the display or the portrayal of action. Popeye seemed like a very action-packed character, but he never actually left the ground. He never bounded from place to place, but he seemed to convey a tremendous amount of action. That always intrigued me and I used to study that very carefully to see how he was able to convey that.

Were you consciously studying the *Popeyes* and *Krazy Kats*, or did you realize they were influences after you were engaged in the medium?

I studied them. I read them carefully, and was intrigued by what they were doing. I used to tell my students that copying is no way to learn another man's work. The thing to do is to sit and understand what he was doing and how he achieved the quality that intrigued you. I guess I was looking at it the way you would look at a puzzle. Or the way you look at a magician, and see how the magician is working, and try to figure out how he's doing it. These men seemed magical to me, anyway.

An actual physical mentor was George Bridgeman, a great anatomist of the time. I studied with him at the Art Students League and I still depend on him for my ability to render.

When did you start teaching?
I started teaching in 1972. The School of Visual Arts (SVA) called me and asked if I would come and teach. By then I had come to the conclusion that this medium is teachable, and that it had a discipline and a structure far beyond what everybody else was doing viscerally. Most of the artists I grew up with, my contemporaries, never really discussed the mechanics of the work. All of them were working on it . . . the only word I can think of is "viscerally." They were just working on it, and they knew.

As a matter of fact, it was the school that enabled me to sit down and write a textbook on the subject. As I began teaching it, I realized that what I was trying to say was not said anywhere else. The old cartoon teaching books of the thirties and forties were either pictures of funny characters, which you were supposed to imitate, or they were about how to draw feet and noses and so forth. And the anatomy books were geared to artists who were going to do major illustrations. The anatomy that was taught in books was not really what should, in my opinion, have been taught. They weren't teaching it the way I would like to teach it. They had a few skeletons, but mostly they were showing off the artist's work. The only real good functional illustrations that I felt were working in anatomy books were the works by George Bridgeman, who assumed—or worked on the premise that—the body was a mechanical thing. He would reduce the shapes of the body into blocks and masses so that you were manipulating masses. It was very, very instructive for me. It was very worthwhile. To this day I think it's the best anatomy book for beginning students out there. As a matter of fact, I used to recommend that book to my students.

SVA began as a trade school in 1947; was it still operating under that premise when you were there, or had it started to become more of a Bachelor's degree-granting institution?
It started as the Cartoonists and Illustrators School with Burne Hogarth and Silas Rhodes. It was serving the kids coming out on the GI Bill. It became a more structured school about the middle sixties. When I was there, they were already giving a degree, although the reason I agreed to teach there is that they would permit me to not give grades.

In the world of art, I don't believe it's possible to grade students, except those who don't attend class, because art is such a personal thing. It's so subjective that it's very hard to sit down and tell a man that he's a failure, or that he's got 80 percent, or that he's got A, B, C, or D. So they agreed to let me teach that way, and I enjoyed teaching there. I taught for seventeen years.

Instead of grades, what sort of feedback did you give students? Were there extensive critiques?

Yes, what I would do is give an assignment, and then I would critique the assignment. I would hang the assignments up across the wall and go over each one of them with them.

The title of my class was "Sequential Art." I devised the name because I didn't want to use "comic strips." I felt "comics" was a misnomer. Although the school double-crossed me. When they put out the catalog they said, "Will Eisner's class in Sequential Art" and in parentheses they put the word "Comics." [laughs] It's very hard to kill that name.

I was basing my teaching on the fact that this is a language and that the ability to manipulate images into a sequence, an intelligent sequence—to convey an idea, to tell a story—was essentially the heart of this medium. As far as drawing is concerned, I told them they could learn drawing by themselves. They didn't need me for drawing. What they needed from me was a way to look at it—the medium they were working in—and how to structure stories and how to organize what they were about to say in some kind of an intelligent sequence. So I would make my students write as well as draw. As far as a drawing style was concerned, some of the kids in the class had very primitive styles, and some of them were very strong draftsmen. But some of them who had very primitive art were much better storytellers than some of the artists who were strong draftsmen.

I was also fighting against what I felt was going to happen to them when they graduated. That is, that the field was breaking up. There'd be a writer, and then there'd be a penciler, then you'd have an inker, a colorist, and so on and so forth. The artists and writers would be struggling for sovereignty, if you will, and in this medium, on first look, the art dominates. It attracts people at first, and so the artists, the students in my class, were really more interested in the art than they were in the writing and I would force them to write and draw at the same time. Which I believe, for this medium, is the best combination: for it to be in the same man.

Did you give specific assignments, or were they open?

I'd give specific assignments. I would create a problem. For example, the back of the room had a door that actually led out to a fire escape somewhere. I would say to them, "Okay, there's a door, back of this room. I want you to do me a one-page or a two-page story on what is behind that door." Each fellow would come in. Some guys would open the door and find that it led to a tunnel, you know, and so forth. This stimulated the imagination. Also, there was a great deal of lecturing in the class. I would discuss stereotypes, for example. I'd hold a whole class on stereotypes, and moral obligations, the morality of what they were doing. And I had a class on the business of art: the kind of contracts they would be facing, the kind of relationships they would have in the business world, and so on and so forth.

When you put out _A Contract with God_, I guess you'd been teaching about six years at that point?

That's right. I started to write it in 1976. It was published in '78.

Did the process of teaching clarify your thoughts on the medium? Did it influence the creation of _Contract_?

Well, it did influence it in the fact that it reassured me that I was right, that it was a valid, legitimate, literary form. And that the arrangement of images in a sequence to convey an idea had a vocabulary, a structure, and a language, and so forth.

But, the reason for _Contract with God_ was a bit more pragmatic than that. And that was that I felt that, by 1975, '76, the thirteen, fourteen-year-olds who had been reading comics that I started with, were by then about thirty-five years old. And they would no longer be interested in the subject matter that was written for them at the time. Also, from the very beginning of my career I believed that this medium was a legitimate art form capable of dealing with subject matter well beyond the simple superhero story or the jokes, the elementary adventure stories of somebody pursuing a villain and catching him, and so forth. And so I began writing what I thought would be a proper—in italics, _proper_—novel. I selected a subject matter that I felt adults would be interested in, that would not be of interest to young people, and that was man's relationship with God. Actually, the title was changed for me by one of the salesmen for the publishing house who said that he didn't think the title, _Tenement Stories_, was a good one. He felt it wouldn't sell in the Midwest. So, he said, "Let's take the title from one of the stories," and one of the stories was called "A Contract with God," so we used that on the cover. The subject matter of the entire book was aimed purely at adults.

**Are comics students better served by a practical, trade-based pro-
gram that will prepare them for the job as it exists now, or a more
academic, University-style degree?**

I would say that it's the combination of the two. They have to make a living.
They've got to get out into the field after they graduate. Probably their first jobs
will be as an apprentice of some kind, somewhere, working with a major house,
doing either backgrounds, or filling-in of some kind. So I think it's important for
them to get a good, basic grounding in the mechanics of art, and also a great con-
centration on reading. I feel very strongly that every artist working in this particular
discipline should have a strong grounding in literature; that is, in the business of
stories, storytelling, and the writing of literature. Those things are a good funda-
mental background to go along with the ability to draw.

The trend right now in the field is to give more attention to artists with primitive
art styles, or primitive art ability, and good ideas. Pick up a *New Yorker* magazine and
you'll find that some of the artwork looks like it was done by some disabled child. But
the concept, the idea, is a very good one, very sophisticated. So, a fellow going into
the field must learn, first of all, the skill of rendering pictures and drawing and creat-
ing art, and also must have something to say. He'll have something to say based on
the amount of literary exposure he has. The emphasis has to be on both sides.

**There's also the reverse of the primitive style that you're talking
about, where the art becomes too slick and you have incredibly ren-
dered oil paintings. It actually slows you down, it will stop you
from following the narrative flow.**

You're absolutely right. What you have there is an artist without any real interest in
what he has to say. His concern is to produce the magnificent piece of art. Most of
the fine arts, if you look at the world of the fine arts, you find that the approval, the
applause, the awards, or the rewards comes to stylists. Candidly, Picasso had very
little to say. Van Gogh had nothing to say. He had an emotional approach to color,
yes. But very few of them really had more to say other than the style they were
working in. These were craftsman more than anything else. I know whenever I dis-
cuss this with anybody it brings up a big argument. I get into a huge fight over this,
but this is how I see it.

You've got to learn minimalism. It is very difficult. I'm still "minimalizing." I've
been learning the last twenty years what to eliminate, and how to break away from
the instinctive desire to produce a magnificent piece of Rococo art. [chuckles]

It depends on what you're trying to say. If you're telling a story about real people, or a real event, then the artwork would have to take on a certain reality. But, essentially, you're doing it in impressionism. Some of the great artists, great draftsmen in the field, tend to, slowly but surely, begin a certain amount of minimalism. They combine the impression of what they're talking about with the reality of what they're talking about. But there's a great deal of applause that goes to realism. In the comic book world, there are people who are producing work that is almost photographically accurate. And these are incredible pieces of art. The applause that they get, and—incidentally, that's all we're looking for, really, is applause or approval— the approval they get comes from their abilities to draw so realistically and so exceedingly well.

But that's not the whole thing.

Do you have different influences today than from when you started?
The influences I have now come from my life experience. I know my craft now. I'm skilled in what I can do. All that's left for me to do is decide what I want to say, what I believe is important for me to say. When I started it was a means to an end. Now it's an end in itself. I've accumulated enough finances so that I don't have to worry about sales. I'm in a perfect position for working in this medium.

What do you look to in order to stay fresh and passionate about making comics today?
I'm still in pursuit of the thing I started with, which is producing work of enduring value. I move from level to level. For example, the last two books I've just completed, they're more polemics than they are entertainment stories. I'm not so much interested anymore in entertainment as I am in producing what I believe is visual literature.

You mentioned once that you were thinking of beginning to call yourself a writer. What did you mean by that?
Everybody in this field, we're looking for a way to describe ourselves. Now, when people ask me what I do I say, "I'm a writer, I write with pictures." The problem with this medium is the word "comics" is a total misnomer, but it's been around so long that they keep referring to your work as "comics." Well, it's not right, so we keep trying to change the name, or change the description, or the classification.

You're regularly cited as the father or the grandfather of today's comics. Are there downsides to being such a revered figure?

Sometimes it's a little embarrassing, but that's no real downside. Look, as I said earlier in this conversation, if you do an autopsy on most artists, you'll find their basic desire is for approval. And when I get approval, I love it.

Lesson Plans

The Importance of Teaching Comics

Ted Stearn

Although the case for understanding and appreciating comics as a viable art form has gained much acceptance in recent years, there can be some confusion about exactly what "comics" are. The popular perception of comics seems to be focused on the content and style. In our American culture "comics" seems to mean Batman and Spider-Man, or Japanese manga. Even comic strips today, with some notable exceptions, are much more about the content (that is, the gags). Frequently, the visual component in these tiny short strips is almost an afterthought.

Each of these genres is also more often than not safely ensconced within a predictable style. Thus, most superhero comics will inevitably contain narratives composed of staccato sentences with a melodramatic tone. Almost every manga face seems to require a nose no larger than a pea, and many comic strips require the most obvious set up possible for the inevitable gag. Interestingly, when I look at earlier examples of these genres, these knee-jerk-style clichés did not seem to be present. They were developed over time, for whatever reason I will not go into now. In any case, in teaching comics I do think it is important to make the student aware of the creative limitations unintentionally influenced by the habits of style.

This perception of comics in terms of content and style sets limits on the potential for what comics can be. When teaching comics, I always try to refer to the importance of form over content and style. Like its cousin, film, comics must be classified as a medium, not a genre. And as a medium, comics have as much potential and possibility as the author can bring to it.

I will not claim that comics are the most holistic, all-inclusive, or challenging of all art forms. I've heard that claim about painting, sculpture, film, writing, and dance. But each does have its strengths. Dance, for example, requires a special awareness of the body. So it follows that each of these art forms contributes a unique voice of artistic expression. One of the most prominent formal features of comics is its natural ability to convey a visual narrative. The process of reading and looking simultaneously is unique to comics. This is the case when there is text, but just as much when there is not. By "reading" I don't necessarily mean deciphering text, but viewing in a deliberate chronological order. The "visual

narrative" created is one with the medium, and cannot be translated to another medium without changing.

Beyond just being a valuable medium of expression, teaching comics can fill a need that is apparent in many art colleges today: to create and develop a visual narrative.* Film and video majors, illustration majors, animation majors, and even writing majors need to understand the importance of emphasizing the visual nature of a story or narrative. I know firsthand, because students from these areas come to my comics and storyboarding classes for that very reason. There are many college creative writing courses, but I don't see how they can effectively tackle the problem of creating a story in images, not words. Comics and storyboards are an ideal medium for this purpose. They are the fastest, most convenient way to create a visual narrative.

As in any other art form, there are a number of skills required to create a successful comic. In order to lend some sense of order to the many aspects of comics that are addressed in class, I have come up with what I call "Visual Narrative Basics." They are as follows:

❯ Drawing: describing volumes and space
❯ Design: visual balance and harmony
❯ Pacing: the inferred timing; how many panels are necessary
❯ Staging: the point of view; what we see and do not see
❯ Acting: what characters are thinking and feeling using pose and expression
❯ Writing: creative use of text; words synthesizing well with images.

By breaking lessons down into segments that emphasize certain aspects over others, I have found it much more convenient to teach comics, and for the students to learn about comics, in a clear and understandable way.

All these basics are important tools in telling a story better. If the story isn't compelling enough, however, no amount of beautiful drawing, or strong pacing, is going to save it. I try to get students to focus on the importance of theme. I describe theme as what the comic is really about. Just by asking the student the question, "Why are you telling me this?" can get us to the true meaning behind the comic. If they say it's funny, I ask them "Why?" again!

*I prefer this term for two reasons; first, it has a broader application than "visual storytelling"; second, it can be applied to comics and storyboarding, which is an important bridge to film and animation mediums.

In one recent assignment, I was reviewing thumbnail layouts of story ideas with students. One student was recounting in her comic an incident where she was being tickled in front of a group of friends, and how she got rid of the perpetrator by kicking him in the crotch. On the surface it would seem to be a minor funny anecdote. But as I questioned her, it became clear she hated to be tickled, and she was extremely embarrassed by the tickling, and it felt good to give him that kick. This helped her start focusing on how she felt about the event, rather than the mechanics of the event itself: The horror of being humiliated in front of one's friends, and the sweet revenge that came with the kick to the crotch. Now she had a theme. Whether she does a humorous take on it or not is irrelevant; it would still be about the same thing. So I encourage students to find a theme running through the comic, however they decide to tell it. Figuring out how the narrative can be told as well as possible usually involves utilizing the Visual Narrative Basics. For example, I encouraged the previously mentioned student to think of ways to build up the suspense of the tickling before the climax of the kick. More panels of her face could be added (pacing), focusing closer and closer on her before she explodes with the kick (staging). Focusing on conveying her expression (acting) would also help in getting to the heart of her theme. Obviously, there frequently is overlap in applying these basics, and many possibilities, but the compartmentalizing helps us focus on finding strong and weak points to address.

One final aspect of storytelling I should mention is how much to tell the reader, and when. All writers deal with this, but beginning students in comics usually think more about the art and less about the narrative structure, so this is an important point to go over. I use the figure of a scale to make my point. Imagine a scale with "clarity" on one side and "complexity" on the other. If there is too much emphasis on being as clear as possible in the story, it will all seem too obvious and thus, boring. But if there is too much going on, or not enough explanation, making the reader feel hopelessly lost, the story will be too confusing and the reader will give up. Only when we can balance the scale will the comic read successfully. The story should be clear enough to follow, but the situation, characters, and their world should be rich and varied enough to hold my interest. Frequently related to this is the issue of cliché and predictability. My three-word warning to students: avoid the obvious!

Portrait of the Comics Artist as a Graphic Designer
James Sturm

One of the first assignments I give to my intro comics students is to create a one-page comic, using no words, that explains how to tie a shoelace. I ask them to imagine presenting their comic to an alien that speaks no earth language (but has feet). This assignment is incredibly humbling. It makes students very aware that knowing something is very different from being able to convey that something.

The students usually succeed or fail, with little in between. The ones that fail tend to fail miserably. They are more concerned with trying to make an "interesting drawing" (i.e., overwrought). All sorts of extraneous information are included; distracting panel configurations, jolting points-of-view, and a need to have their "character" in every panel. The students that succeed do so because they zero in on the information that needs to be conveyed and present that, front and center. When it comes to visual narratives, graphic design predicates drawing.

Any instructor who has taught a comic studio class is familiar with the sound of a student's rambling description of their intended epic graphic novel. This book usually has no outline and, with the exception of a few character sketches, exists only in their head. It is a sobering lesson when students realize they have difficulty visually expressing the rote task of tying a shoelace, let alone their three-hundred-page, ill-conceived magnum opus.

Graphic design is planning. Creating an extended narrative comic requires a tremendous amount of planning which, on the surface at least, seems antithetical to cartooning. Writing for *The New Republic* (June 22, 1987), Adam Gopnik wrote, "Our mistaken beliefs about cartooning testify to the cartoon's near magical ability, whatever its real history, to persuade us of its innocence."

In many ways, cartooning takes a lot of the fun out of drawing. Doodling is fun. A doodle only has to account for itself. Drawing for comics requires the doodle to play well with others. Its relative size, relationship to other panel elements, and its need to stay visually consistent, or at least recognizable, from panel to panel demands a fair amount of labor. A drawing asserts its own logic. The imagery created for comics must conform to a larger gestalt. Again, the cartoonist must first and foremost be a designer. A graphic novel is a visually expressed narrative. Good design in each panel is akin to proper diction.

Students, however, have the expectation that comics should be made as effortlessly as they read. They slowly come to realize that the simplicity of a cartoon image

too often belies the labor of its construction. Students are too often wed to the idea that the enjoyment of reading a comic should be similar to that of creating one.

So the goal is creating work that is both carefully considered and seemingly spontaneous. This is the holy grail of many artists and writers, and not just cartoonists. The great *New Yorker* cartoonist Peter Arno's cartoons are simple, bold, and direct. Although Arno calls spontaneity his god, a finished single panel—that had already been written—would take him four to six hours to execute. He would restart drawings repeatedly: "Sometimes I make five six beginnings . . . striving for the exact quality the idea calls for."

Arno's fellow *New Yorker* cartoonist, Whitney Darrow Jr., describes an arduous process of sketches, overlays, and the application of multimedia in order to achieve his seemingly loose drawings. For the gag cartoonist, the joke or idea is the organizing principle for the drawing's formal structure. For the narrative cartoonist the organizing principle is story.

It's jolting for students to consider working that long on each and every panel. There is the expectation that the process should move more quickly. This expectation stems from the fact that, historically, comics have been sold as periodicals. Each month a new issue is published, each day another strip in the newspaper. Of course these comic books are created assembly line style with different craftsmen accounting for the individual tasks of lettering, inking, writing, coloring, and drawing. Often the drawing is subdivided into background and figures. Many comic strip cartoonists also work in tandem with assistants to meet the daily deadline grind.

Speed remains a much-respected skill for a cartoonist to possess. Many a student becomes totally dejected when they cannot produce quickly. This was certainly the case for myself. I grew considerably as a cartoonist when I disavowed myself of this bias toward speed. It took me three years to create the one hundred pages of my book *The Golem's Mighty Swing*. Of course, no one blinks an eye when a novelist takes twice that long to write a book. I received many expressions of surprise that a comic should take that long. The re-labeling of comics as "graphic novels" could conceivably unmoor them from traditional expectations and assumptions.

Perhaps that is all what teaching is, recalibrating expectations, providing a more realistic road map to help students avoid the more treacherous and frustrating terrain. Nothing seems to frustrate young cartoonists as much as when they struggle with drawing. The back-end work of planning a comic is invisible; the drawing is out front and thus gets all the press. However, cartoonists with only marginal

drawing skills have produced plenty of solid and successful comics. And just as importantly, many cartoonists with strong drawing skills understand that a simple expressive drawing more effectively serves their narrative purposes. An overdrawn comic is like an overwritten book: when too much information is given, the reader feels patronized.

You don't have to draw well in order to feel you're a legitimate cartoonist. By placing too much emphasis on drawing, young cartoonists lose sight of the real magic of comics, that alchemy of words and pictures, juxtaposed images that create something larger than the sum of its parts. This is where comics derive their energy, not from virtuoso displays of elaborate crosshatching or detailed cityscapes. Understanding the narrative implications of the formal arrangements of visual elements is understanding comics. Understanding graphic design goes a long way to understanding comics.

Experimental Comics in the Classroom

Matt Madden

THERE EXISTED A HANDSOME CHISELED MAN WHO WAS LOOKING FOR A UNHUMANLY THIN WOMAN.

ONE DAY A WITCH WITH AFRO HAIR ASKED HIM OUT.

HE "HMPHED" AND REFUSED AND TOLD HER SHE HAD HIDEOUS AFRO-HAIR AS HE WALKED AWAY.

SHE DIED FROM CHOKING ... NEVER HAVING MARRIED.

IT WAS TOO BIG FOR HER UNHUMANLY SKINNY NECK.

SADLY, THE DRUMSTICK GOT CAUGHT IN HER THROAT.

HIS DISTASTE FOR HER AFRO HAIR HURT HER FEELINGS. SO ...

SHE CURSED HIM TO BE THE UGLIEST CHISELED GARGOYLE IN THE WORLD.

NOW CURSED AS A GARGOYLE, HE REMAINS FOREVER CRYING FOR HIS MISTAKES.

SHE WAS VERY HUNGRY, SO SHE ATE A PIECE OF KFC® DRUMSTICK.

A WOMAN WHO WAS BEAUTIFUL AND THIN, UNHUMANLY THIN.

SOMEWHERE IN A FAR DISTANT LAND, THERE EXISTED A WOMAN WHO WAS LOOKING FOR A HANDSOME CHISELED MAN.

SVA student upside-down comic © Hyeondo Park

Classroom exercises based on experiments in comics form are a great way to challenge students to engage with the language of comics and to open their minds to different ways of thinking about art and storytelling.

An easy exercise that can be done over the course of a three-hour class is to ask students to thumbnail a one-page comic that fits one of the following models:

› A *palindrome* comic
› An *acrostic* comic
› An *upside-down* comic, as in Gustav Verbeek's classic *Topsy-Turvy* strip
› A *morlaque* (a comic that "bites its own tail")
› A *repeating* comic where the image, or some part of it, stays the same from panel to panel
› A *Mad* magazine–style *fold-in* comic.

All these concepts are clear enough that most students grasp them easily, although it helps to show some examples.* Introduce the idea of formal play and experimentation by discussing word games like palindromes and anagrams while writing some on the board: "A Man, A Plan, A Canal: Panama," "Insane Anglo Warlord" derived from "Ronald Wilson Reagan," etc. This is an interactive way to get students engaged in the topic and to have a few laughs along the way.

Make a handout or write the choices of "constraints" on the board. Give students a few minutes to choose a constraint; I find that most have little trouble in choosing one that appeals to them, but a few might need some suggestions or clarifications.

Once everyone has chosen a constraint, the students should rough out a thumbnail in pencil. As they work, and you monitor their progress, try to nudge them into pushing their comic a bit further than the simple mechanical operation of the rule: if they are doing a palindrome or morlaque, suggest that the story they tell could be about characters who are stuck in a vicious circle of some sort or who are constantly undoing what they have just done; if they are doing a fold-in comic, help them find a way to have the second "folded-in" comic somehow comment in some way on the "open" comic.

* Some helpful resources:
A Book of Surrealist Games, Alastair Brotchie, Ed. (Shambhala)
The Oulipo Compendium, Harry Mathews and Alastair Brotchie, Eds. (Atlas)
Oupus 1-3, Oubapo collective (L'Association) (in French)

When everyone has a legible thumbnail completed, have the class do a critique. Give the students two criteria for discussing the thumbnails. One, does the constraint work? That is, does the palindrome make sense? Does the acrostic read clearly in all directions? And two, does the constraint reinforce or comment on the story or situation created in the comic in an amusing or enlightening way?

Even if all students do is mechanically complete the assignment, they will have learned a simple but valuable lesson: that in addition to telling stories, comics language can be used to make different kinds of works—akin to word games but also to poems—where the content is partially determined by a formal constraint you place on the work from the outset.

This exercise can be used as a stand-alone tangent in a more-conventional comics class or as a starting point to exploring more complex and nuanced experiments in formalist comics. For students who are inspired by this exercise, a whole world of exploration has just opened up to them. On the one hand, the simple but radical notion of creating storytelling via form—letting content be generated through constraints placed on structure—can lead them to creative breakthroughs and new directions in storytelling. On the other hand, a further exploration of the kind of game-like constraints used in this exercise will lead them into the whole world of avant-garde, formalist, and process-based approaches to art and narrative.

A formal exercise like this will certainly be exciting for students who have a bent towards the unusual but don't yet have the tools for it, but it will also provide a valuable lesson to students interested in more conventional comics, whether manga, superhero, autobiography, or whatever. Obviously, not every comic is a palindrome; nonetheless, there are plenty of works out there—from Winsor McCay to Alan Moore to Chris Ware—which reward the attentive reader by revealing intricate formal structures that often enrich and inform the content of the work. This exercise teaches students not to take form for granted and shows them how factors like panel arrangement, repetition, and unconventional reading paths can affect the comics reading experience.

Funnybook Lit 101
Rich Kreiner

When thinking about what might be included in any substantive syllabus of comic-related prose, one guiding criterion emerges: skilled writers taking considered positions to address comics seriously, whether as serious works of art, serious sources of pleasure, serious social reflection, serious means of personal expression, or serious threats to society. A second earmark might be that, like the classic writings of any other field, such books and articles are far more honored in citation and reference than actually read.

One of the earliest, most articulate, and influential advocates of the medium was Gilbert Seldes. A card-carrying intellectual himself, Seldes sought to broaden the refined regard that the cultural elite reserved for the "high arts." He did this by advancing a reasoned if passionate admiration for the increasingly popular "popular arts." In his 1924 paean *The Seven Lively Arts*, he praised "The 'Vulgar' Comic Strip" for its vitality, however "grotesque and harsh and careless." He found special merit in George Herriman's *Krazy Kat*, "easily the most amusing and fantastic and satisfying work of art produced in America today."

Through the linkage of comics to the other mediums of mass culture, particularly movies, Seldes opened passage for other writers to soberly appraise the funnies. It remained for Coulton Waugh to cultivate, at book's length, the medium's independent significance in his seminal look at *The Comics* in 1947. Waugh's approach was personal and encyclopedic; he offered a wealth of information and casual detail, providing perspective on almost two hundred strips in a sunny, descriptive style. His final chapter dealt with comic books, which Waugh ranked among "the important discoveries made in the world in the last ten years." The evaluation was offered more on the basis of comics' potential than on the less than savory aspects they flaunted from the racks and newsstands of the day. He optimistically held, "A new and healthier trend is on the way."

Some, such as Gershon Legman, were hardly willing to wait: "That the publishers, editors, artists, and writers of comic books are degenerates and belong in jail goes without saying," he wrote in his self-published screed of media criticism, *Love & Death* (1949). Legman was in step with the full-blown anti-comics crusade underway at the time, one that would dovetail nicely with the McCarthy era's penchant for witch hunts and scapegoats. As working-class entertainment of the most common sort, comic books were denounced for their poor quality, crude execution,

and base content. Worse: many voices portrayed them as contributors to, if not the causes of, a whole range of social ills, the most spectacular being juvenile delinquency.

Chief prosecutor in the court of public opinion was psychiatrist Fredric Wertham who, in 1954, published funnybooks' *Necronomican*, a dire tome of dark foofaraw called *The Seduction of the Innocent*. The book, however burdened with suspect logic and even less credible methodology, still managed to set the tone and the agenda for the congressional investigation of comics under Senator Estes Kefauver in the fall of that year.

Social critics, commentators, and the intelligentsia-at-large had long been picking sides and staking positions relative to the topic. In a 1952 piece, poet and essayist Delmore Schwartz gave a close reading to three issues of *Classics Illustrated*, the series that, in the comic book equivalent of cross-dressing, retold epics of world literature in forty-four pages of words and pictures. Since "mass culture is here to stay," Schwartz believed that "even if the reading of cartoon books might be stopped, it is probable that prohibition and censorship would have the usual boomerang effect." His solution was for intellectually responsible citizens to set a good example by reading both the prose and cartoon versions of the literary classics, thus serving as inspiration for the less enlightened to get their noses out of comics alone.

Robert Warshow had similar beliefs about the ready availability of cheap diversions and the dismal prospects of social engineering for children, noting "as we sweep away one juvenile dung heap, they will move on to another." Warshow's interest in the subject was anything but abstract or impersonal. In his book *The Immediate Experience*, he approached the medium through his son, writing on "Paul, the Horror Comics, and Dr. Wertham" at the height of the anti-comics campaign. Though he faulted Wertham's reasoning and claims, Warshow himself was no fan of comics: "most of us find it hard to conceive of what a 'good' comic might be" (even allowing for exceptions like *Pogo* and *Dennis the Menace*). His enthusiasm for the medium had distinct limits: "When no art is important, *Krazy Kat* is as real and important a work of art as any other."

In time, to escape the threat of rigid standards imposed by the government, a consortium of comic book companies preemptively tailored a set of their own rigid standards and imposed it upon themselves. The Comics Code outlawed sexy women, successful criminals, dead cops, animated corpses, drug use, as well as use of the words "horror," "terror," and "crime" in a comic's title. The specificity of the guidelines had the effect of driving one highly successful company from the field in addition to, as we now know, extinguishing delinquency and all forms of childhood misbehavior forever.

Those perilous shoals navigated, comics commentary sailed into a broader exploration of more expansive and promising seas. Polarized and politicized position papers gave way to more ambitious, balanced studies. In 1959, Stephen Becker not only undertook another encompassing survey of comic strips and books in his *Comic Art in America*, he also included magazine, editorial, and sports cartooning and animation; it was that very breadth that ultimately defied an authoritative summary.

No summation was expected when David Manning White and Robert Abel brought together a number of diverse opinions for their anthology *The Funnies* in 1963. "[L]iterary critics, social scientists . . . psychiatrists, and three of the very articulate comic strip creators" all circled around the question, "What do comic strips tell us about American culture?" Many of the book's pieces took as their starting point the implicit significance of the funnies' formidable popularity and daily presence in readers' lives (*"Blondie,* which appears in some twelve hundred papers throughout the world, may be read seventeen billion times in a single year").

Testifying to comics' impact on a single reader, albeit an astute cartoonist and accomplished writer, Jules Feiffer released one of the most forthright and productive (read: "entertaining and useful") examinations of the subject in 1965, *The Great Comic Book Heroes.* Part historical overview, part memoir, part artistic critique, and spiced with social, cultural, and psychological observations, the book dealt frankly and blithely with old stigmas and modern amusements: "Comic books, first of all, are junk . . . there to be nothing else but liked. Junk is a second-class citizen of the arts. . . . There are certain inherent privileges in second-class citizenship. Irresponsibility is one." That privilege, along with other aesthetically unconventional liberties, was celebrated with relish by underground cartoonists. It was this generation that would expand the vocabulary and provide the daring to further advance the medium's claims for unrestricted first-class citizenship within the arts.

While the present article has preoccupied itself with American funnies and English-speaking authors, the reasoned assessment of comics has been anything but. One of the most perceptive analysts of the medium has been the Italian theorist and novelist Umberto Eco. As Seldes before him, Eco maintained that any proper appraisal of the medium of comics must begin with an accurate perception of what they do and how they go about doing it, both internally and within their larger social and cultural environment . . . or as Eco scholar Peter Bondanella put it, "messages in popular culture must be decoded to reveal their latent ideological content in order to prevent the mass media from becoming an instrument of control." In four dense, intellectually dexterous, and radically different essays, Eco "decoded"

Peanuts, Steve Canyon, Superman, and Chinese comic strips to examine their implicit, if regularly overlooked, meanings and implications.

Following the social upheavals of the sixties and early seventies, another watershed of comics prose was reached. A thousand flowers bloomed and not through the worthiness of subject matter alone. There was more widespread media attention devoted to comics. A broader academic curiosity about them flourished, about their mechanics, their artistic achievements, and their social impact. Comics' subject matter and visual techniques made incursions into fine art's domain and the general ascendancy of pop culture raised the medium's profile in novel ways. The quantity of comic-related writing increased along with a concomitant growth in insightful and rewarding prose.

It's an advance that continues through to this day. The self-published newsletters and devotional fanzines of the sixties paved the way for today's diverse library of comics-related periodicals. The best of these invariably deepen an appreciation for the medium's history, its practitioners, and its communicative and expressive capabilities. The preeminent companion to the funny pages is *Hogan's Alley*, a lively look at comic strips from the dearly departed to those cutting an up-to-the minute edge. *The Comics Journal*, the industry's foremost source of news and criticism, aggressively pursues its mission of "illumination and subversion," principally through discriminating prose and substantive interviews (disclosure protocol demands I own up to writing pretty exclusively for this magazine). *The International Journal of Comic Art*, the English language's most concerted intellectual forum on the medium, bills itself as "academic but readable" and remains the best one-stop immersion in the global bazaar of comics.

Such outlets have nurtured a wealth of accomplished writers holding forth on the medium, several of whom appear in this present volume. Engaging, knowledgeable critiques arise from any number of diverse philosophies and temperaments, from elegant prose stylist Donald Phelps to trenchant R. Fiore to erudite Kenneth Smith to resolute strip historian Bill Blackbeard (as with every other listing here, I could go on and on to the limits of patience).

Cartoonists, too, continue to prove themselves thoughtful students and rigorous analysts of the form. Art Spiegelman has written prominently in a number of venues. Embedded artists such as Chris Ware, Chester Brown, Seth, Joe Sacco, Eddie Campbell, and others of their aesthetic ilk provide invaluable intelligence from unique perspectives when they are properly cornered, which often is during the course of interviews.

Thus the essentials of comics literature has become less a closed book of accepted wisdom than an ongoing series of updates on an ever-changing situation. Merely the latest case in point is *Arguing Comics: Literary Masters on a Popular Medium*. Editors Jeet Heer and Kent Worcester juxtapose commentary from several of the writers mentioned here along with a range of other rational heavyweights to collectively refract any simplistic view of comics, their past, and their potential. It proves anew that good writing about the art form is less ancient history than breaking news available from a number of sources.

Resources

The National Association of Comic Art Educators is an organization committed to helping facilitate the teaching of comics in higher education. Among the site's features are listings of schools offering comics art curricula, teaching resources (including exercises, study guides, handouts, and syllabi), student work samples, and a message board.
www.teachingcomics.org

The Comics Scholars' Discussion List is an e-mail-based academic forum for those involved in comics art-related research, criticism, and teaching. The site's features include a directory of comics scholars, online syllabi, and upcoming conferences and calls for papers.
www.english.ufl.edu/comics/scholars

ComicsResearch.Org is devoted to the study of the history and criticism of comics, with listings that include academic resources, how-to guides, and comics news.
www.comicsresearch.org

The American Library Association's ACRL division lists a variety of Internet resources for the study of cartoons, comics, and graphic novels.
www.acrl.org/ala/acrl/acrlpubs/crlnews/backissues2005/february05/comicbooks.htm

The National Cartoonists Society is an organization dedicated to advancing the ideals and standards of professional cartooning.
www.reuben.org

The Graphic Artists Guild publishes a handbook of pricing and ethical guidelines applied to cartoonists, comics artists, and other visual communications professionals.
www.gag.org

The Society of Illustrators and its Museum of American Illustration promotes interest in the art of illustration, past, present, and future.
www.societyillustrators.org

The Association of American Editorial Cartoonists site offers news of contents and events and links to member homepages.
http://info.detnews.com/aaec

Friends of Lulu is a national organization that promotes and encourages female readership and participation in the comic book industry.
www.friends-lulu.org

The Xeric Foundation is a nonprofit corporation established to provide grants and other financial assistance to self-publishing comics creators.
www.xericfoundation.com

The Comic Book Legal Defense Fund is a non-profit organization dedicated to the preservation of First Amendment rights within the comics community.
www.cbldf.org

The San Diego **Comic-Con International**, a major convention of professionals and exhibitors, and the San Francisco **Alternative Press Expo**, a large gathering of independent, self-published, and alternative comics creators, are annual events.
www.comic-con.org

The International Comic Arts Festival is an annual academic conference devoted to the study of comics from around the world.
http://go.to/icaf

The Comics Journal Message Board is an online open forum for discussing comics-related news and opinion.
www.tcj.com/messboard/ubbcgi/Ultimate.cgi

Egon provides a calendar of international comics artist events and art exhibits as well as news.
www.egonlabs.com

Thought Balloons and **Fanboy Rampage** are just two of the many blogs that provide links to comics-related Internet news and features.
http://thoughtballoons.blogspot.com
http://fanboyrampage.blogspot.com

Sequential Tart is a Web zine providing articles, interviews, and news that increase the awareness of women's influence in the comics industry.
www.sequentialtart.com

Comiclopedia contains capsule biographies, art samples, and Web links for over 5,000 comics creators worldwide.
www.lambiek.net/artists/index.htm

uComics and **Comics.Com** are two sites that provide on-line versions of comic strips and editorial cartoons.
www.ucomics.com
www.comics.com

The Professional Cartoonists Index site presents an ongoing collection of editorial cartoons from around the world and provides news and teacher guides related to political cartooning.
http://cagle.slate.msn.com

Comixpedia is an online community for news, reviews, and dialog about Web comics.
www.comixpedia.com

Business.com has an extensive list, with links, of large and small comic book publishers.
www.business.com/directory/media_and_entertainment/publishing/books/publishers/comics_and_graphic_novels

Contributor Biographies

Cartoonist and writer **Jessica Abel** is currently working on a non-comics novel, tentatively titled *Carmina*, for HarperCollins Children's Books. Her graphic novel *La Perdida* is due from Pantheon in 2006, and she has co-authored a graphic novel script called *Life Sucks*, to be published by First Second. She continues to teach at the School of Visual Arts, and is developing a comics textbook with Matt Madden.

Ho Che Anderson has done comics work for Milestone, Vertigo, Dark Horse, and Fantagraphics. He's created illustrations for several publications including *Time*, *The Boston Globe*, *The Globe and Mail*, and Fox. He's been a reporter at *The Toronto Star* since 2003.

Tony Auth has won numerous awards, including five Overseas Press Club Awards, the Society of Professional Journalists' Award for Distinguished Service in Journalism, and the Pulitzer Prize. In June of 2002, he was named the eighth American recipient of the Thomas Nast Prize, awarded by the Thomas Nast Foundation of Landau, Germany. He is the author and/or illustrator of several children's books, most recently *My Curious Uncle Dudley* by Barry Yourgrau.

Bart Beaty is an Associate Professor in the Faculty of Communication and Culture at the University of Calgary. He writes a regular column for *The Comics Journal*, "Euro-Comics for Beginners," and has published articles on comics in a wide variety of scholarly journals. His *Frederic Wertham and the Critique of Mass Culture* is forthcoming from University Press of Mississippi.

Award-winning art director **Monte Beauchamp** is the creator, editor, and designer of *Blab!*, an annual compendium of experimental art, illustration, cartoons, and design. His books include *The Life and Times of R. Crumb* (St. Martin's Press, 1998), *New and Used BLAB!* (Chronicle Books, 2003) and *The Devil in Design* (Fantagraphics, 2004).

Colin Berry is a contributing editor to *Print* and *Artweek*, and writes for National Public Radio, *I.D.*, *CMYK*, and KQED-FM. He is the co-author, with Isis Rodriguez, of *A Field Guide to American Strippers*. He lives in Guerneville, CA.

Nicholas Blechman (a.k.a. Knickerbocker) is the Art Director of the *New York Times Week in Review* and former art director of the Op-Ed page. He edited *Nozone IX: EMPIRE* (2004) and is the co-author of *100% EVIL* (2005), both from Princeton Architectural Press.

Peter Blegvad is an illustrator and cartoonist with a popular weekly strip, *Leviathan*, published in *The Independent on Sunday* from 1991 to 1998 and the Italian comics magazine, *Linus*. A photo-based comic strip, *The Pedestrian*, ran in England from 1999 to 2000. *The Book of Leviathan* was published by Sort of Books in London in 2000 and the Overlook Press, New York, in 2001 and was nominated for an Eisner award in 2002.

Steve Brodner is a caricaturist working in New York City. His work has appeared in most major publications in North America. *Freedom Fries*, a collection of his political art, was published in 2004 by Fantagraphics.

Paul Buhle was the publisher of *Radical America Komiks* (1969); co-edited a comic-format history of the Industrial Workers of the World; and is scripting *Wobblies, a Graphic History*, a comic-format version of Howard Zinn's *A People's History of the United States*. He teaches in History and American Civilization at Brown University.

Kim Deitch got into comics professionally (after a fashion) in 1967 and now in the murky early days of the twenty-first century, he is at it yet. He is married and is a Democrat.

Michael Dooley is a Los Angeles-based creative director, lecturer, and research consultant on matters of fine art, design, photography, film, and comics. A former *Comics*

Journal writer and current contributing editor of *Print*, the graphic design magazine, his feature articles and critical essays appear in a variety of publications.

Will Eisner joined the Quality Comics Group in 1939 to produce a syndicated sixteen-page newspaper supplement, for which he created his most famous character, *The Spirit*. Beginning with *A Contract with God*, he created a series of graphic novels and short stories with subject matter ranging from semi-autobiographical (*The Dreamer* and *To the Heart of the Storm*) to observations of modern life (*The Building* and *Invisible People*) and parables (*Life on Another Planet*). His instruction books include *Comics & Sequential Art* and *Graphic Storytelling*.

Robert Fiore is a long-time observer and commentator on the art and business of comics, and writes the "Funnybook Roulette" column for *The Comics Journal*. As an editor at Fantagraphics Books he worked on collections of the work of Robert Crumb, Kim Deitch, Spain Rodriguez, and Vaughn Bode.

Rick Geary is a freelance cartoonist and illustrator. His work has appeared regularly in *National Lampoon, Mad, The New York Times Book Review, Disney Adventures*, and many other publications. His series of graphic novels depicting famous nineteenth-century murder cases continues with *The Murder of Abraham Lincoln*.

Bill Griffith began his comics career in 1969. His first major comic book titles included *Tales of Toad* and *Young Lust*. He was co-editor of *Arcade, The Comics Revue* in the mid-1970s. His first Zippy the Pinhead story appeared in *Real Pulp Comics* #1 in 1970. The strip went weekly in 1976. In 1985 Griffith began doing *Zippy* as a daily strip, first appearing in the *San Francisco Examiner* and then syndicated nationally to over 200 papers by King Features Syndicate.

R.C. Harvey is a comics historian and freelance cartoonist who has produced comic strips, gag cartoons, comic books, and editorial cartoons. He conducts a Web site at *www.RCHarvey.com*, where he reviews graphic novels, reprint collections, and similar books. He has contributed numerous cartoonist biographies to Oxford University Press's *American National Biography* (both on-line and in print).

Steven Heller is the art director of the *New York Times Book Review* and co-chair of the School of Visual Arts MFA design program. He is the author, editor, or co-author of over ninety books on design, popular art, and illustration.

David Heatley is a cartoonist who publishes a series called *Deadpan*, available for purchase at *www.davidheatley.com*.

Todd Hignite is the founder and editor of *Comic Art*, a Harvey Award–winning magazine devoted to all aspects of the comic medium. Trained as an art historian, he has worked in various capacities as a critic, writer, and curator, recently organizing the exhibition *The Rubber Frame: American Underground and Alternative Comics, 1964–2004*. His book *In the Studio: Visits with Contemporary Cartoonists* is forthcoming in 2006 from Yale University Press.

Nicole Hollander holds a BFA from the University of Illinois and an MFA in painting from Boston University. She was a freelance designer and illustrator when she started her feminist cartoon career doing illustrations for *The Spokeswoman* in the early seventies. Her first book published by St. Martin's Press was titled *I'm in Training to be Tall and Blonde*. She is syndicated by the Tribune Media Services to more than 60 papers in major markets.

Dan James wears his only/favorite pair of pants every day. Everything he ever draws can be seen at *www.ghostshrimp.net*.

Chip Kidd is a designer and writer. He also edits books of comics for Pantheon, including the work of Chris Ware, Dan Clowes, Kim Deitch, Mark Beyer, and Alex Ross.

Paul Krassner is the author of *Murder At the Conspiracy Convention and Other American Absurdities*. To read George Carlin's introduction, check out *www.paulkrassner.com*, which also has for sale the original Disneyland Memorial Orgy poster.

Tim Kreider's first book of cartoons, *The Pain: When Will It End?*, was published by Fantagraphics in 2004. His cartoon of the same title runs in *The Baltimore City Paper* and *The Jackson Planet Weekly*, and his illustrations appear in *Lip*. His second book, *Why Do They Kill Me?* will be released in the spring of 2005. He has contributed essays to *The Comics Journal* and *Film Quarterly*.

Rich Kreiner lives in Maine and has written for *The Comics Journal* since 1986, two facts which go a long way to account for his dispositional bipolarity.

During his sixty-plus years as a writer, illustrator, and educator, **Joe Kubert** has worked on a variety of comics, including *Sgt. Rock*, *Hawkman*, and *Enemy Ace*. He was a DC Comics editor for over two decades. In 1976 he founded the Joe Kubert School of Cartoon and Graphic Art in Dover, New Jersey. His graphic novels include *Rock and a Hard Place*, *Tor*, *Fax From Sarajevo*, and *Yossel: April 19, 1943*.

Peter Kuper's illustrations and comics appear regularly in *Time*, the *New York Times*, and *Mad*, where he illustrates "Spy vs. Spy" every month. He is co-art director of INX, a political illustration group syndicated through the web at *inxart.com*. His most recent books are adaptations of Franz Kafka's *The Metamorphosis*, Upton Sinclair's *The Jungle*, and *Sticks and Stones*, a wordless graphic novel about the rise and fall of empires. His work can be seen at *www.peterkuper.com*.

Heidi MacDonald is an editor, journalist, critic, and co-founder of "Friends of Lulu." She has worked for Walt Disney and Warner Bros. Her "The Beat: the news blog of comics and culture" is at *www.comicon.com/thebeat*.

In addition to painting his *Kabuki* series for Marvel's Icon imprint, **David Mack** is writer and artist of Marvel's *Daredevil*. He's taught classes in writing, drawing, and painting all over the world, including a Master class at the University of Technology in Sydney, Australia. His next project is an autobiographical comic based on his eight-page "Self Portrait" in Vanguard's *Edge* tenth-anniversary edition compendium.

In addition to creating comic strips, **Stan Mack** has written and illustrated numerous books for young people and adults including his latest, an illustrated memoir, *Janet and Me, An Illustrated Story of Love and Loss.*

Matt Madden is a cartoonist and illustrator who teaches comics and drawing at the School of Visual Arts and Yale University. *99 Ways to Tell a Story*, a collection of his comics adaptation of Raymond Queneau's *Exercises in Style*, will be released by Chamberlain Brothers in 2005. Future plans include more experimental short stories and a comics textbook, co-authored with Jessica Abel.

Bob Mankoff has been a cartoonist for *The New Yorker* magazine since 1977, and was made cartoon editor in 1997. He is the editor of *The Complete Cartoons of The New Yorker*, a book and CD combo that he claims you can't put down, provided you're strong enough to lift it.

Barbara McClintock writes and illustrates books for children for Farrar, Straus, and Giroux, Random House, Scholastic Press, Houghton Mifflin, David Godine, and Harper Collins.

Scott McCloud is a comics artist in the broadest sense. His book *Understanding Comics* revolutionized thinking about comics as a communication medium and *Reinventing Comics* did the same for the business and technology of comics. McCloud was a pioneer of on-line comics and is a popular speaker on comics, communication, and technology. More at *www.scottmccloud.com.*

In 1986, illustrator **Dave McKean** teamed up with journalist Neil Gaiman to illustrate a strange story about a little boy and Al Capone's osteopath, *Violent Cases.* Since then, with Gaiman, he has illustrated *Black Orchid, Mr. Punch, Signal To Noise,* and *The Wolves in the Walls,* and with Grant Morrison, the illustrated the Batman graphic novel *Arkham Asylum.* He has written the award-winning *Cages,* and a collection of short comics called *Pictures That Tick.* He has recently directed his first feature film, *Mirrormask,* also written by Gaiman.

Rick Meyerowitz was born in New York City during the last century. He lives and works there still.

Dan Nadel is director of the Grammy-winning visual content studio PictureBox, Inc., *www.pictureboxinc.com*, which has most recently published *The Wilco Book*. His next book, *The Underground That Wasn't: An Anthology of Unknown Visionary Cartoonists*, will be published in 2006.

Mark Newgarden is a cartoonist living in Brooklyn. *We All Die Alone*, a collection of his work in the comics medium, is due from Fantagraphics in 2005.

Dennis O'Neil is an award-winning writer and editor. His numerous accomplishments over the decades include introducing social relevancy to DC Comics with his early 1970s *Green Lantern/Green Arrow* scripts. He lives in Nyack, New York, with his wife Marifran.

Gary Panter made his mark in the 1980s as head set designer for *Pee Wee's Playhouse*. He is also the creator of *Jimbo*, a post-nuclear punk-rock cartoon character. Equally groundbreaking are his extended comic novels *Dal Tokyo* and *Cola Madness* (published by Funny Garbage Press) and his adaptation of Dante's *Purgatorio* (Fantagraphics).

Joel Priddy is an illustrator, cartoonist, and educator in Memphis, Tennessee.

Bill Randall writes about manga for *The Comics Journal*. A native of Kentucky, he currently lives near Osaka.

David Rees is the author of *My New Fighting Technique is Unstoppable, My New Filing Technique is Unstoppable, Get Your War On*, and *Get Your War On II*.

Eric Reynolds has worked for Fantagraphics Books since 1993 in a variety of capacities; he has edited books by R. Crumb, Robert Williams, Johnny Ryan, and

others. He is a longtime contributor to and former editor of *The Comics Journal*, and his cartoons and illustrations have appeared in *The Ganzfeld*, *New York Times*, *New York Press*, *Stranger*, *Mojo*, and many other publications.

Leonard Rifas welcomes correspondence on educational comics in care of his one-man company, EduComics, at Box 45831, Seattle, WA 98145-0831. A list of his scholarly activities can be found online at: *www.english.ufl.edu/comics/scholars/directory/pt.html rifas.*

Retired cartoonist **Trina Robbins** turned her talents to feminist pop culture over ten years ago when she wrote her first book on women cartoonists, *A Century of Women Cartoonists*. Since then she's written a dozen more books, including one about dark goddesses, *Eternally Bad*, one about women who kill, *Tender Murderers*, and her latest, *Wild Irish Roses*, a history of Irish women. But she still likes to write about killer women cartoonists.

Roger Sabin lectures in Cultural Studies (including a "history of comics" course) at Central Saint Martins College of Art and Design, University of the Arts, London. He is the author of several books, including *Adult Comics: An Introduction* (Routledge) and *Comics, Comix, and Graphic Novels* (Phaidon).

David Sandlin was born in Belfast, Northern Ireland. He has lived in New York City since 1980, where he paints, makes prints and comics, and teaches at the School of Visual Arts.

A lifelong newspaperman, **Ben Sargent** worked as a printer, copy editor, and reporter before becoming *The Austin American-Statesman*'s editorial cartoonist in 1974. He won the Pulitzer Prize for editorial cartooning in 1982 and is distributed nationally by Universal Press Syndicate.

Marjane Satrapi is the author of *Persopolis: The Story of a Childhood* and *Persepolis 2: The Story of a Return* (Pantheon). Her comics and illustrations have appeared in major magazines and newspapers, including *The New Yorker* and *The New York Times*.

Arlen Schumer, named by *Comic Book Artist* magazine in 1998 as "one of the more articulate and enthusiastic advocates of comic book art in America," is the writer and designer of the coffee-table book, *The Silver Age of Comic Book Art*. As a co-founder and partner of The Dynamic Duo Studio, Schumer creates award-winning comic book art illustrations for the advertising and editorial markets.

In addition to having had a major impact on the comic book field, award-winning artist/writer **Bill Sienkiewicz** has worked on many successful films and received two Emmy nominations.

After spending eight years as an art director, **Elwood Smith** began his career as a full-time illustrator. He and his wife, rep, and creative partner, Maggie Pickard, live in Upstate New York where, in addition to art assignments, he is hard at work on his latest passion, animation, samples of which can be seen on his Web site, *www.elwoodsmith.com*.

Art Speigelman's autobiographical "Maus," first published in *Breakdowns*, was based on the experiences of his parents as concentration-camp survivors. He expanded his story into a two volumes, *Maus: A Survivor's Tale* and *Maus II: From Mauschwitz to the Catskills* (Pantheon Books), which he drew from 1980 to 1991. For it was awarded a special Pulitzer Prize in 1992. In addition to co-editing *Raw* magazine and creating illustrations for books such as *The Wild Party* and covers for *The New Yorker*, Spiegelman is the co-editor with Françoise Mouly of the children's *Little Lit*, an original anthology of comics for children. In the wake of the attack on the World Trade Center, Spiegelman created a ten-part series of Sunday pages titled "In the Shadow of No Towers," which was published in book form in 2004.

Tom Spurgeon is a co-author of 2003's *Stan Lee and the Rise and Fall of the American Comic Book* and is a former executive editor of *The Comics Journal*. He wrote that magazine's "Minimalism" column for four years. He currently runs the Web site The Comics Reporter, which includes resources for mini-comics makers and readers, *www.comicsreporter.com*.

Mark Alan Stamaty is the author-illustrator of numerous children's books, including *Who Needs Donuts?* and *Alia's Mission.* He is the creator of numerous comic strips, including *MacDoodle St., Washingtoon,* and *Boox.*

Ted Stearn's first book, *Fuzz and Pluck,* was published by Fantagraphics. He is now working a five-part comic book series called *Fuzz & Pluck in Splitsville.* Since 2001 he has been teaching comics and storyboarding at the Savannah College of Art and Design in Georgia. He's also a storyboard artist for the animated sit-com *King of the Hill.*

Jim Steranko drew *Nick Fury, Agent of S.H.I.E.L.D., Captain America,* and *The X-Men* for Marvel, then established the publishing company Supergraphics to produce material related to visual storytelling in every medium, including his two-volume *History of Comics,* which has sold more than 100,000 copies each. He painted the initial production illustrations for *Raiders of the Lost Ark* and was Project Conceptualist for *Bram Stoker's Dracula.* Recently, he served as Creative Consultant for the History Channel's two-hour documentary *Comic Book Superheroes: Unmasked.*

Barron Storey, artist, has freelanced for *Time, National Geographic,* NASA, the American Museum of Natural History, and the Franklin Library. He has been an illustration teacher with Art Center College of Design, Brookhaven College, Pratt Institute, School of Visual Arts, Syracuse University, California College of Arts and Crafts, and San Jose State. He is also a musician, poet, and exhibiting painter. His work hangs in the Smithsonian's National Portrait Gallery.

James Sturm is a cartoonist (*The Golem's Mighty Swing*) whose comics, illustrations, and writings have appeared in scores of national and regional publications including the cover of *The New Yorker.* He is currently the director of The Center for Cartoon Studies, *www.cartoonstudies.org,* a two-year cartooning school in White River Junction, Vermont.

Ward Sutton is a cartoonist/animator/illustrator who creates the weekly political comic strip *Sutton Impact.* His freelance clients include Comedy Central, HBO, VH1, The Sundance Film Festival, *The New York Times, Rolling Stone, The Village Voice,* and *Entertainment Weekly.*

Gunnar Swanson is a graphic designer, writer, and educator. His designs have won over a hundred awards; his articles on graphic design subjects have been widely published in the popular and academic press. Swanson also edited the Allworth Press book, *Graphic Design & Reading*. More at *www.gunnarswanson.com*.

Teal Triggs is head of research, School of Graphic Design, London College of Communication, London University of the Arts. She has written extensively on graphic design, typography, and feminism and is co-editor with Roger Sabin of *Below Critical Radar: Fanzines and Alternative Comics From 1976 to Now* (Slab-O-Concrete).

Chris Ware produces a weekly newspaper strip and the irregular periodical *The ACME Novelty Library*, and is the author of *Jimmy Corrigan, the Smartest Kid on Earth*, which received the Guardian First Book Award in 2001, and the American Book Award in 2000. His work has been published in *The New Yorker* and *New York Times* and was included in the 2002 Whitney Biennial. He most recently edited the thirteenth issue of *McSweeney's*.

Robert Williams has contributed comics to *Gothic Blimp Works*, *Cootchy Cooty Men's Comics*, *Felch*, *Snatch*, *Tales from the Tube*, and most issues of *Zap*. He currently makes his living with his fine-art oil paintings. He also is the founder of *Juxtapoz*, the contemporary art magazine. His most recent books, *Malicious Resplendence* and *Hysteria in Remission*, are published by Fantagraphics.

Craig Yoe's YOE! Studio, *www.yoe.com*, designs toys, books, comics, etc. for Disney, Nickelodeon, Cartoon Network, MTV, etc. He has won many awards, including an Eisner, and The Gold Medal from the Society of Illustrators. Craig's books include *The Art of Mickey Mouse*, *Weird But True Toon Factoids*, and *Arf*, *www.ArfLovers.com*, a series about the Great Dead Cartoonists and Craig's own work.

Index